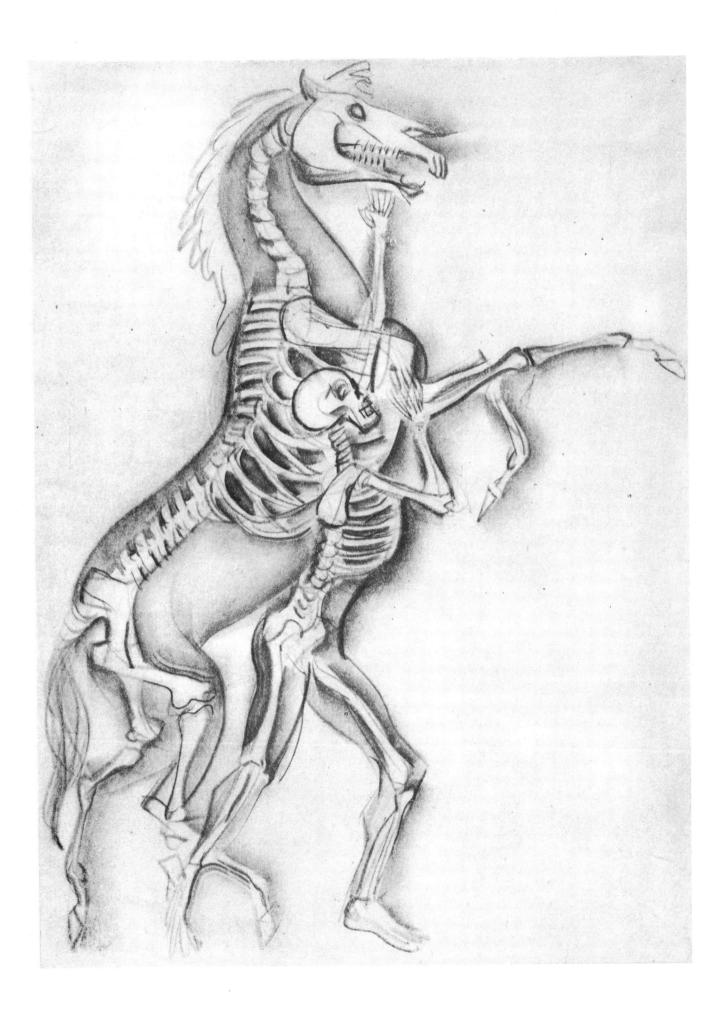

Dynamic Animal Drawing

Arthur Zaidenberg

DOVER PUBLICATIONS, INC.
Mineola, New York

Bibliographical Note

This Dover edition, first published in 2009, is an unabridged republication of *Anyone Can Draw Animals,* originally published by Pitman Publishing Corporation, New York and Chicago, in 1946.

Library of Congress Cataloging-in-Publication Data

Zaidenberg, Arthur, 1903-
 [Anyone can draw animals]
 Dynamic animal drawing / Arthur Zaidenberg. — Dover ed.
 p. cm.
 Originally published: Anyone can draw animals. New York : Pitman Pub., 1946.
 ISBN-13: 978-0-486-47008-5 (pbk.)
 ISBN-10: 0-486-47008-3 (pbk.)
 1. Animals in art. 2. Drawing—Study and teaching. I. Title.

NC780.Z3 2009
743.6—dc22
 2008042844

Manufactured in the United States of America
Dover Publications, Inc., 31 East 2nd Street, Mineola, N.Y. 11501

CONTENTS

~~~~~

SEEING ANIMALS AND DRAWING
    THEM . . . . . . 3
SKETCHING . . . . . 4
MATERIALS . . . . . 6
BASIC FORMS . . . . 10
HORSES . . . . . 12
ZEBRAS . . . . . 34
MULES . . . . . 35
DONKEYS . . . . 36
DOGS . . . . . 37
FOXES . . . . . 56
WOLVES . . . . . 57
CATS . . . . . 58
TIGERS . . . . . 70
LEOPARDS . . . 82
LYNX . . . . . 84
LIONS . . . . . 86
DEER . . . . . 91

MOOSE . . . . . 95
BUFFALO . . . . 96
CARABAO . . . . 100
GNU . . . . . 103
COWS AND BULLS . . . 104
SHEEP AND GOATS . . 110
SWINE . . . . . 114
WART HOG . . . 119
ELEPHANTS . . . . 120
HIPPOPOTAMUS AND RHINOCEROS 127
GIRAFFES . . . . 133
BEARS . . . . 134
CAMELS . . . . 140
SQUIRRELS, OTTER, BEAVER,
    MINK, RABBIT, KANGAROO . 144
BIRDS . . . . 150
MONKEYS AND APES . . . 161

꩜꩜꩜ DYNAMIC ANIMAL DRAWING is in the main a collection of sketches made by Mr. Zaidenberg in the manner recommended (on page 4) for the person who seeks proficiency in this field. Some of these sketches have been analyzed for anatomical and structural detail; some have been developed almost to the point of finished drawings. Thus they give examples of the observation of this distinguished artist, plus an insight into his methods of observation and rendering; and even more, a number of examples to show how quick sketches are worked up into finished artistic compositions.

# *DYNAMIC* ANIMAL DRAWING

# SEEING ANIMALS AND DRAWING THEM

⌒⌒⌒ DRAWING ANIMALS AND BIRDS presents the same problems involved in drawing human beings. The main problem, broadly stated, is learning to *see*. Once you have done that, you have acquired the essence of the artist's craft. Having that essence, you need merely to acquire methods of putting down on paper what you have seen. For the artist, seeing is not just the process of looking at things, which is the normal function of the eye. For him, seeing means examining with emotion, taste, interest, discrimination, and above all with elimination of nonessential detail. In that sense, seeing combined with craftsmanship will produce good drawing, perhaps even art "creation." And craftsmanship is easily learned if the student wants to learn it, through study in class, from books, and with practice. Talent is not indispensable.

The average intelligent person who loves his pets or admires the movements and grace of animals and birds can learn to draw them. Toward that end this book is planned to help him in two respects: First, to see them in their simplest basic forms of structure. Second, to learn the approaches to drawing animals and birds so as to capture their essential character and at the same time eliminate superficial details.

The superficial details make the problem of drawing appear, at first glance, too complicated for the amateur and even in many cases for the professional artist. Experienced artists, excellent draftsmen, faced with the necessity of drawing a horse or a dog, have been known to pale. Their anatomy studies did not include animals; therefore they considered animals too difficult to attempt.

But an artist's ability to draw should not be limited in any degree, and he should be able to say anything he wishes with his pencil. He should make a determined effort to *know* the animal he wants to draw rather than to know its anatomy. He should make a study of the general characteristics of the animal, then draw it as it appears to *him* through his "feel" of it. Its character is more important and expressive than the exact number and placement of its bones. For ferocity, lines will be bold and strong; for stealth, they will be subtle and tend to smoothness.

# SKETCHING

⌒⌒⌒ THE BEST ADVICE to those who love animals and would like to draw them is to fill many sketchbooks with drawing notes. Animals will not consciously pose for you. They move quickly and every movement is worthy of study because every action of an animal is a complete expression.

Sketch them in every position and mood—relaxed, active, calm, angry, eating, fighting. Get to know them intimately. To the degree that you know them well, you will draw them well.

Combine your understanding of animal character with the structure plans shown on the facing page and on other pages of this book; thus you will develop any latent talent for drawing that you may have.

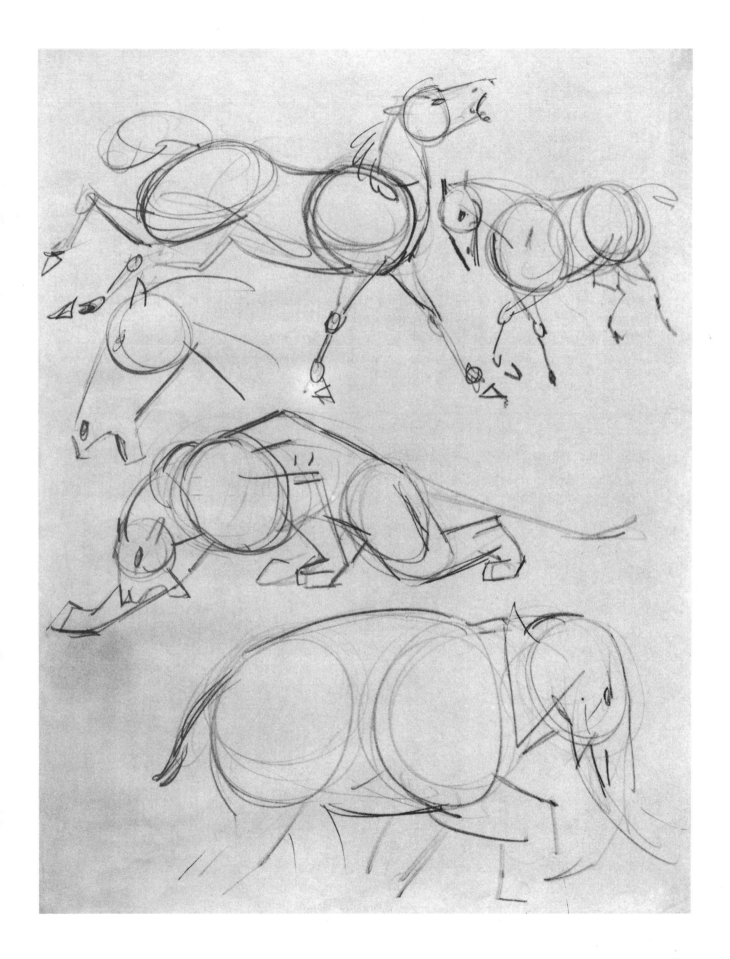

# MATERIALS

◠◠◠ BECAUSE ANIMALS ARE RESTLESS as a rule and their movements fleeting and unpredictable, it is best to use a quick medium for drawing notes. Oil paints and water colors require much setting up and preparation to be feasible for animal sketching. Pencil, Conté crayon, pen and ink, dry brush, or color crayons are the best quick materials, and they make entirely satisfactory notes for elaboration into any other medium.

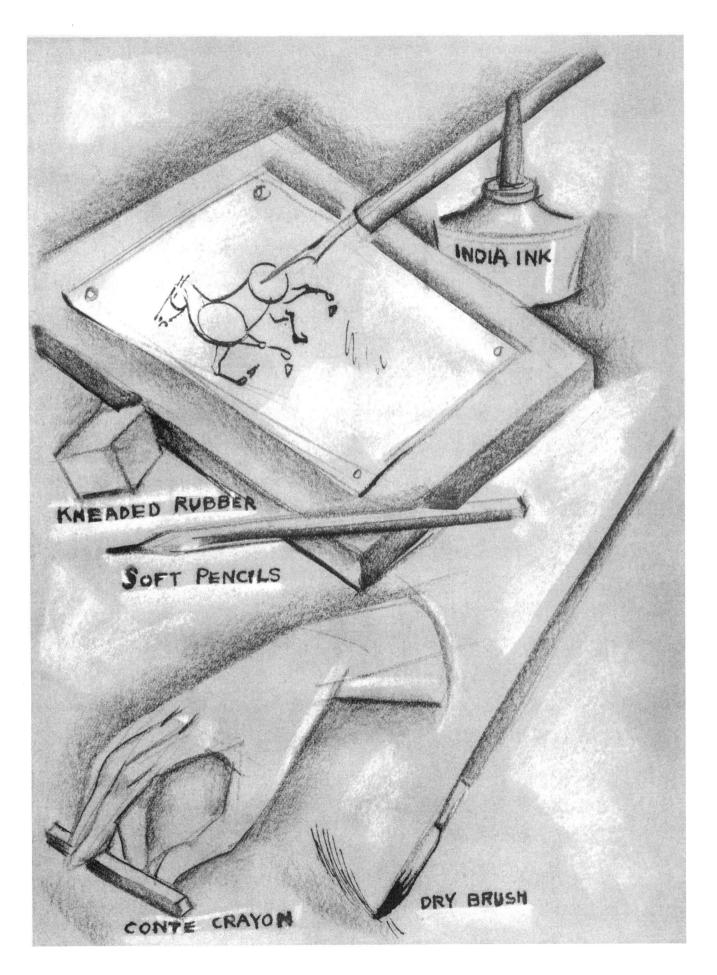

INDIA INK

KNEADED RUBBER

SOFT PENCILS

CONTE CRAYON

DRY BRUSH

7

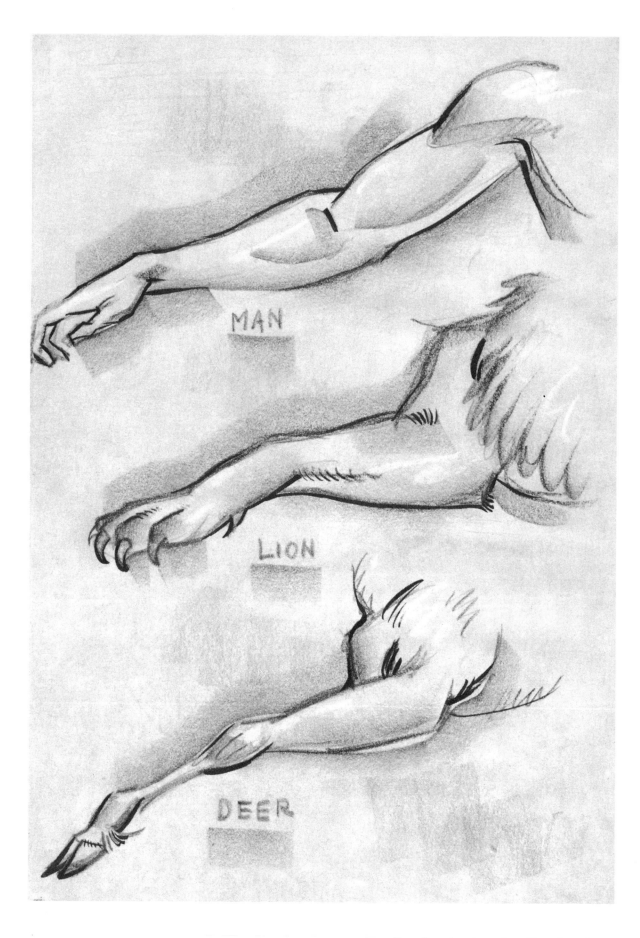

MAN

LION

DEER

Human and Animal Arms and Legs, Compared in Similar Movement

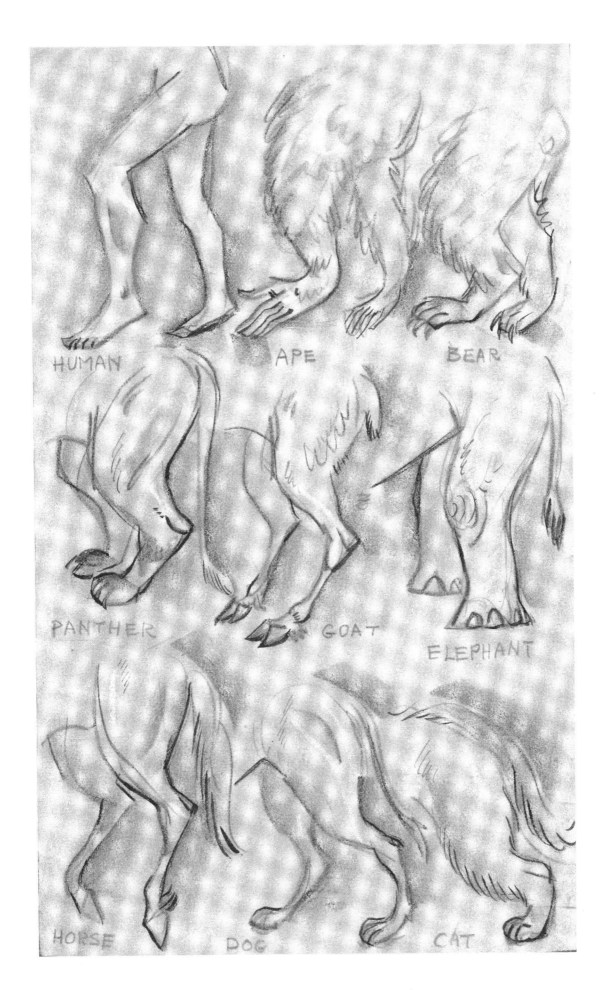

9

# BASIC FORMS

⌒⌒⌒ THE TWO CIRCLES ARE THE BASIC FORMS for the drawing generalization in this book, because with few exceptions this two-circle principle can be applied to the drawing of all animal torsos.

These circles are the key forms used to construct the torso. From them is suspended the barrel of the body. The neck form and forelegs are joined to one, the tail and hind legs to the other.

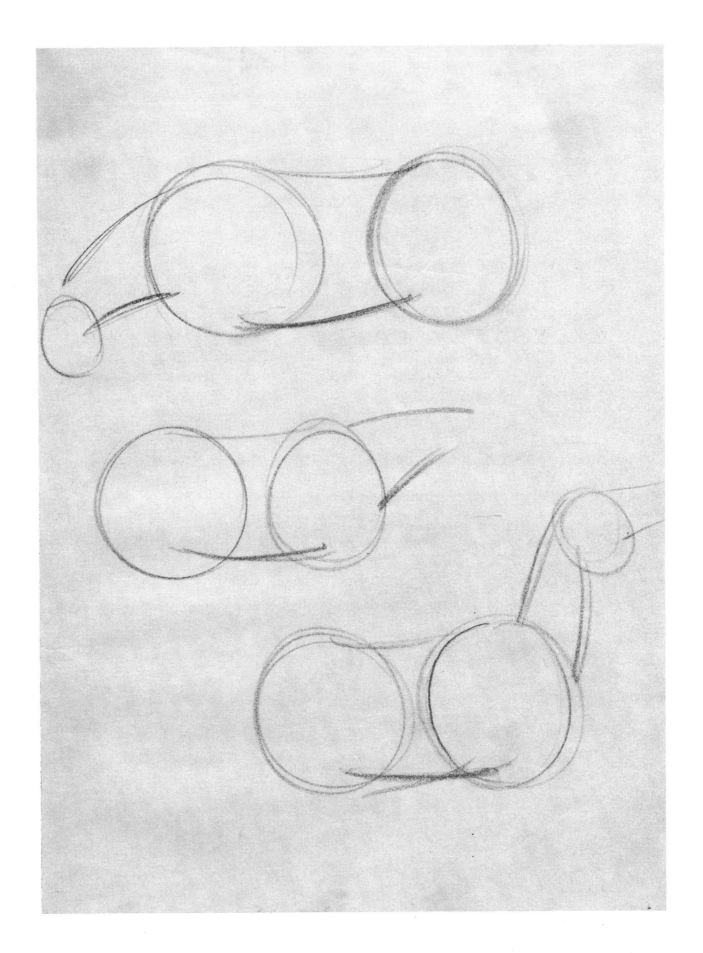

# HORSES

ﾍﾍﾍ ALTHOUGH HORSES ARE AMONG THE MOST BEAUTIFUL and graceful of animals, they possess great strength. This combination makes for subtle lines. To capture this subtle strength and beauty with a pencil requires considerable observation of horses and much practice in drawing them.

There are, however, a few basic forms that can be used in learning the construction and action principles of horses that will help greatly in acquiring the ability to draw them.

Most people find it difficult to draw the leg movements of horses and to represent their gait. In the following pages, forms of the body and the legs of the horse have been reduced to a few simple principles that can serve as working drawings upon which to build the details that will give the drawing more finish. The leg parts have been conventionalized, and the movements are shown in their most direct functional action. Study these exercises and make many similar simple chart drawings of your own. You will soon find that drawing a horse in any position or action is a simple process of basic design, and this basic design applies to almost all animals as well as to horses.

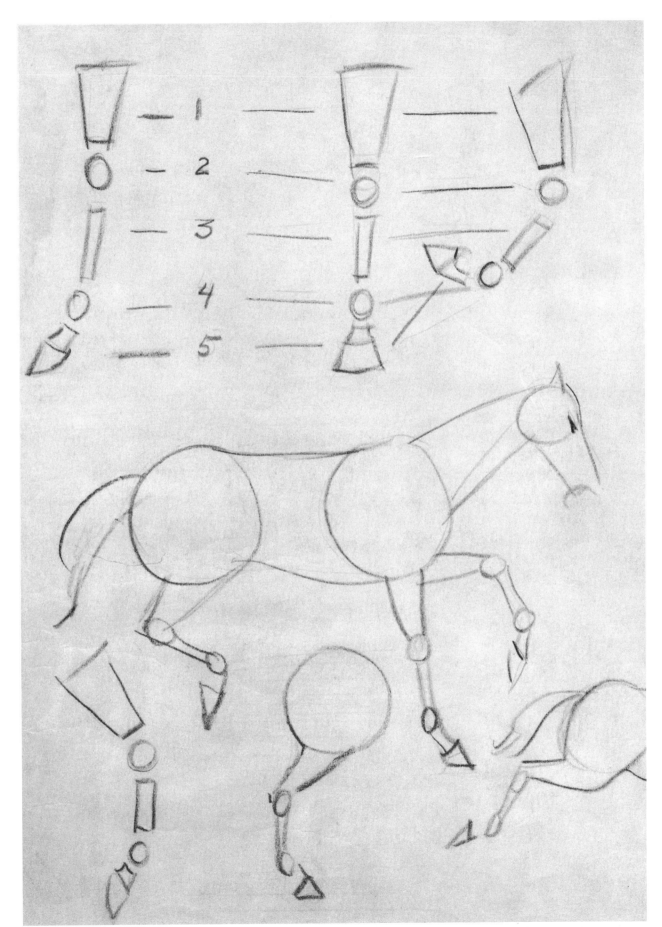

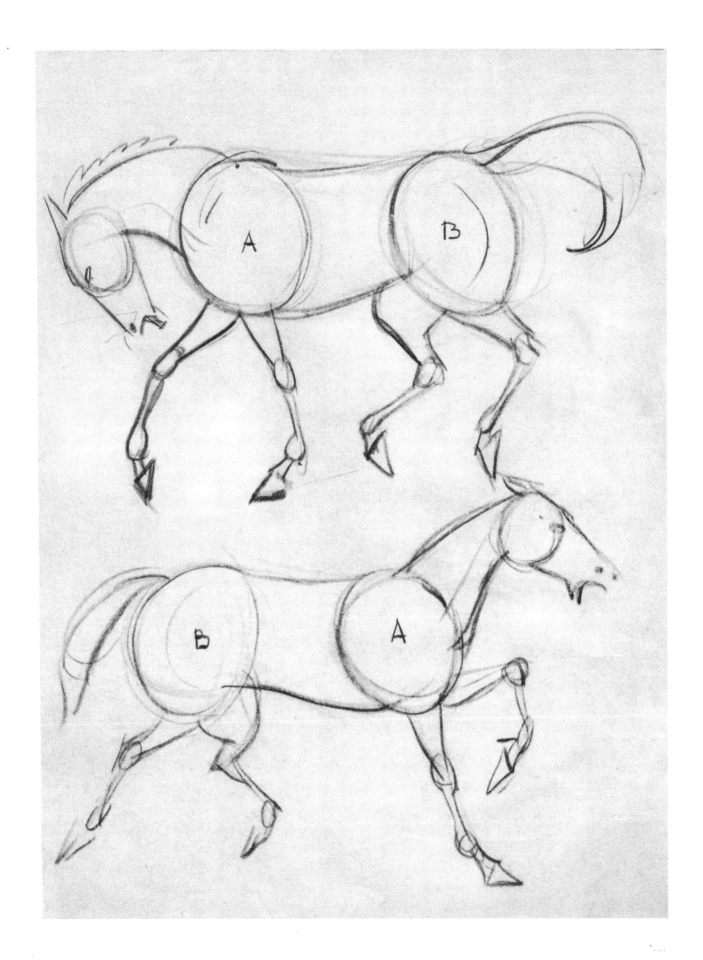

14

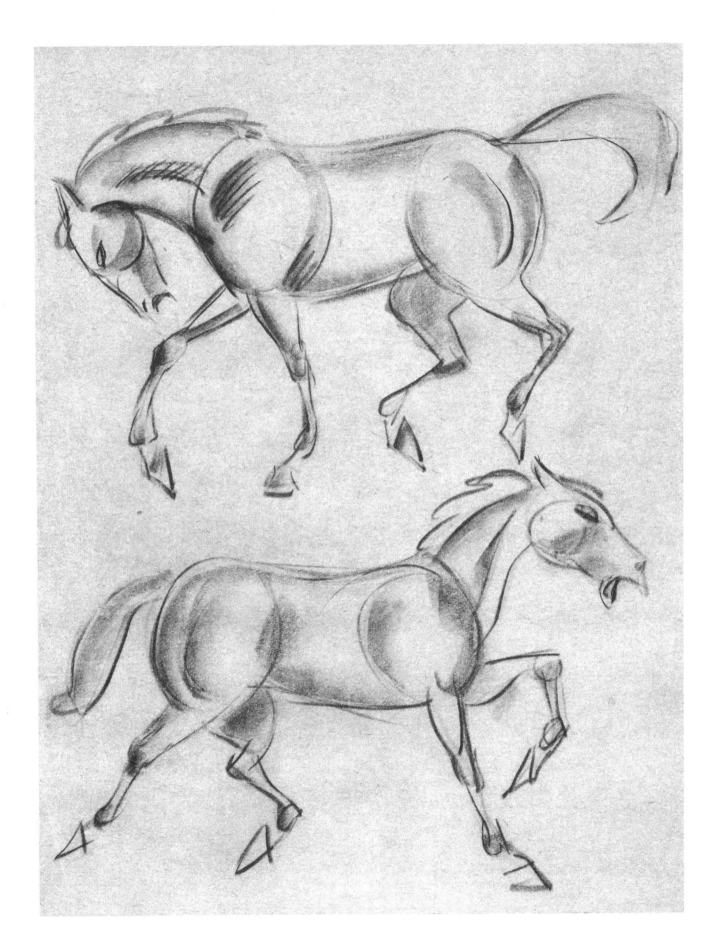

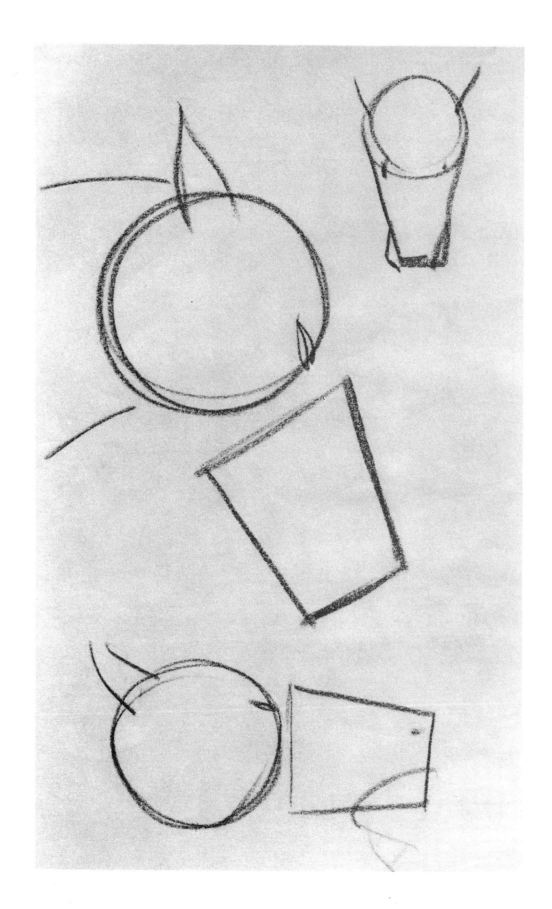

The head of the horse may be contained in two basic forms. Within these two shapes will fall all the detail that will finish the drawing. Practice drawing these two shapes

16

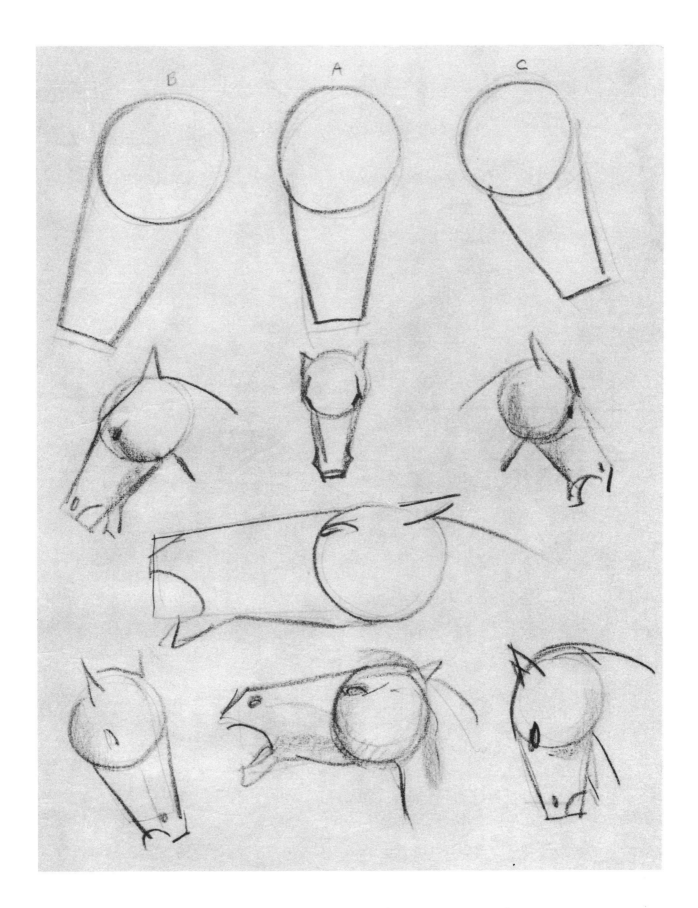

in the various positions indicated on the following pages in order to show the turn of
the head. As you do so, notice the way the head is joined to the neck.

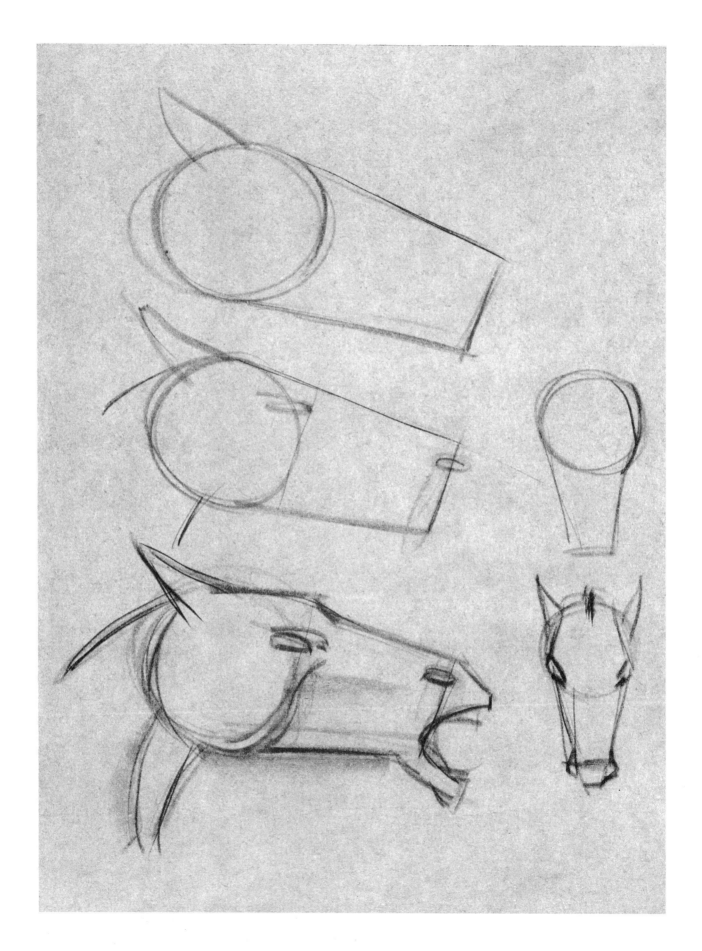

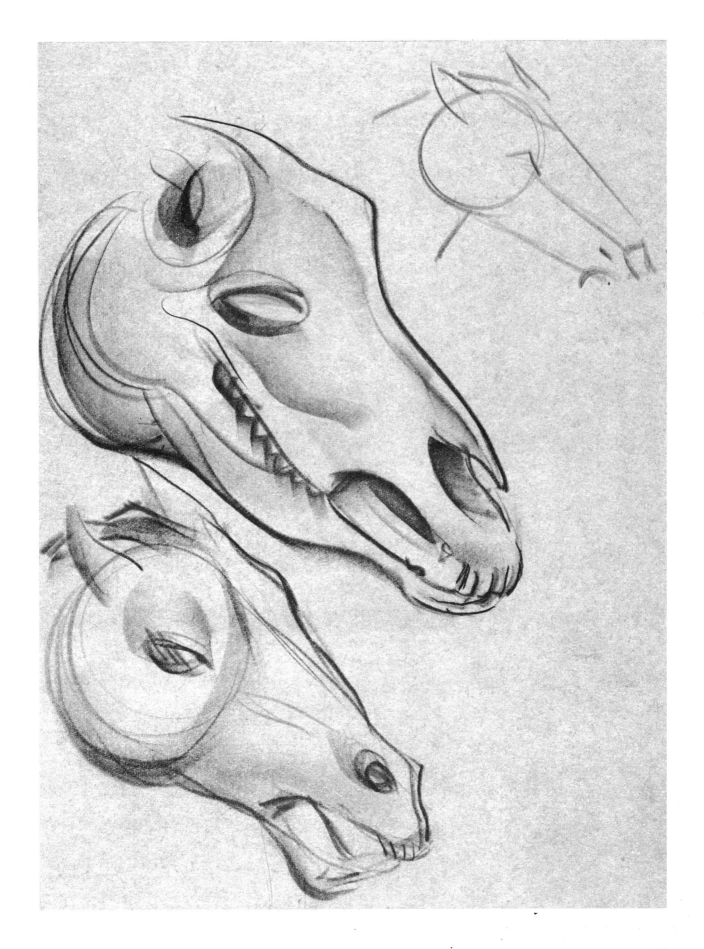

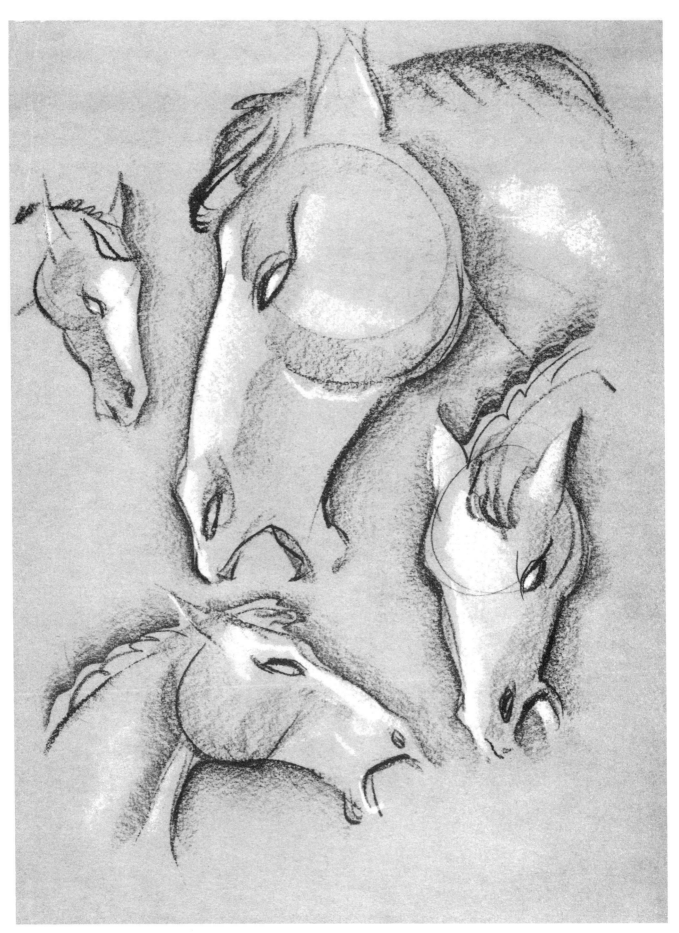

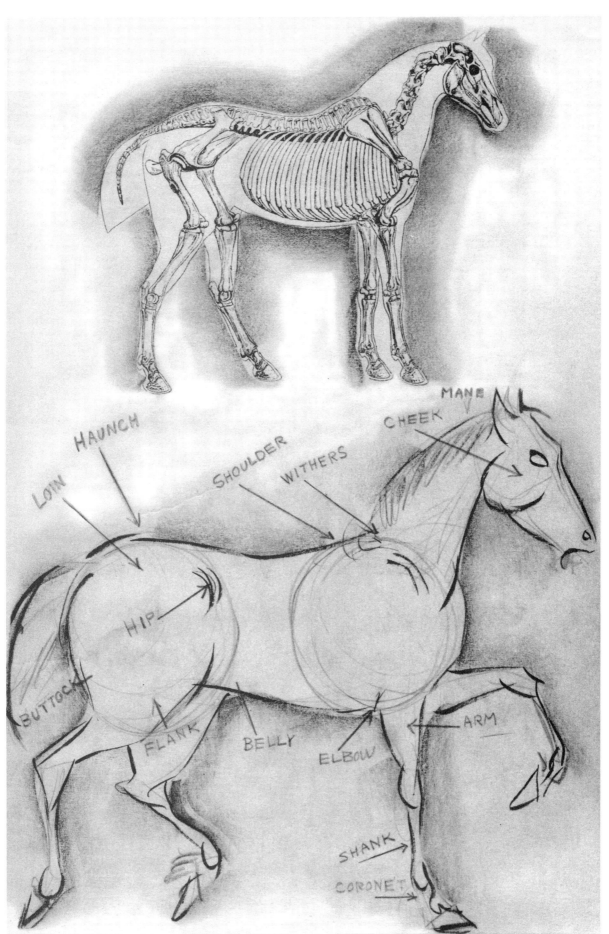

HAUNCH

LOIN

SHOULDER

WITHERS

MANE

CHEEK

HIP

BUTTOCK

FLANK

BELLY

ELBOW

ARM

SHANK

CORONET

The drawing of the legs of the horse often presents difficulty. Their subtle grace and beauty, however, can be reduced to a few principles of basic design that also hold true for most hoofed animals—donkeys, zebras, buffalo, and deer. On page 13 and on page 23 are the fundamentals for drawing the legs of horses, shown in various positions and in progressive stages of completion.

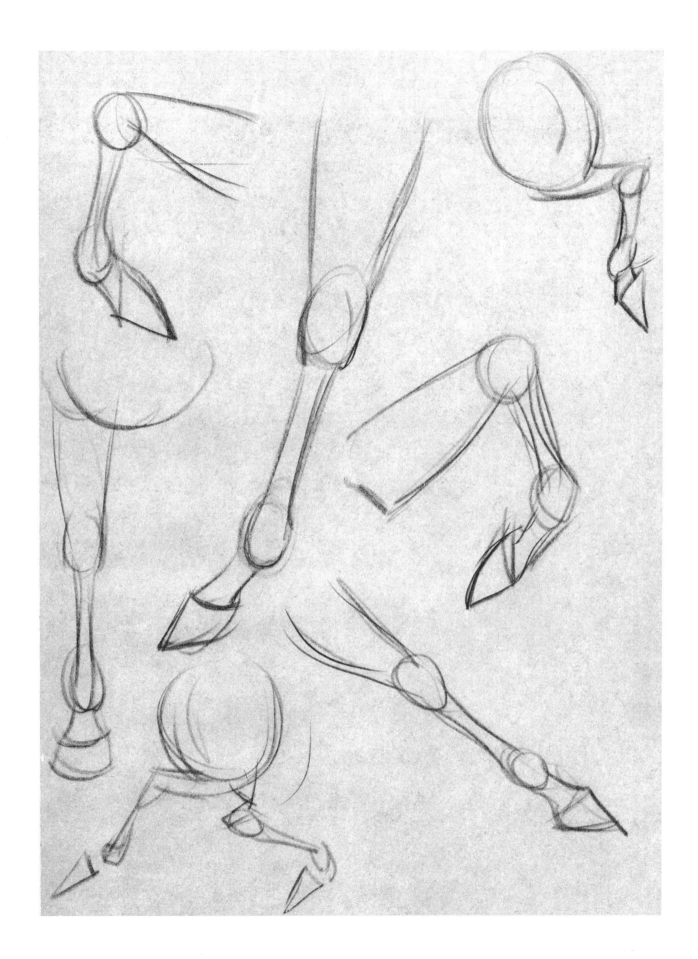

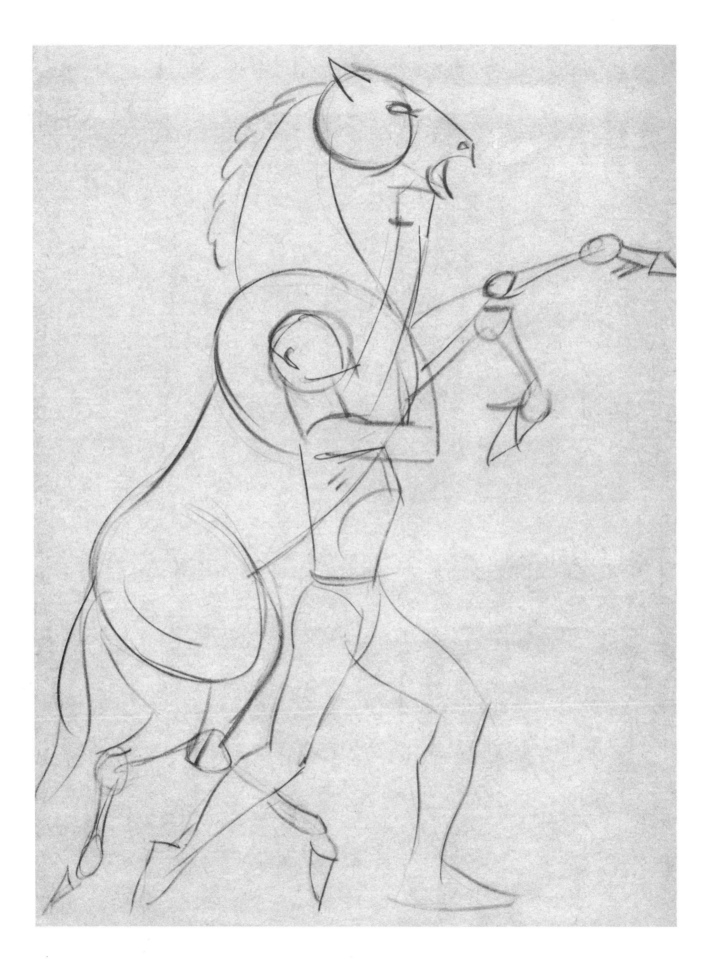

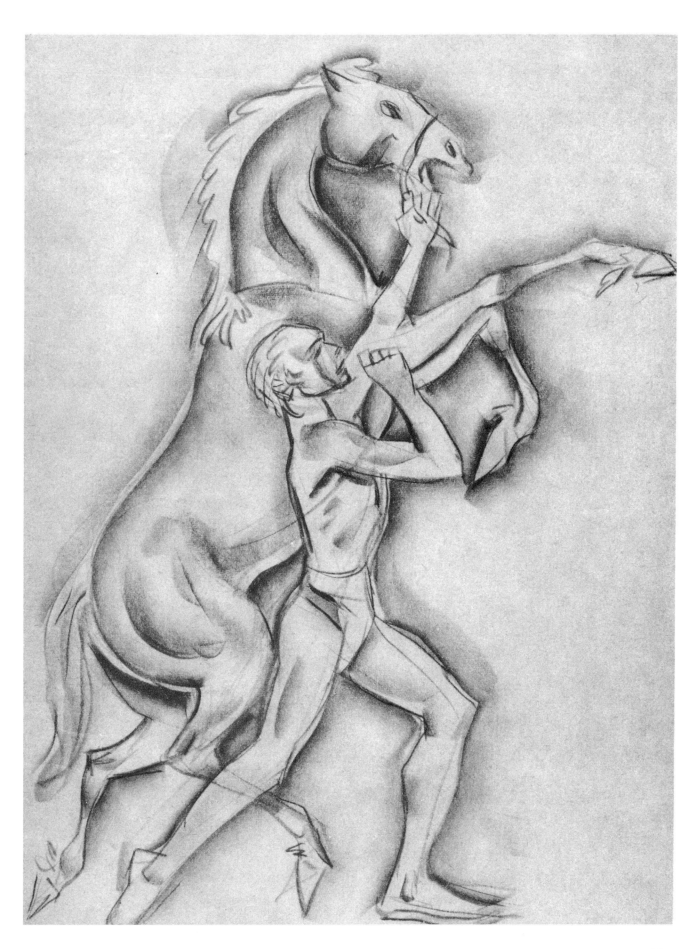

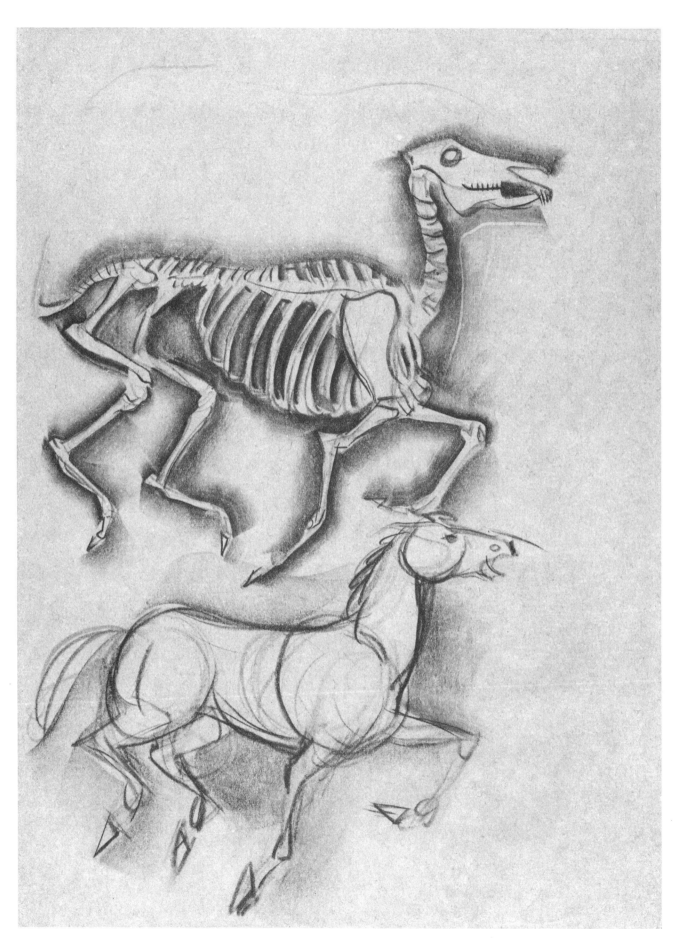

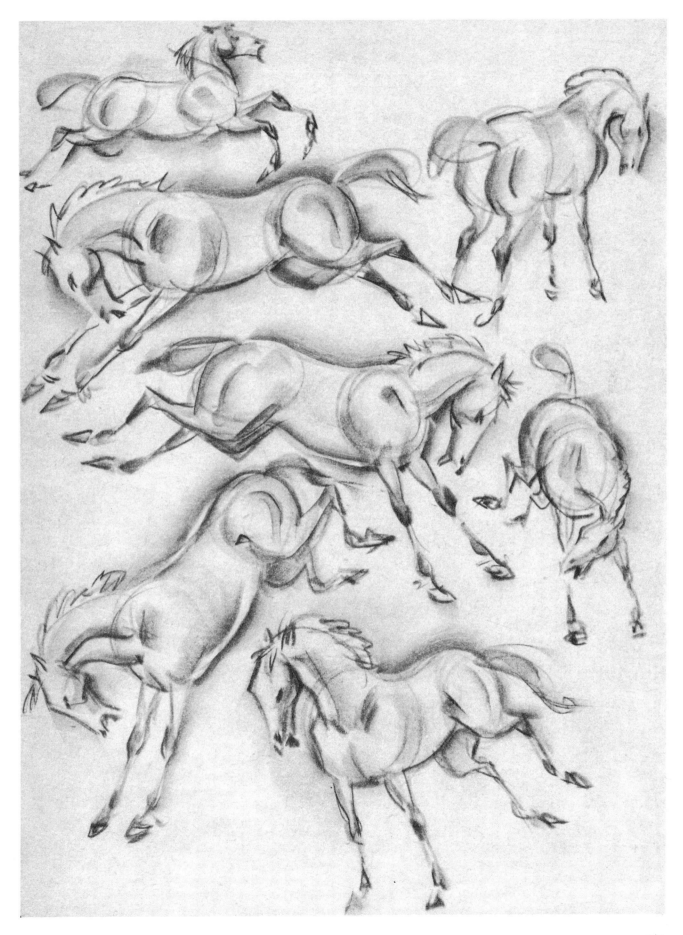

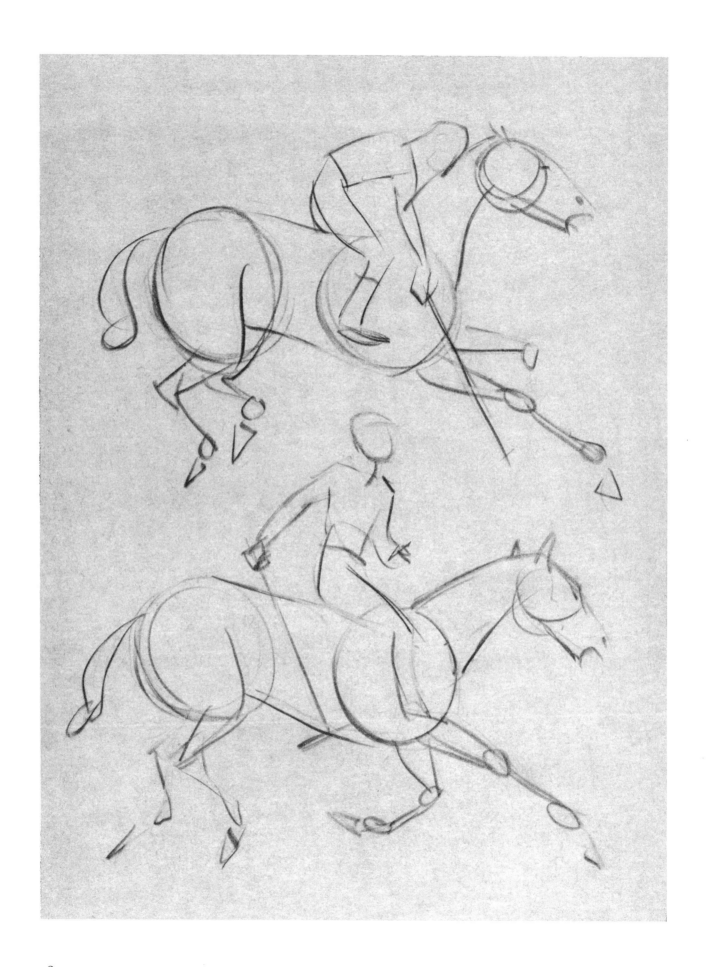

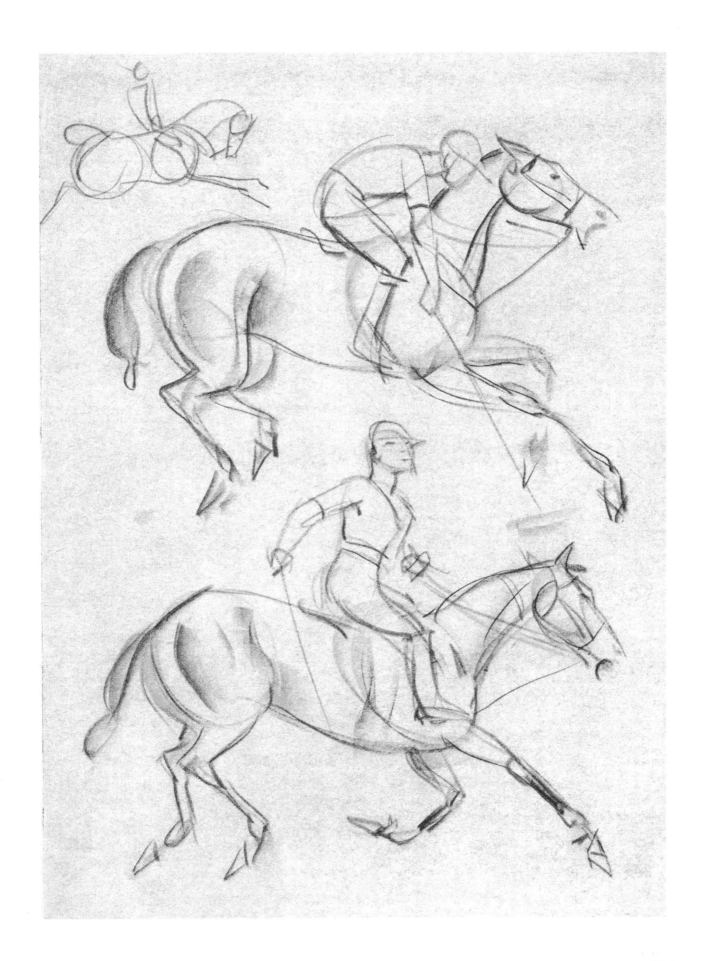

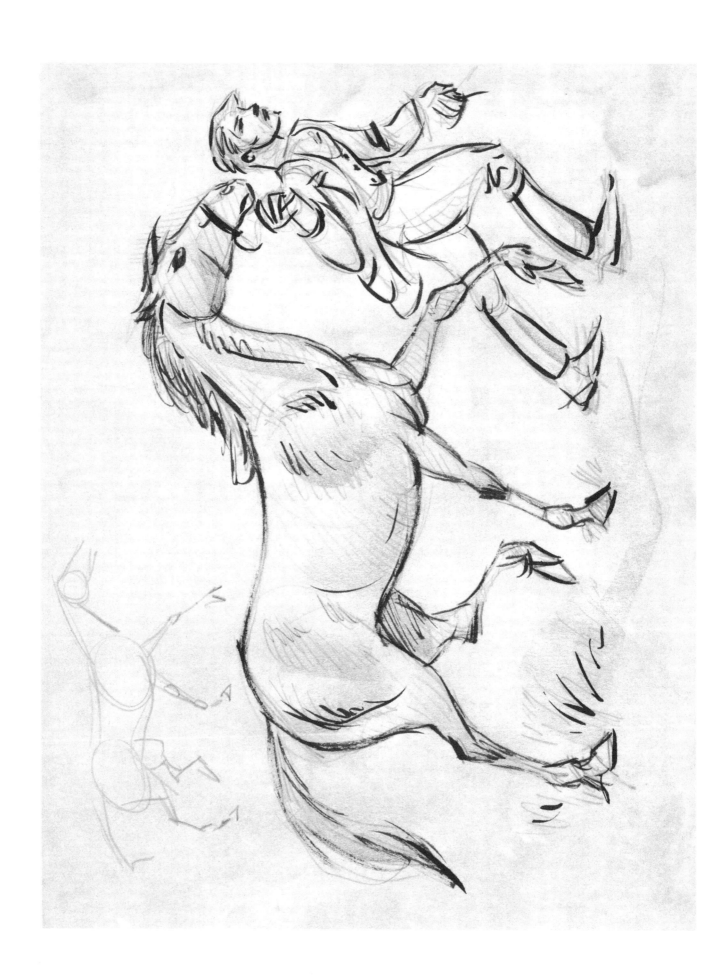

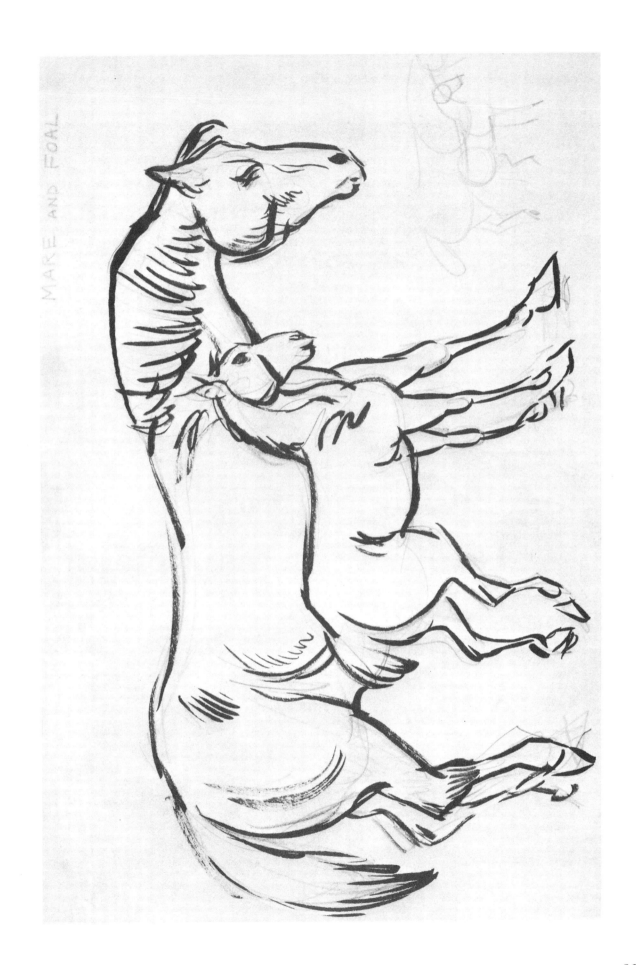

MARE AND FOAL

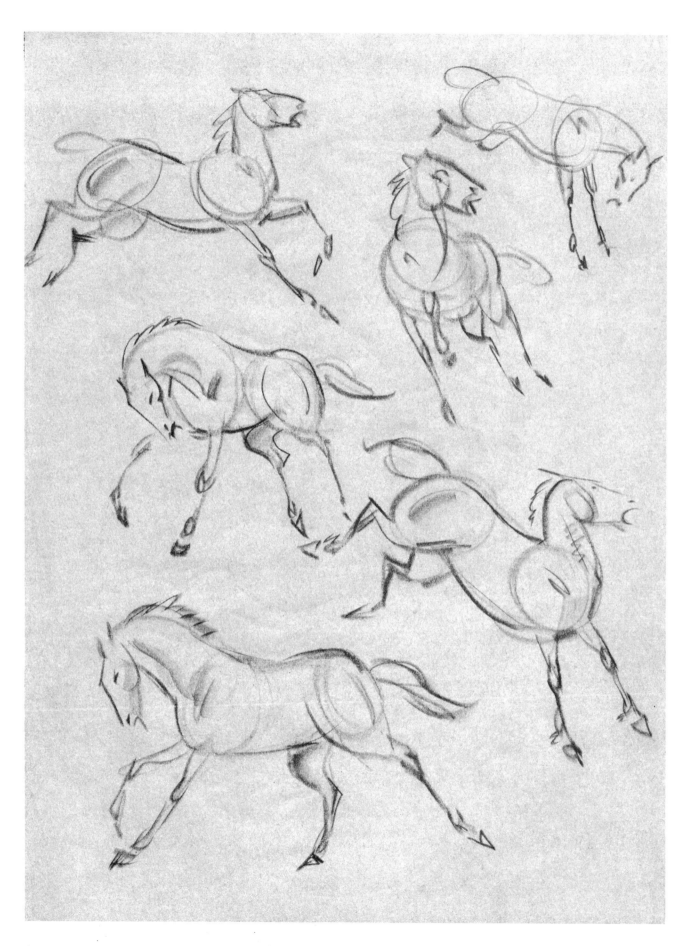

# WORK HORSES

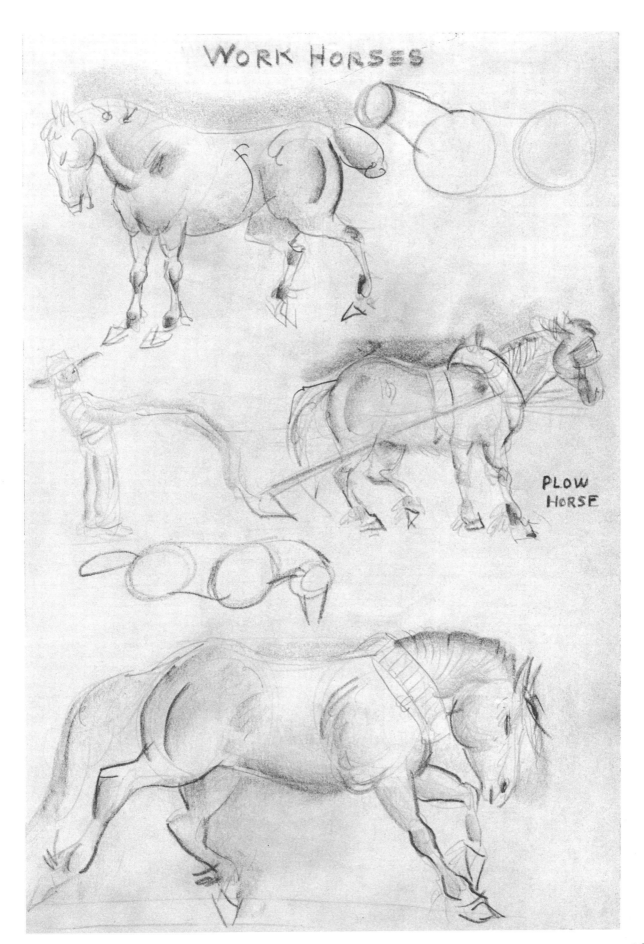

PLOW
HORSE

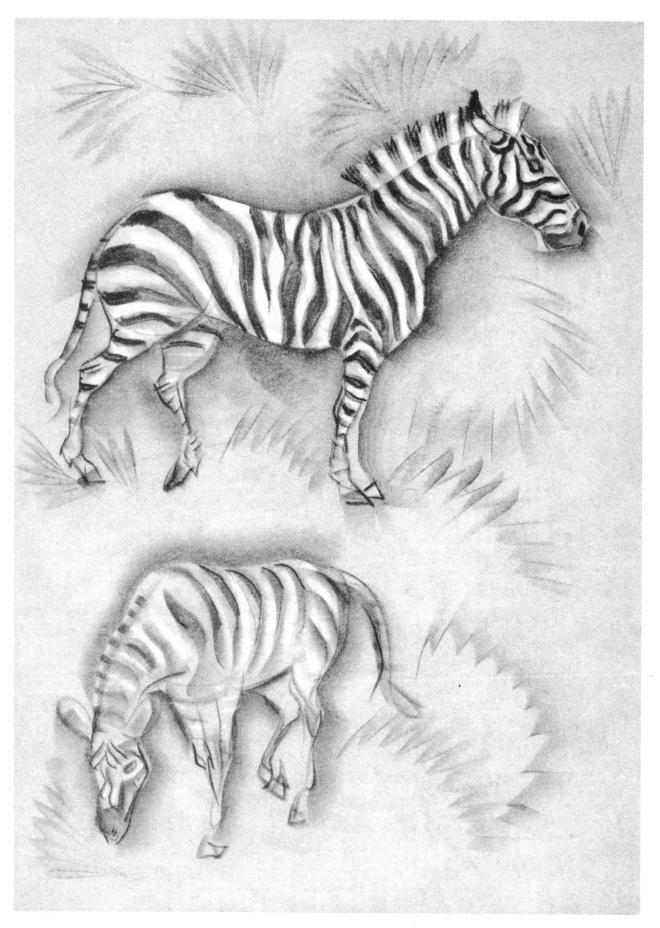

Zebras

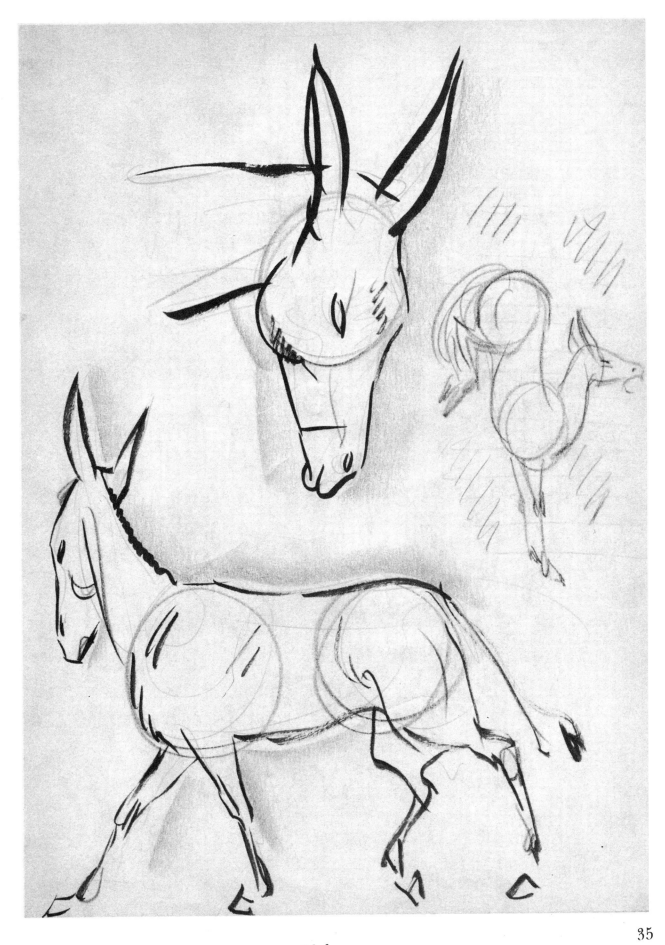

Mules

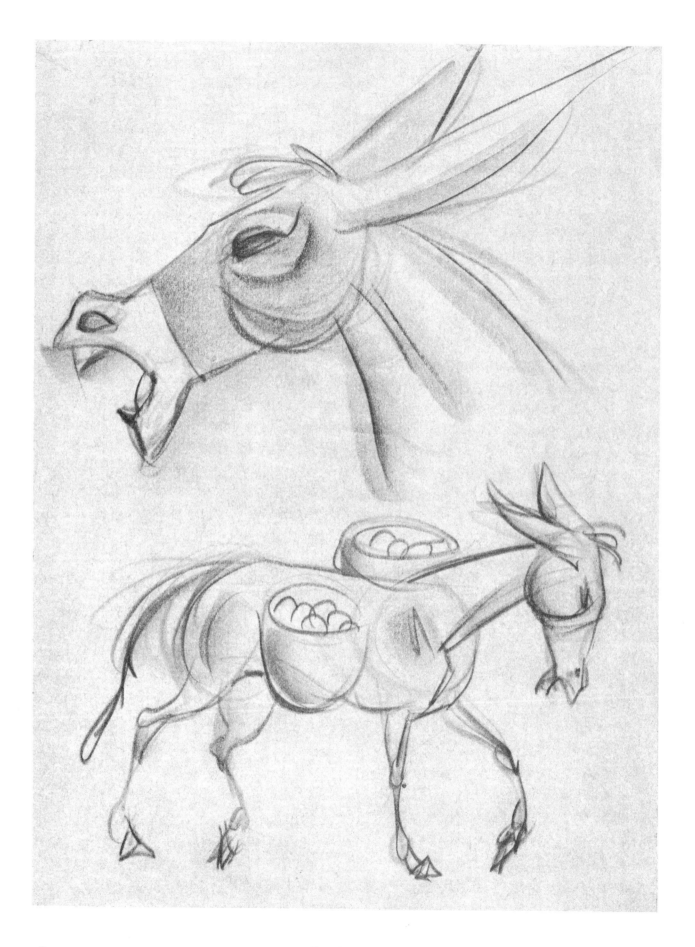

36 Donkeys

# DOGS

⌒⌒⌒ THERE ARE OVER A HUNDRED DIFFERENT SPECIES of domestic dogs, and each has its special characteristics and behavior pattern. They vary enormously in size and outward shape. Some are heavy-coated, others smooth-skinned. They differ in color movement, and habits.

But basically they have the same skeleton design. The difference in bone length and weight are virtually the only differences in their understructure. Unlike cats. dogs are not soft-boned and their understructure more directly controls their movements, making them less agile and more predictable. It is well, therefore, to examine the skeletons of dogs; and though it is not necessary to know all the bones, a knowledge of the general bone formation will be a valuable guide in drawing.

No attempt has been made to show all the breeds of dogs, but enough of the outstanding types have been included to give a range of study that will cover generally the whole family, including the wolf and the fox.

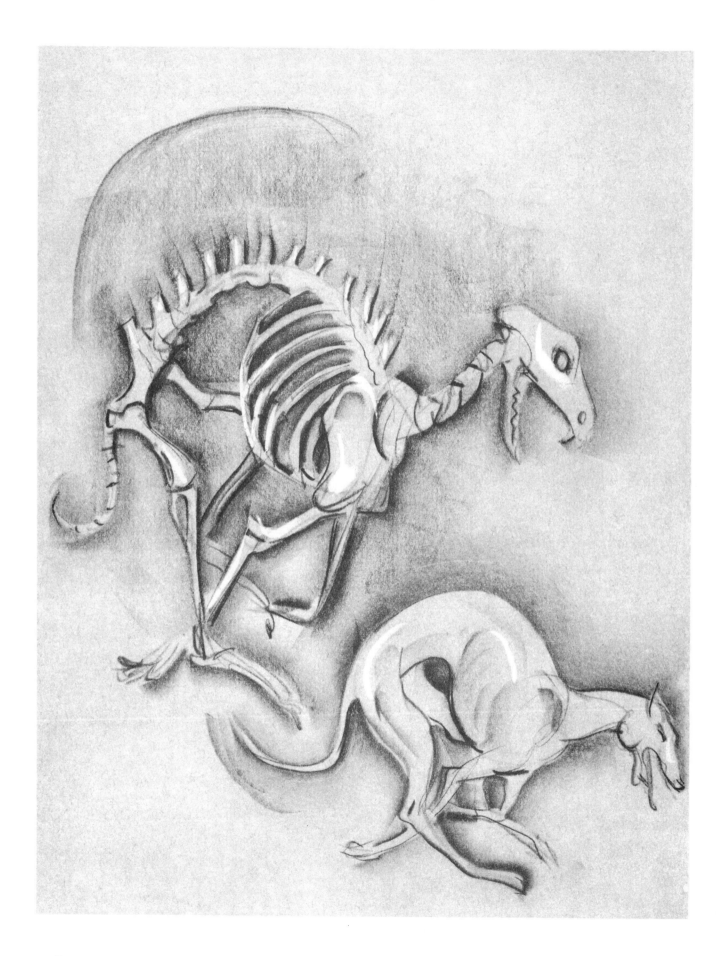

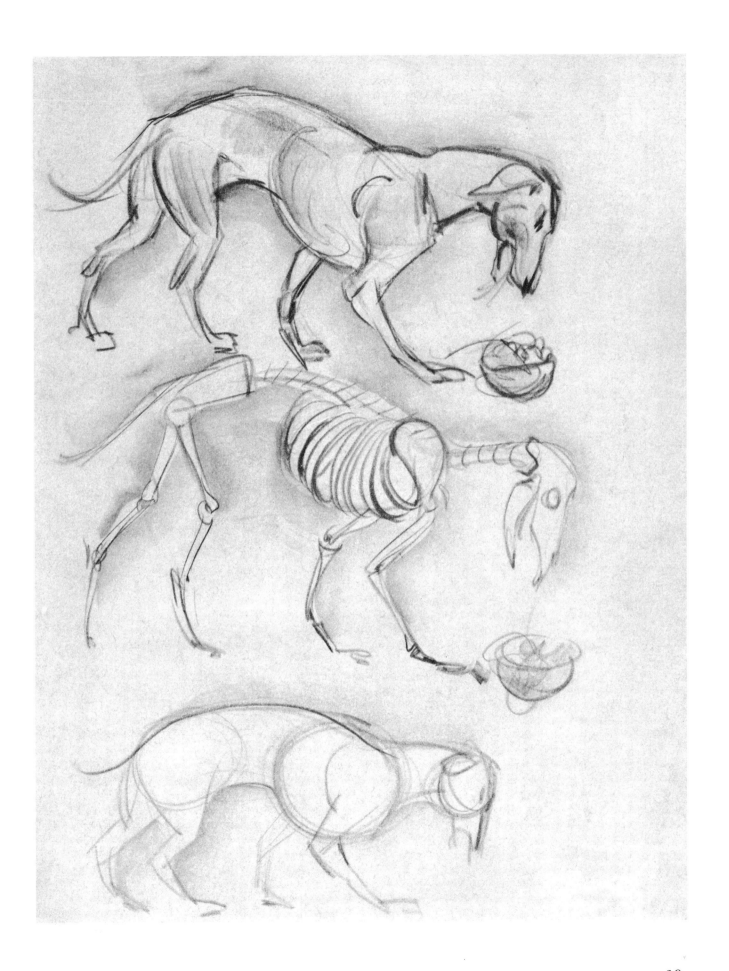

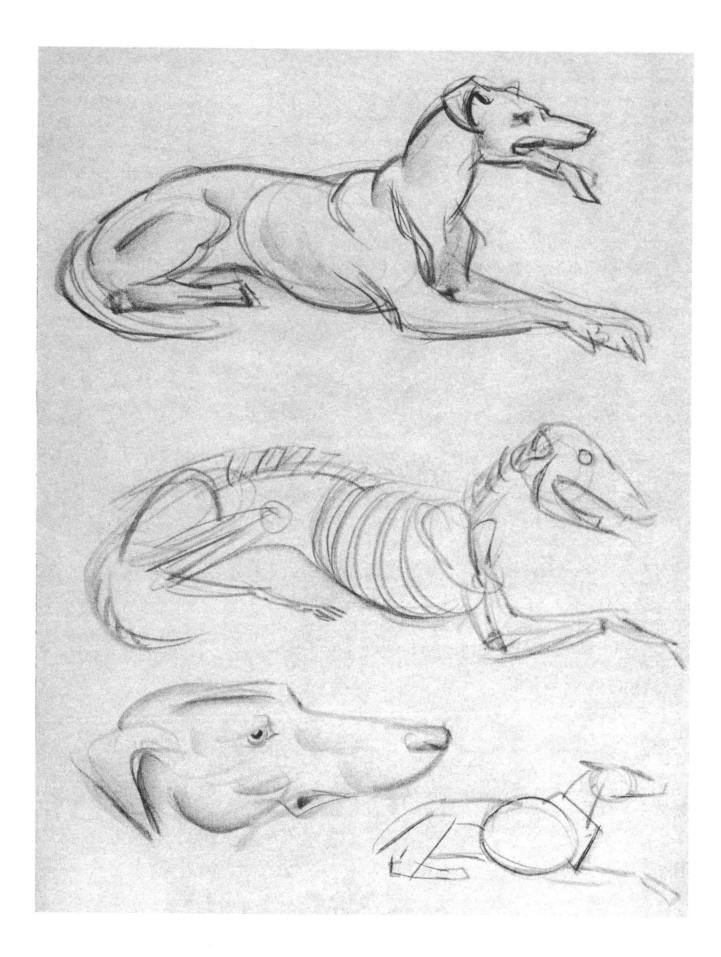

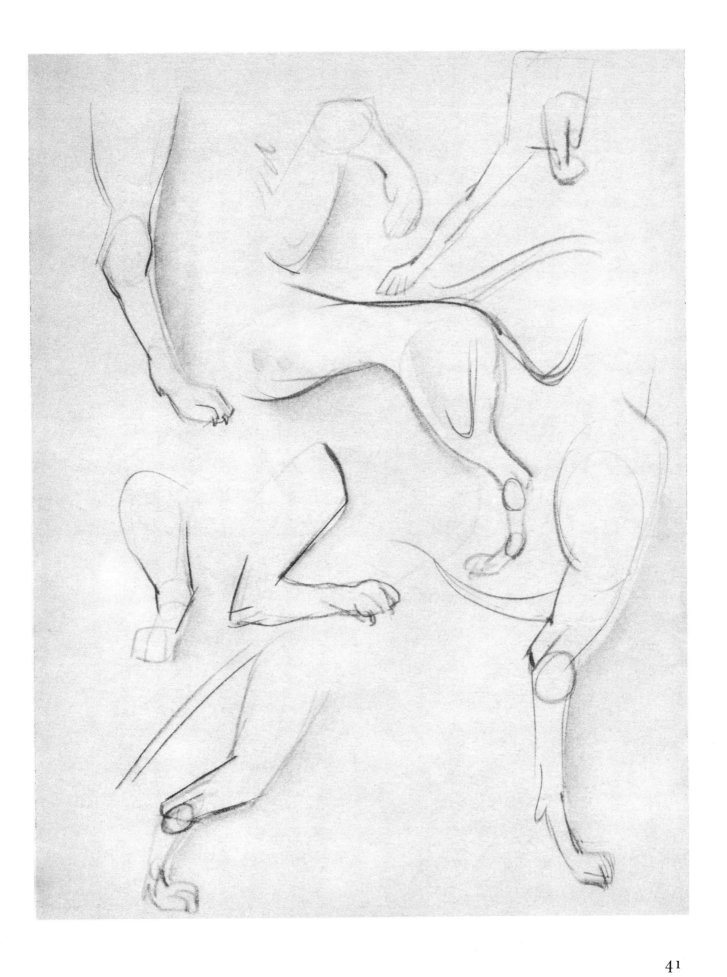

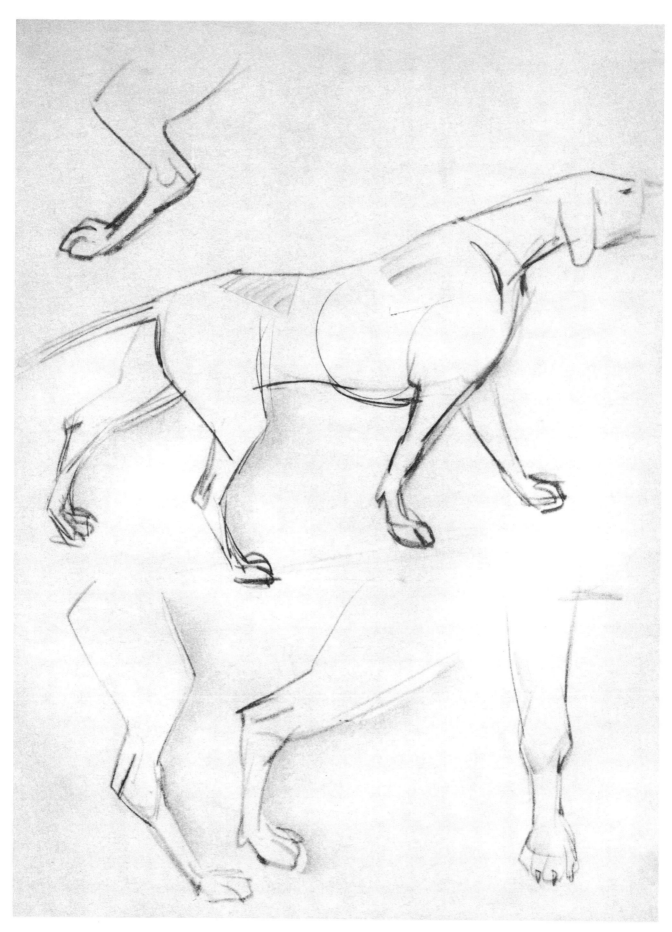

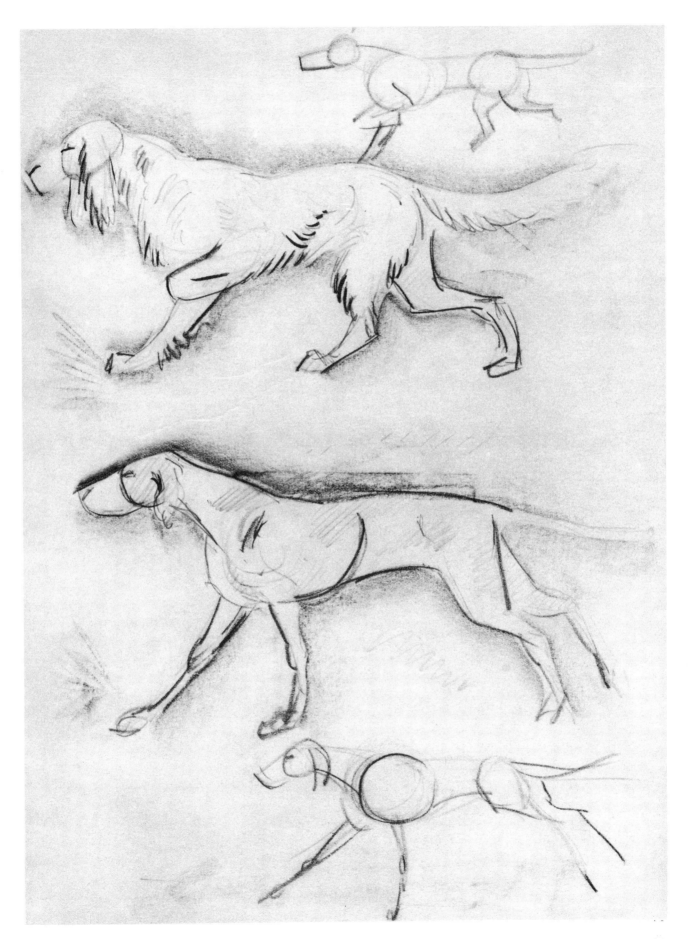

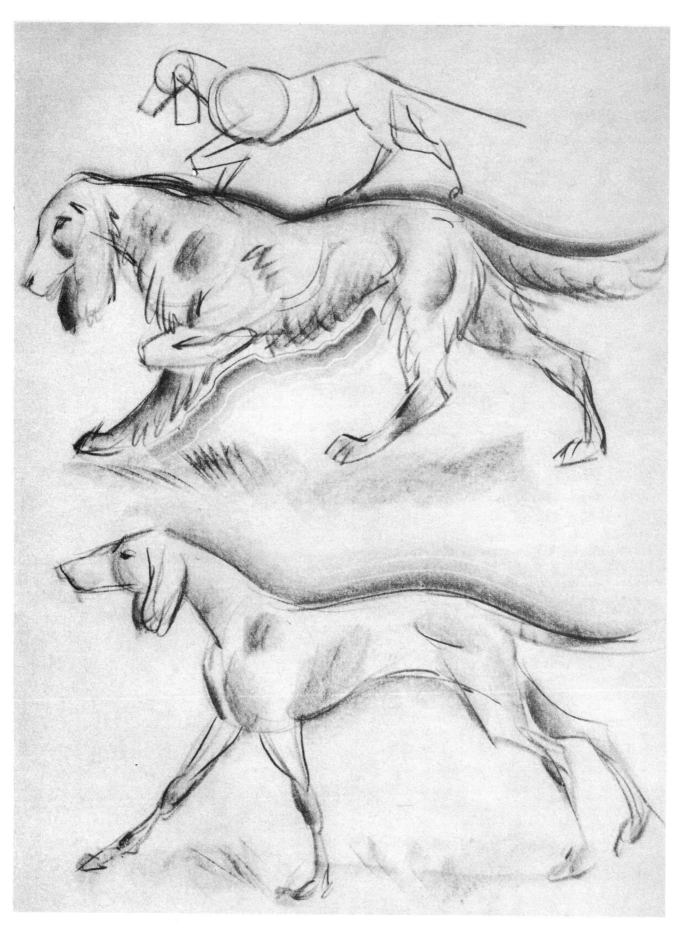

44

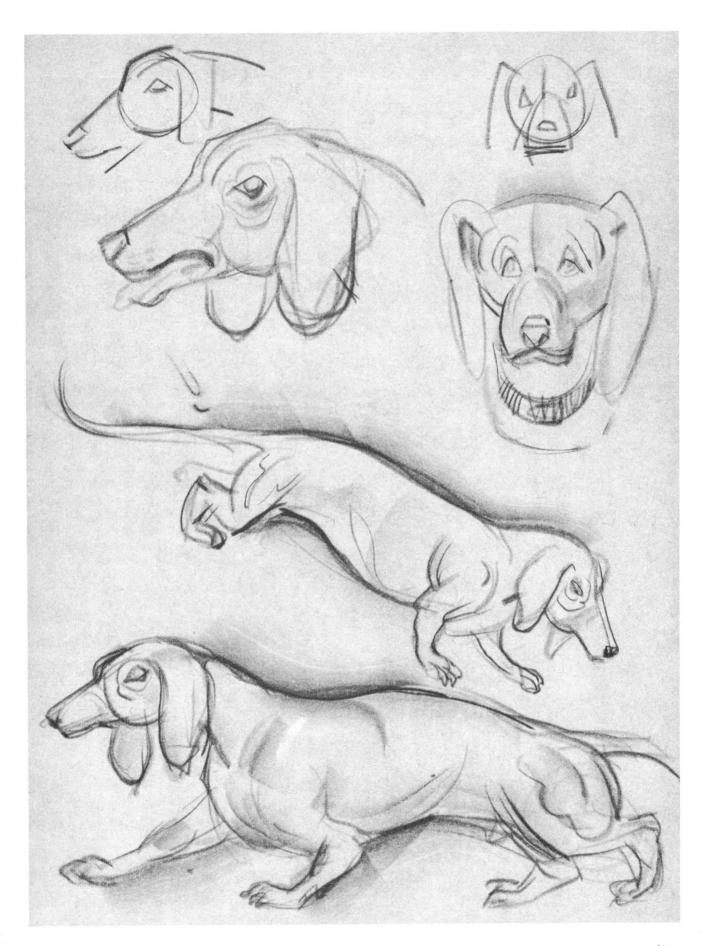

45

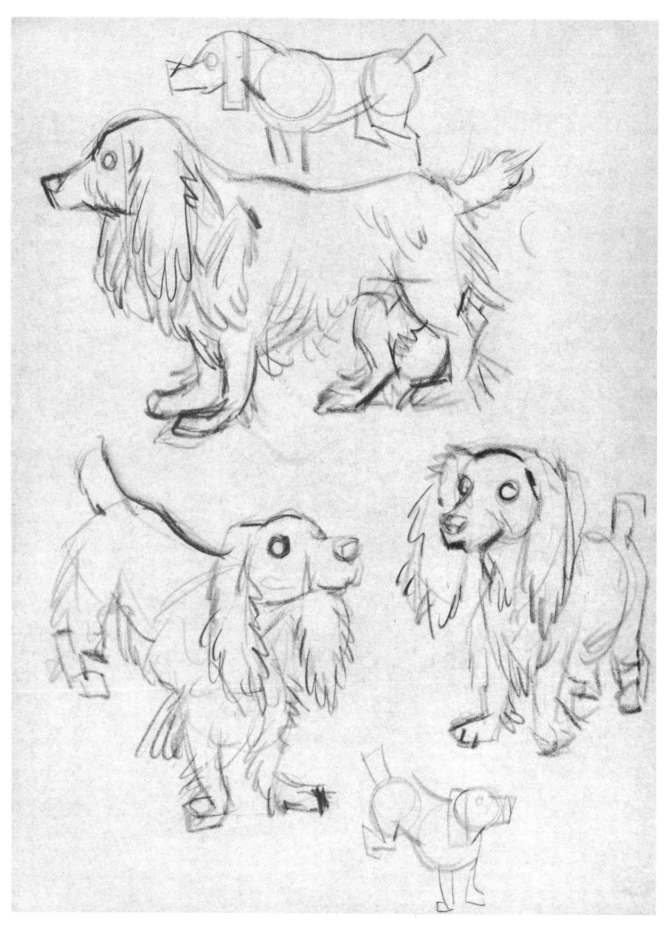

46

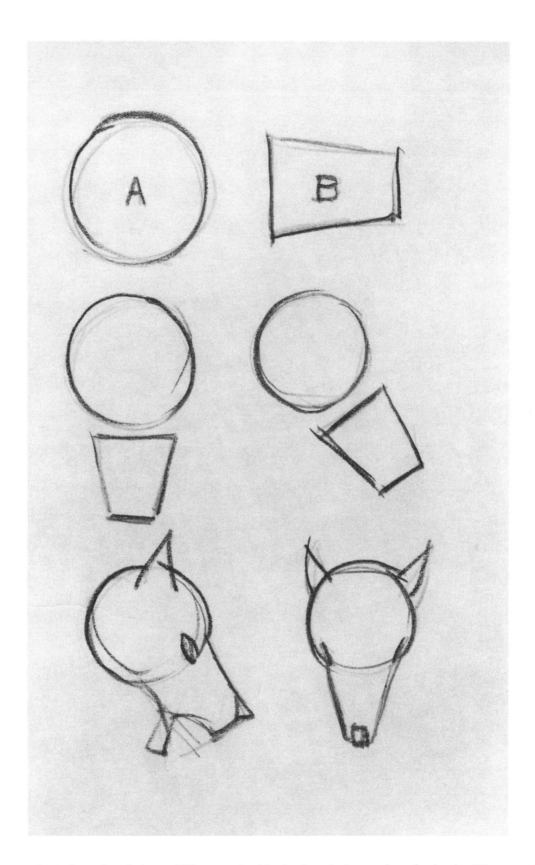

The various breeds of dogs differ markedly in head shape, but in basic "first-step" structure any dog's head is made up of a circle and a quadrangle, the two forms shown. The relative proportions of the two parts differ from breed to breed, but the combination forms the base upon which the external differences of breed may be fashioned.

47

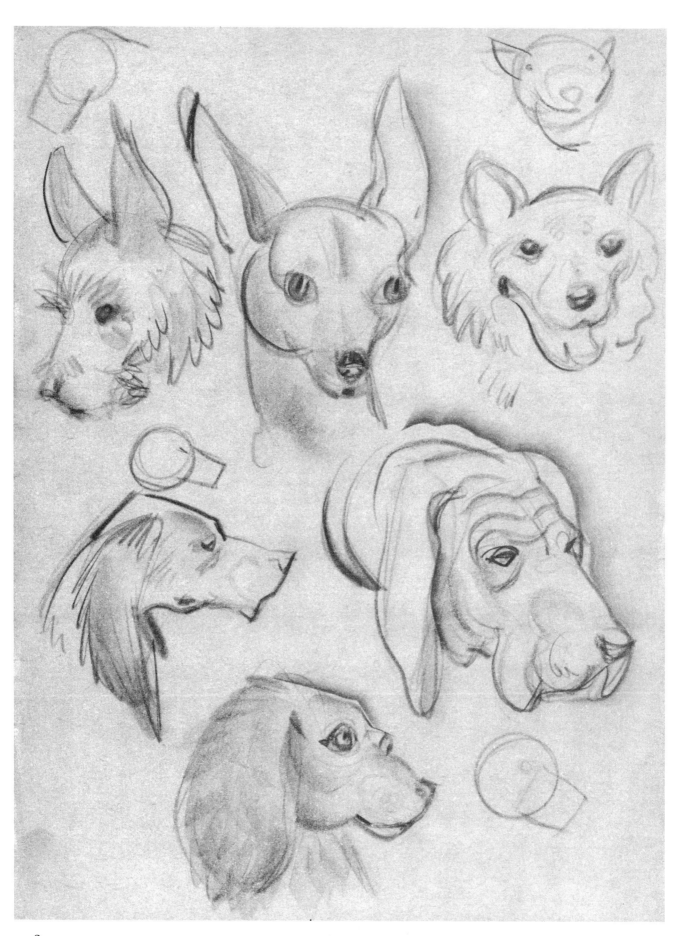

48

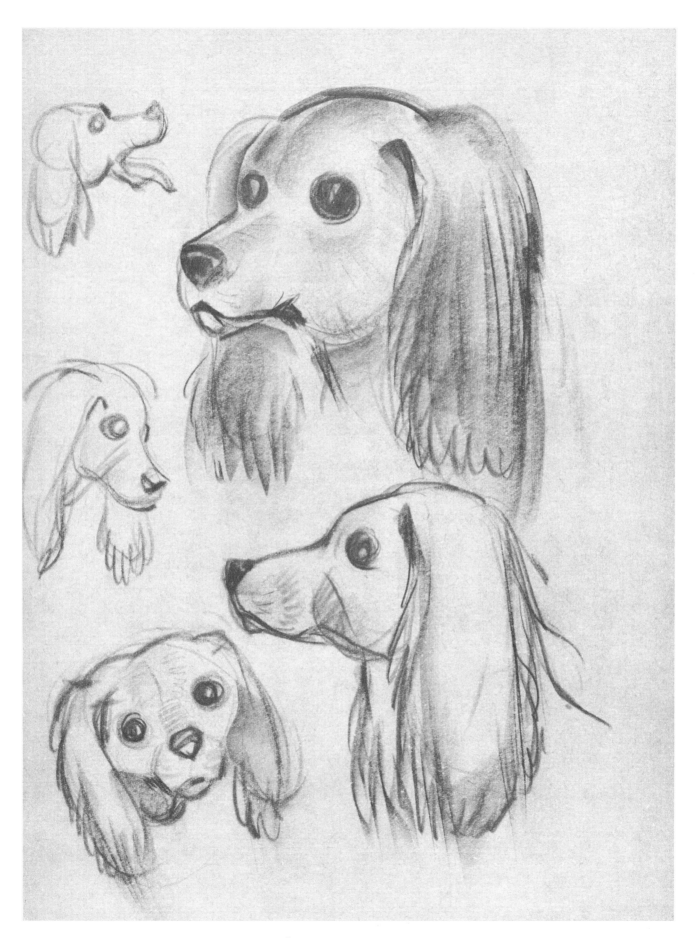

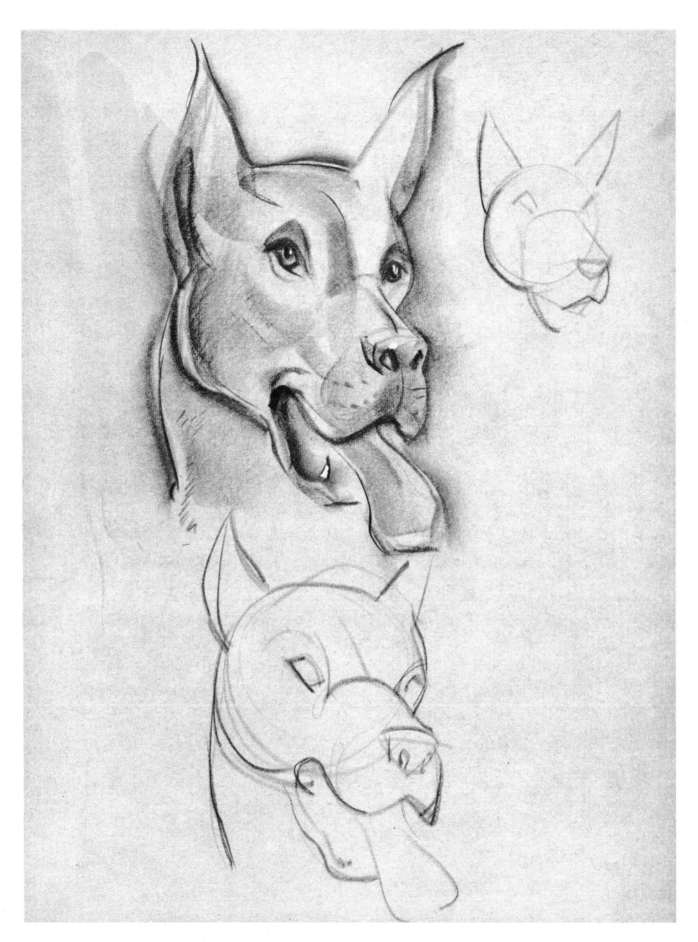

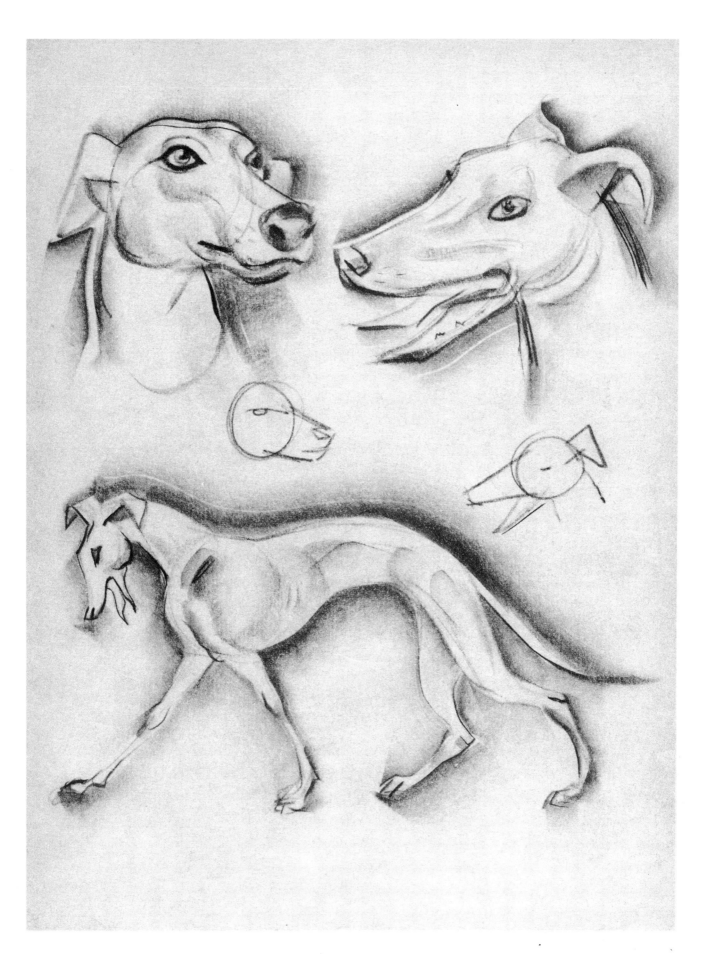

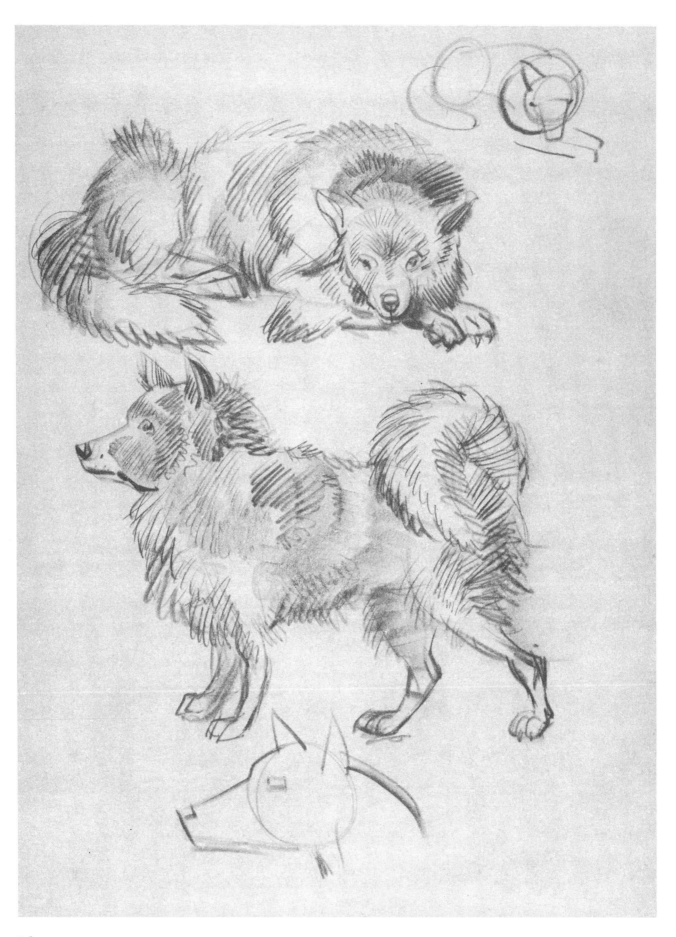

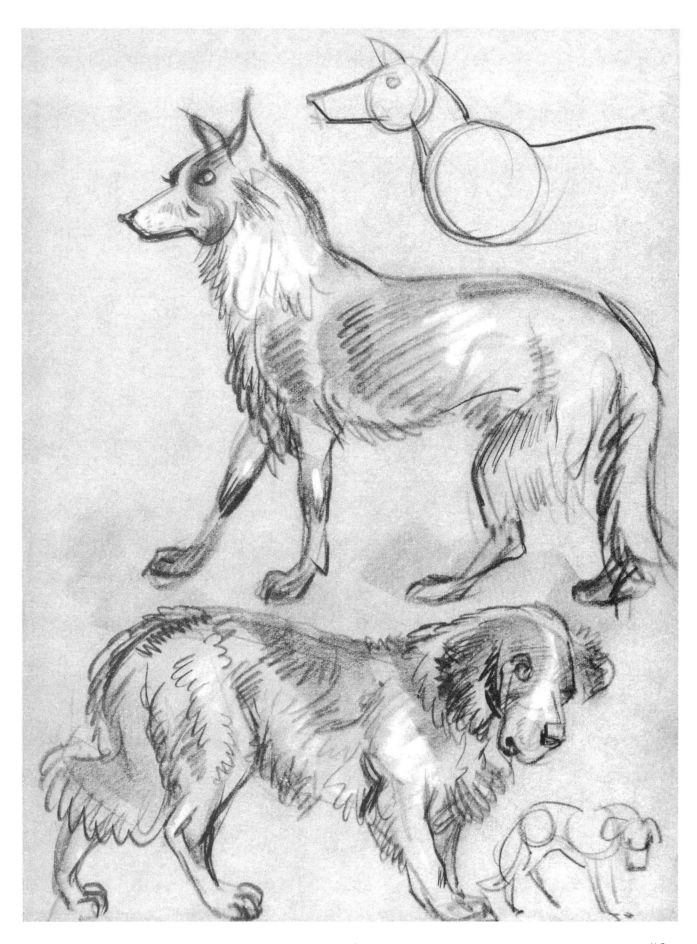

53

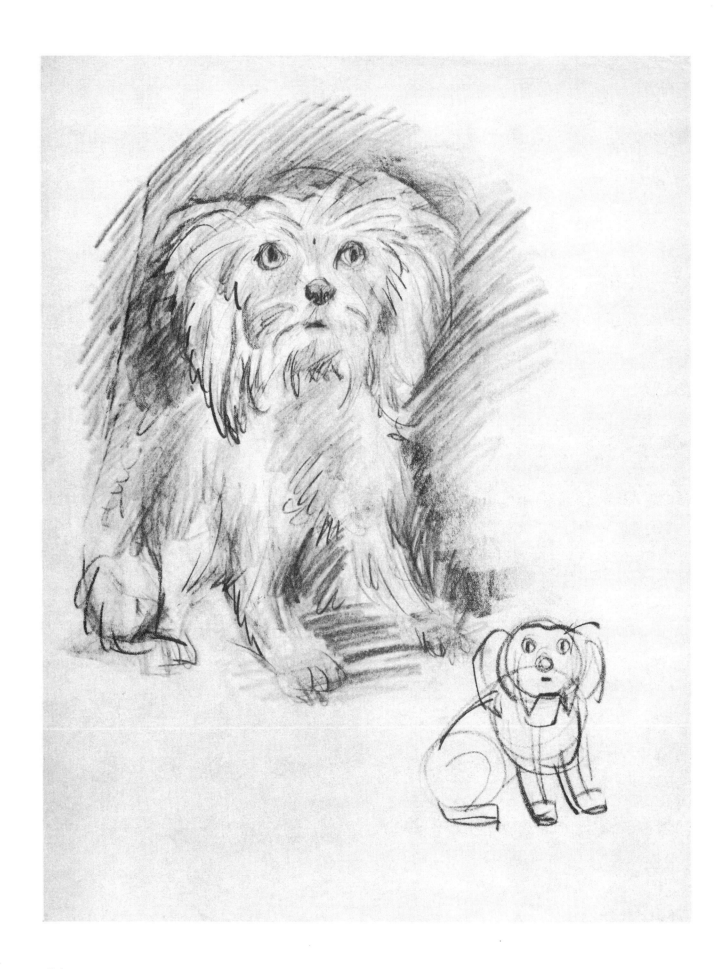

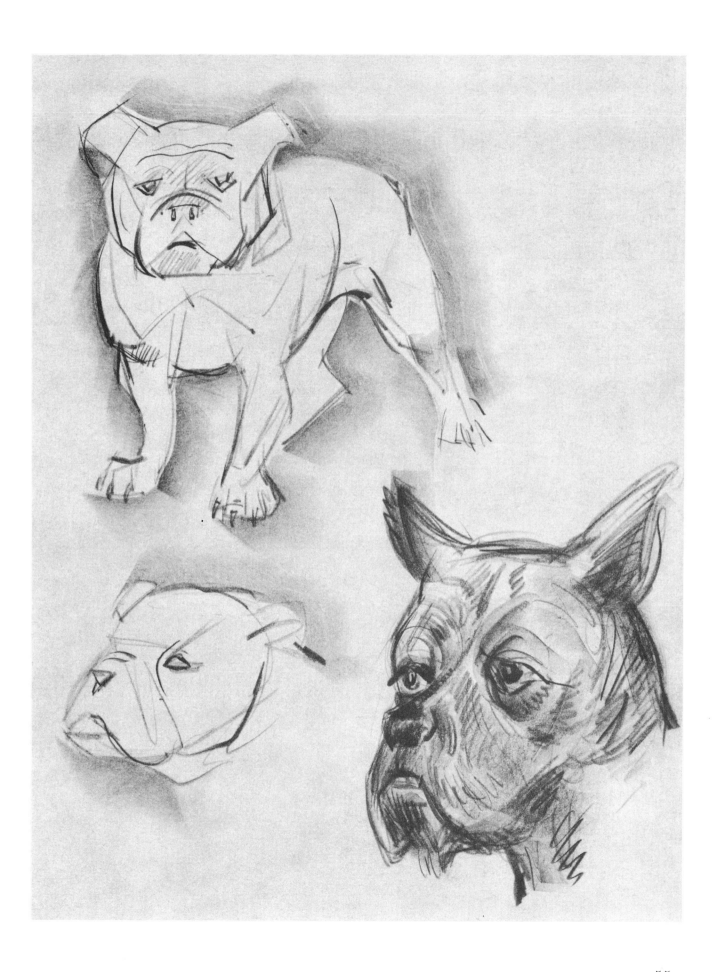

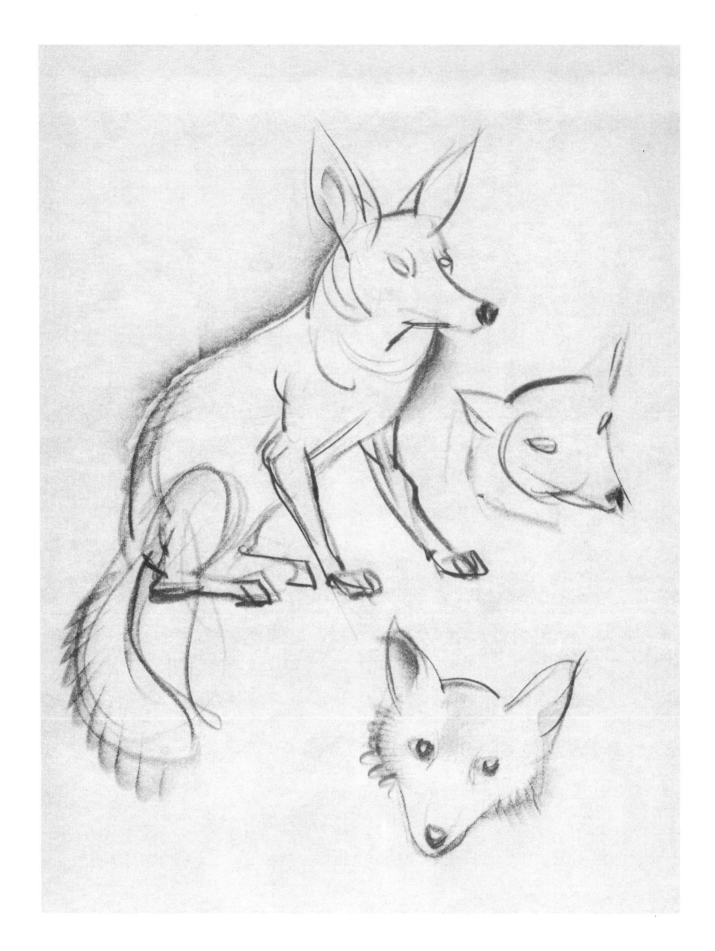

The Fox (above) and the Wolf (opposite) are Wild Dogs

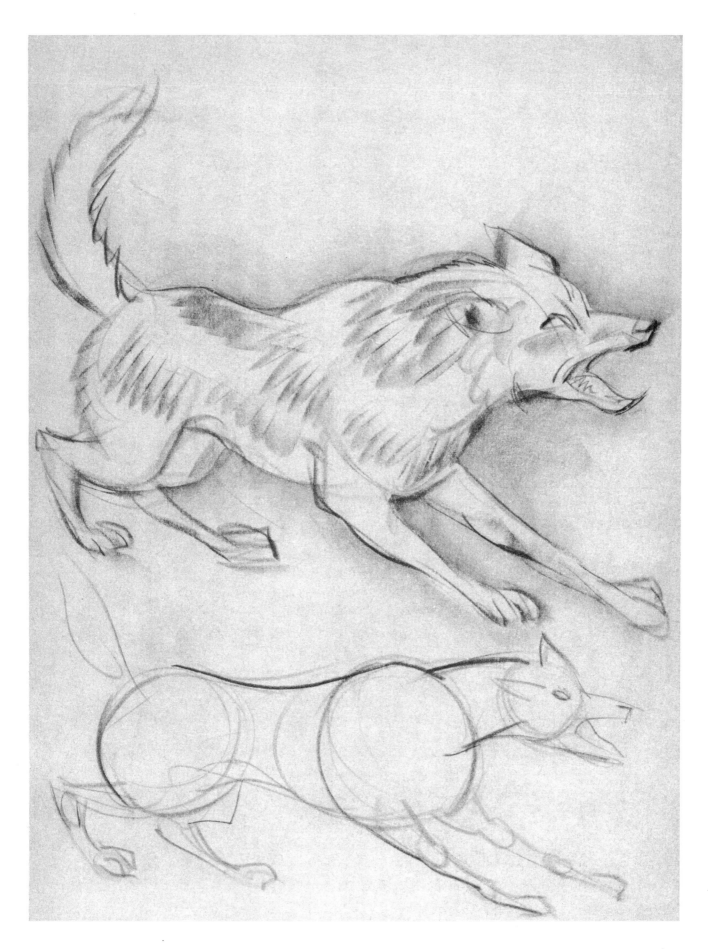

# CATS

⌒⌒⌒ THE SOFT CHARACTER of the movements and structure of cats makes a profound study of their anatomy of little use. Their lithe, muscular, stealthy action seems almost independent of anything so restraining as a skeleton. A cat, however, is by no means bulky; the speed with which it can be galvanized into action and the steel-spring leap attest to latent strength. In drawing a cat, strive to feature this muscular strength half hidden by furry softness in order to capture the cat quality.

The following pages show cats in various positions—in stride and in repose. These positions, together with faces, have at first been reduced to simple line terms and then carried to a more finished stage.

Study these simple, generalized forms, and practice drawing cats moving about in positions other than those indicated here.

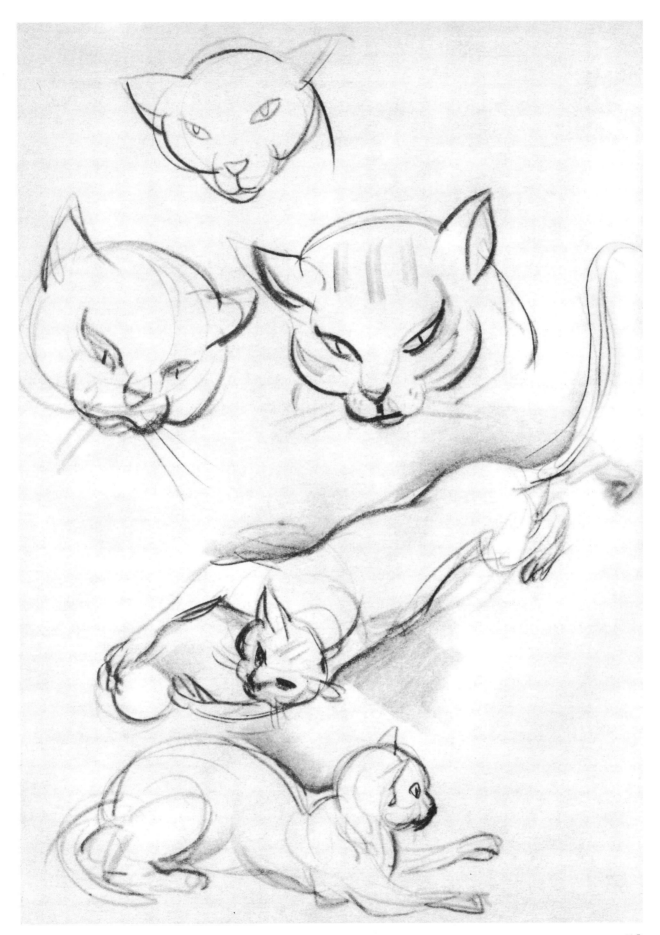

59

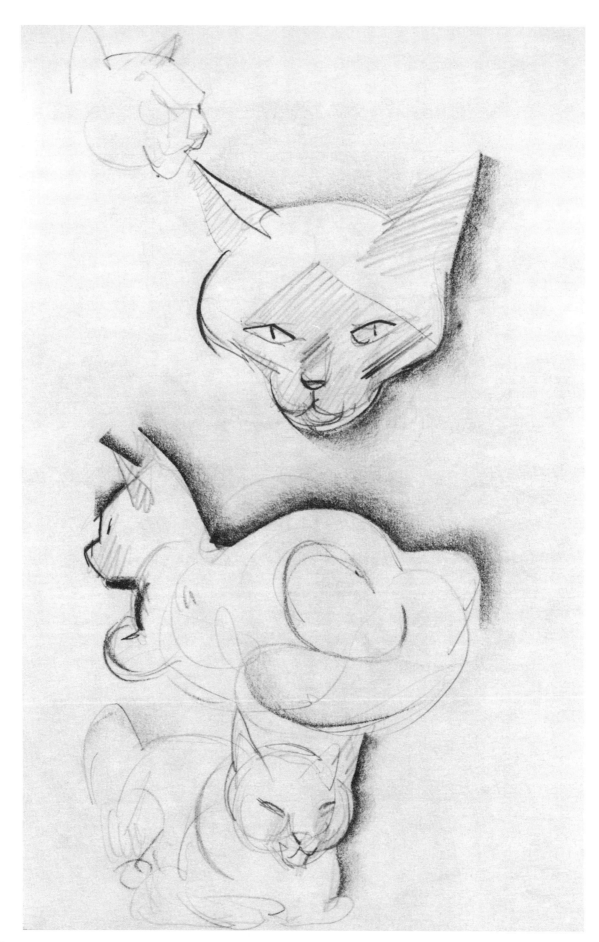

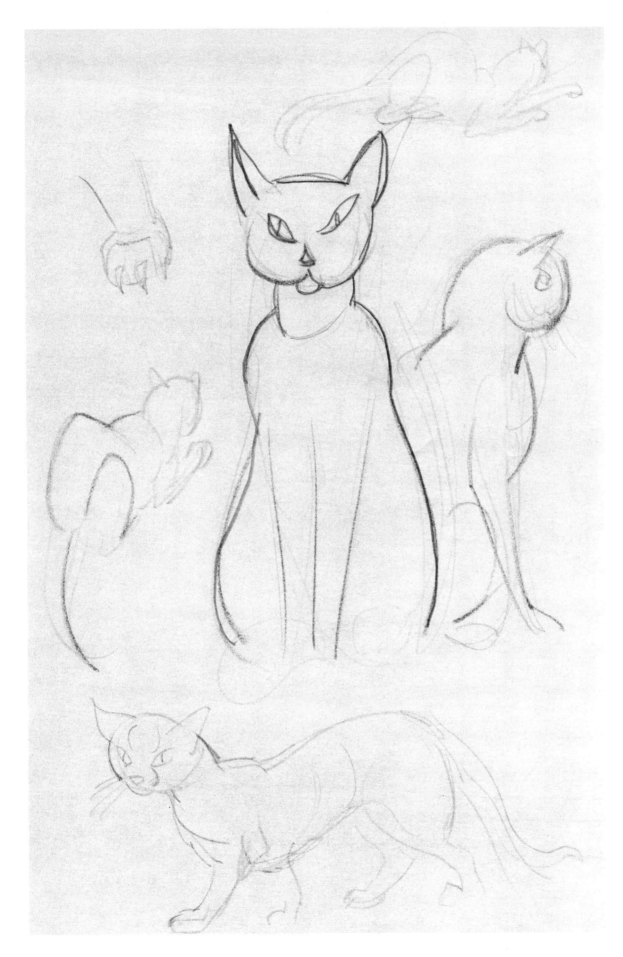

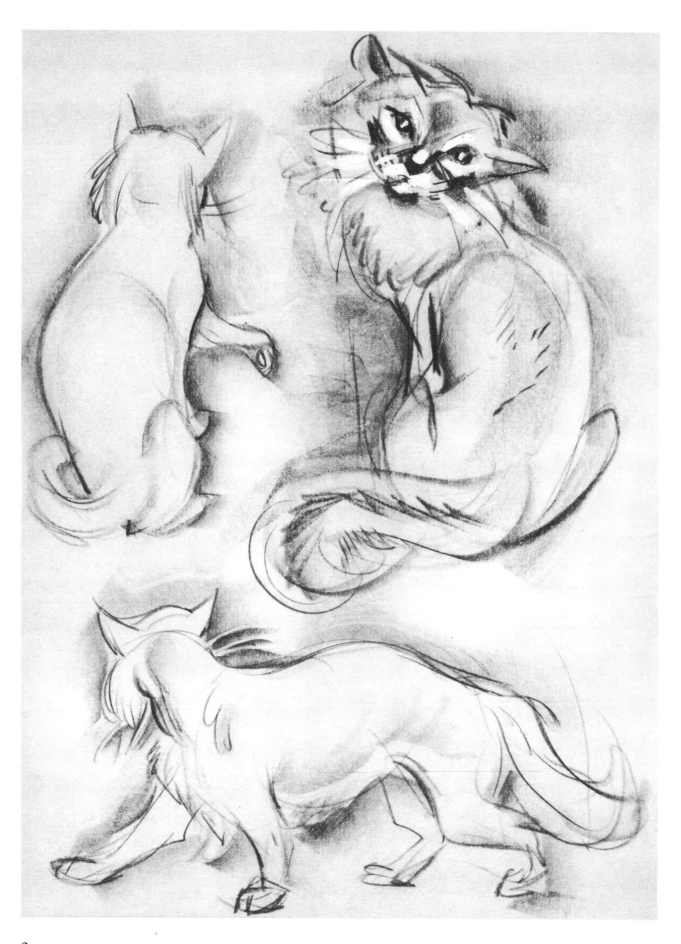

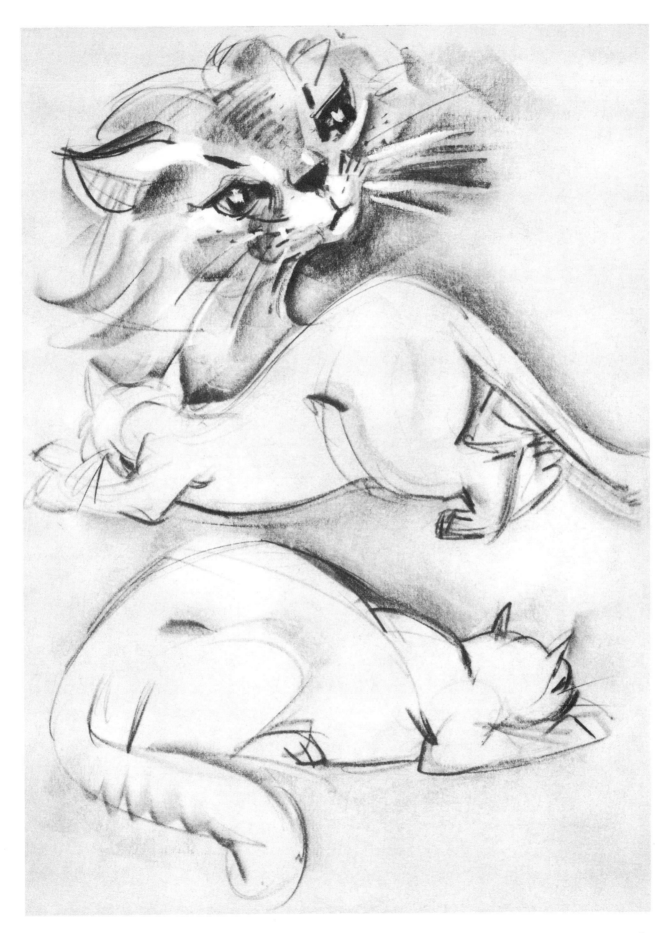

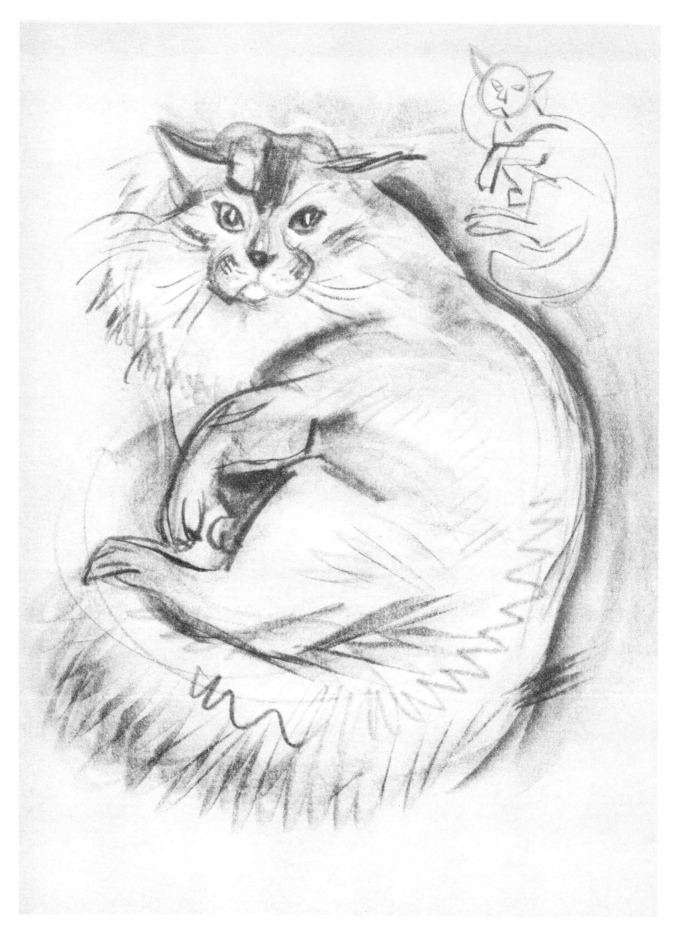

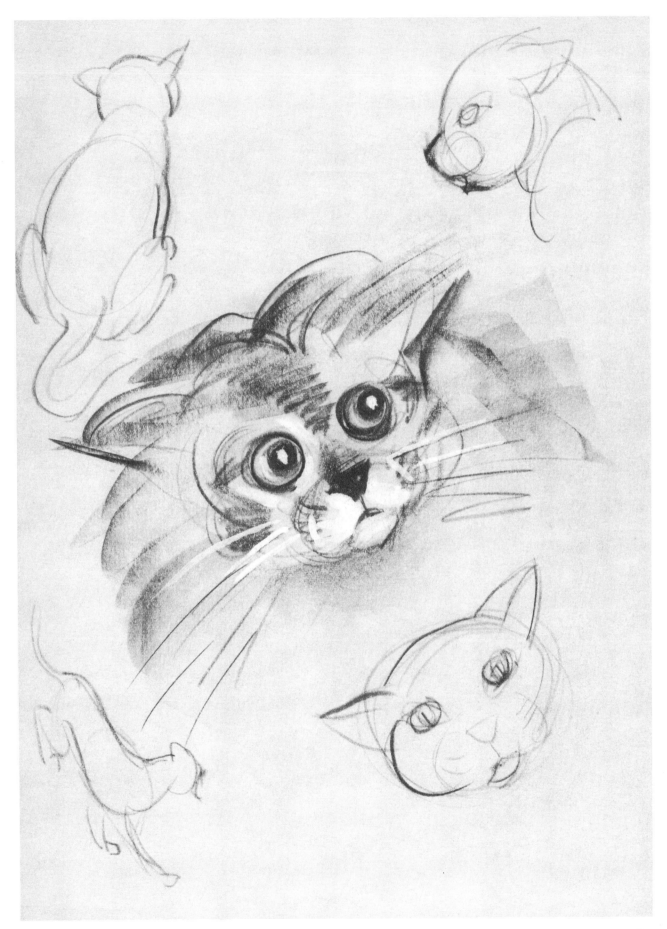

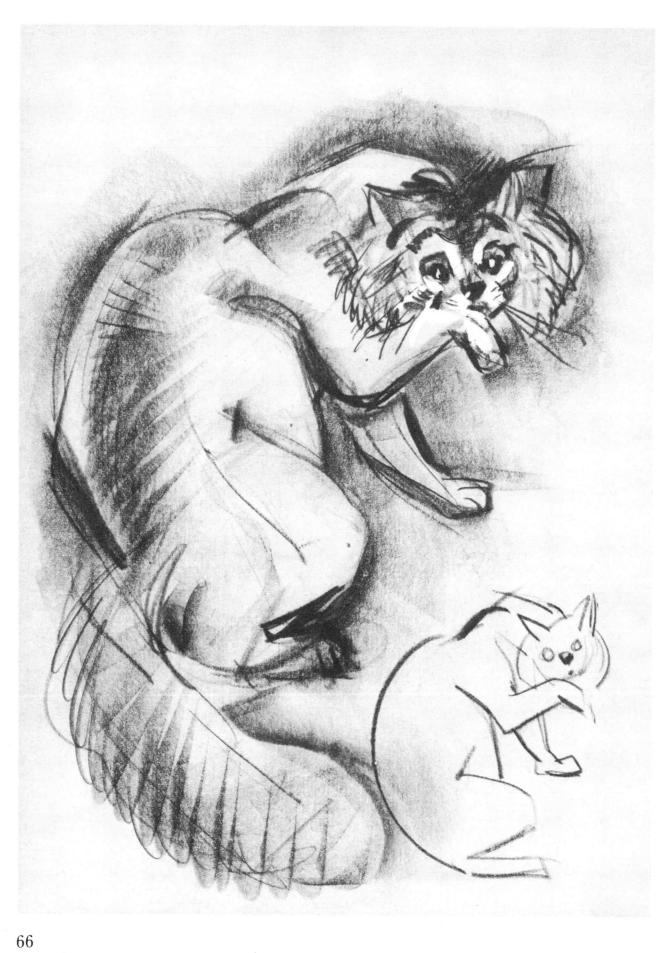

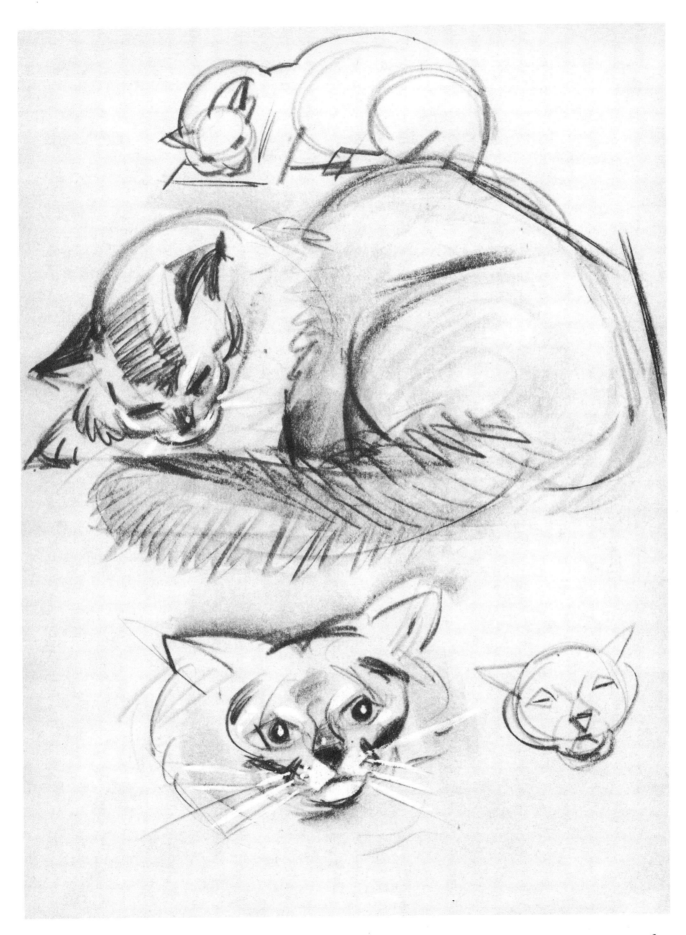

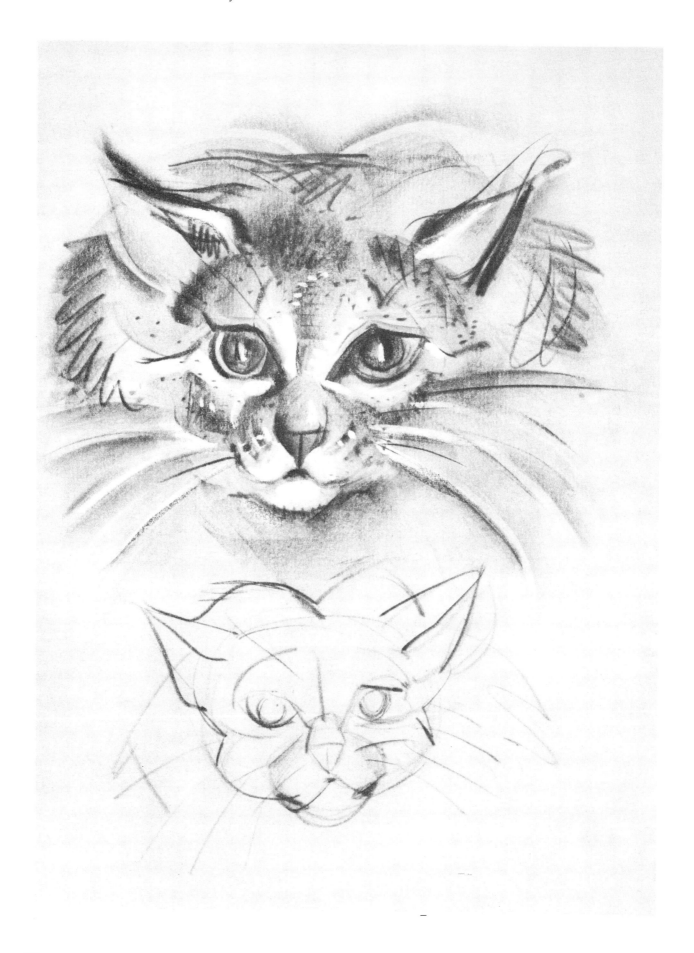

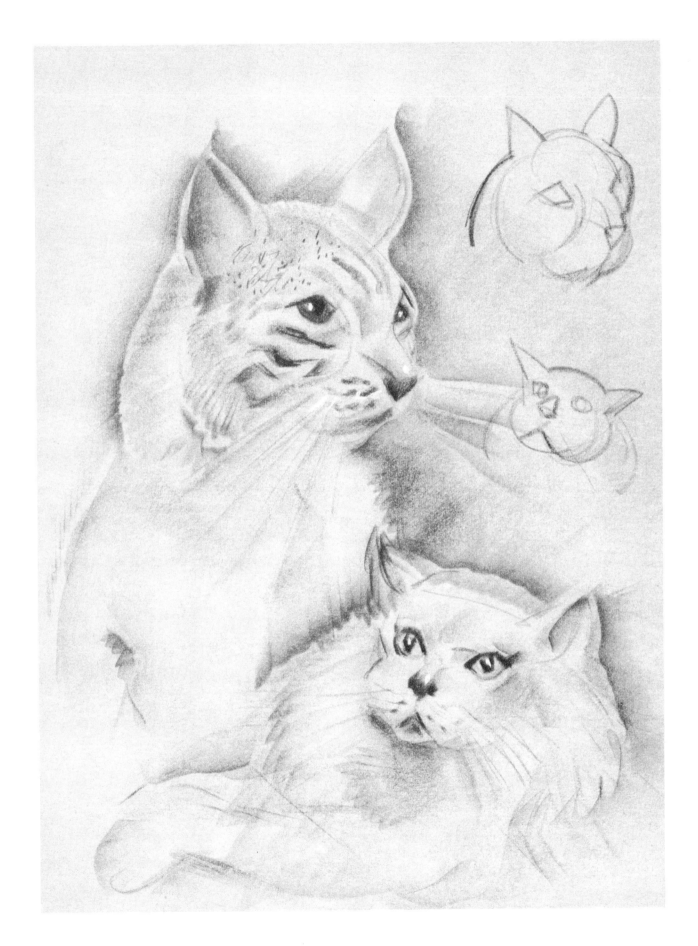

# TIGERS

⌒⌒⌒ ANATOMICALLY. there are few essential differences between the tiger and the house cat. The two have almost identical understructures; the differences lie in size, coloring, and habits. Tigers can act like tabby cats, and alley cats like tigers. Magnified or diminished, the one could be mistaken for the other.

Ferocity, however, is one of the most typical characteristics of tigers—that and great, fur-sheathed strength. Every line that goes into the drawing of a tiger should contribute to these. Exaggeration that results in an increased feeling of tigerishness is good exaggeration—and good art.

Practice drawing the construction forms shown here and then try to draw them in other positions. It is advisable to keep them in simple line—at first.

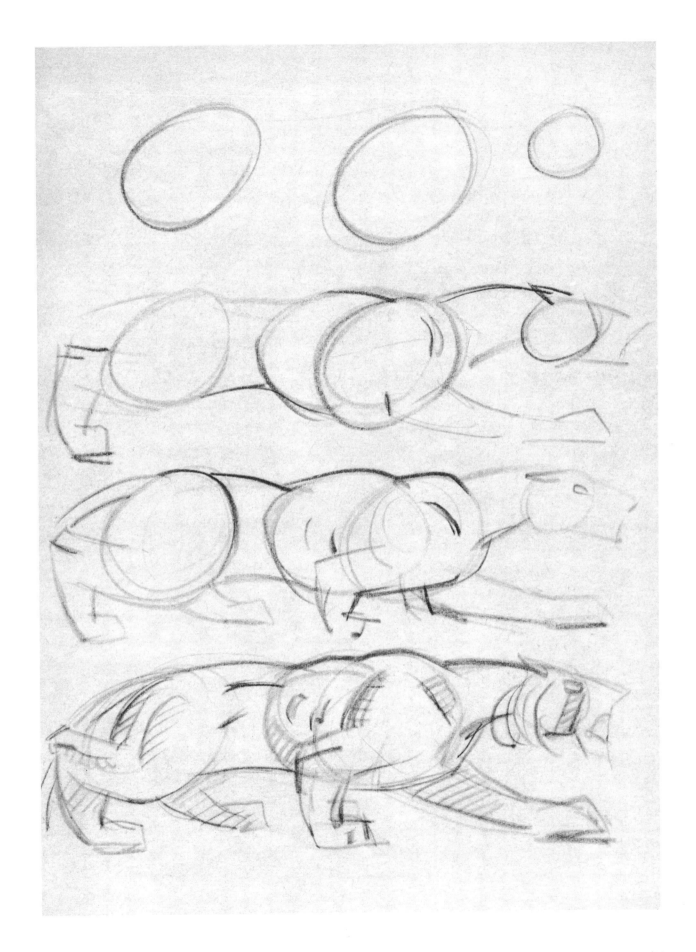

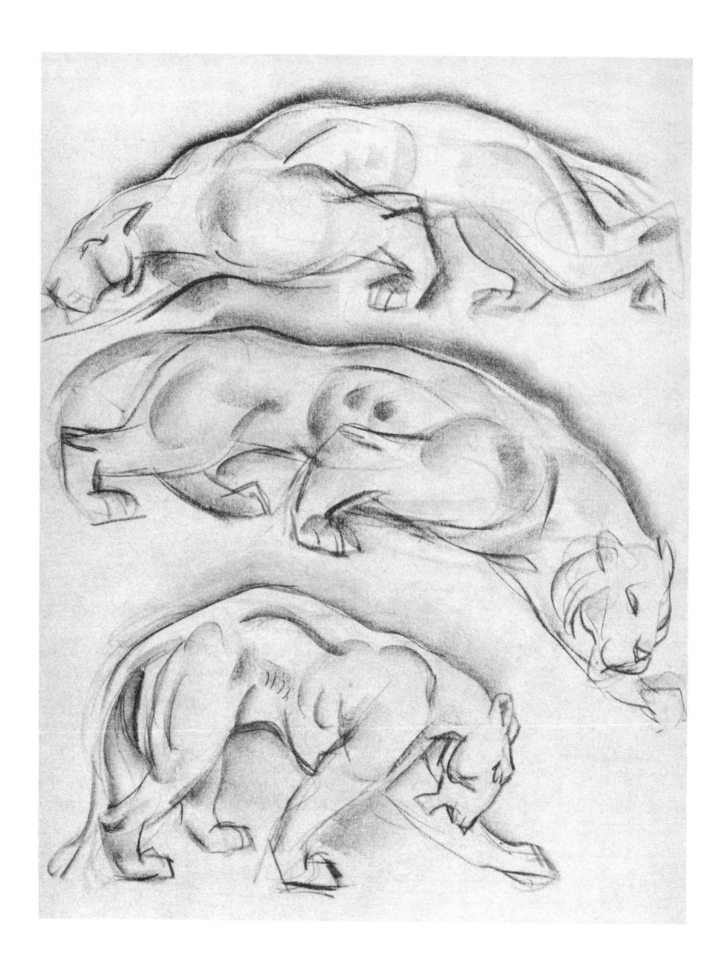

72

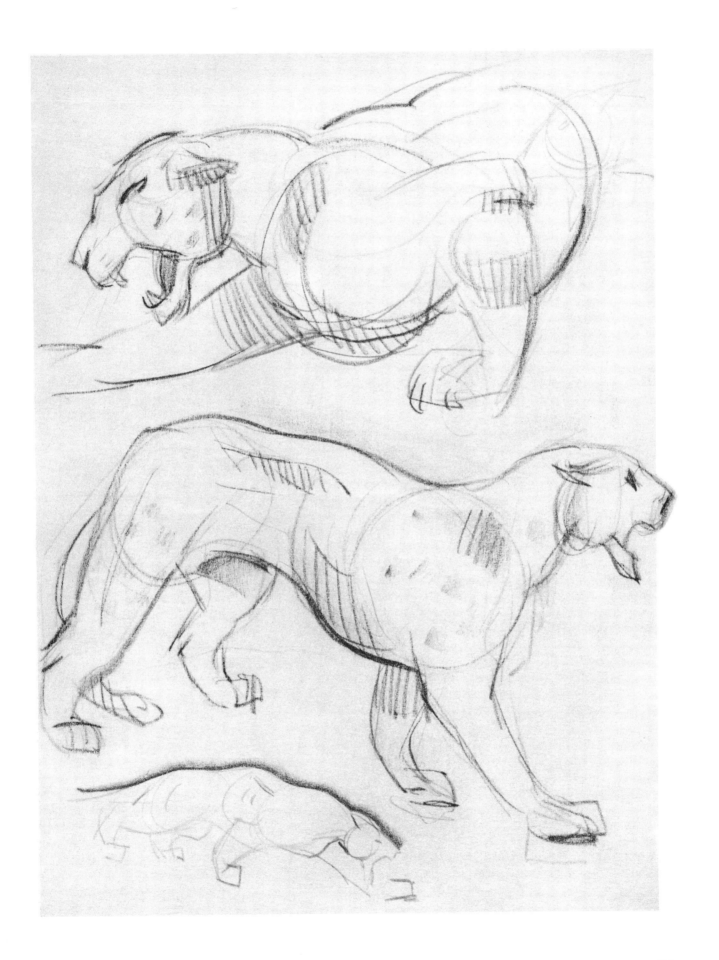

73

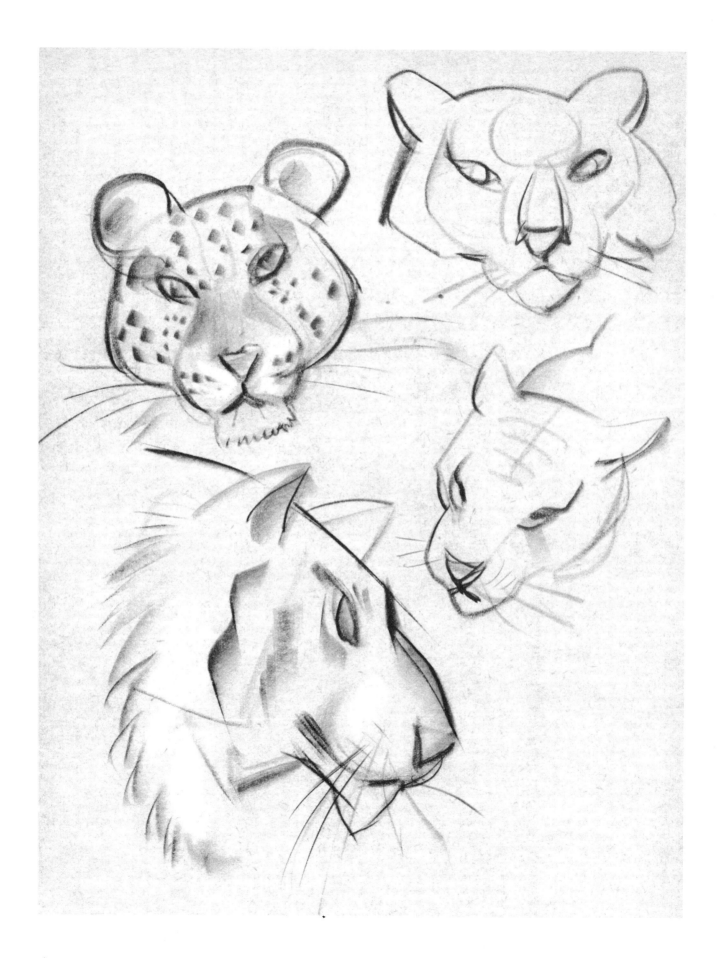

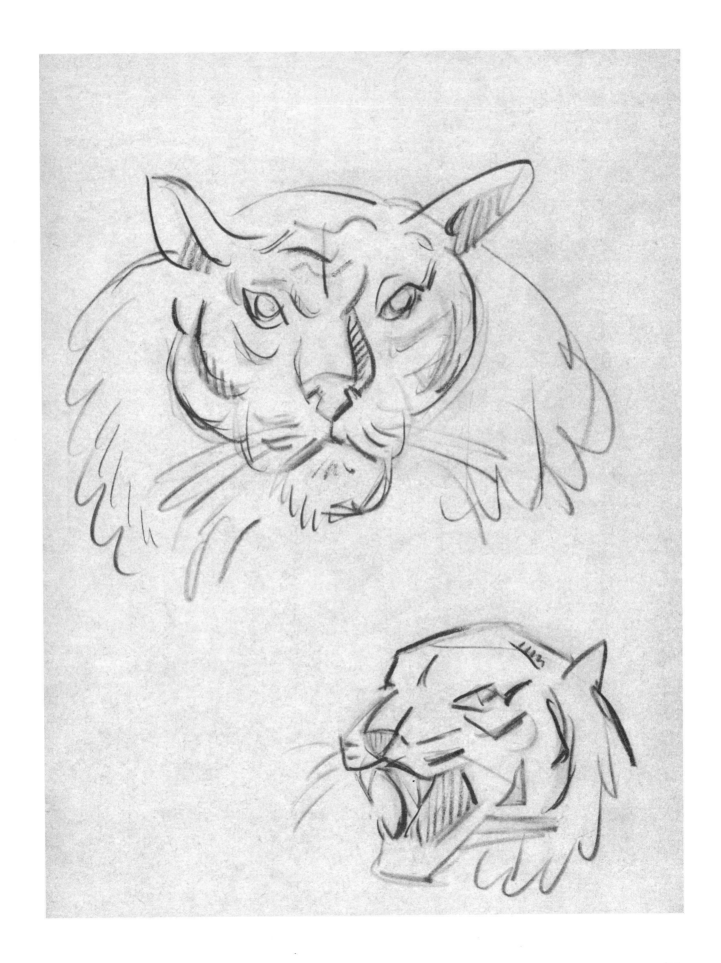

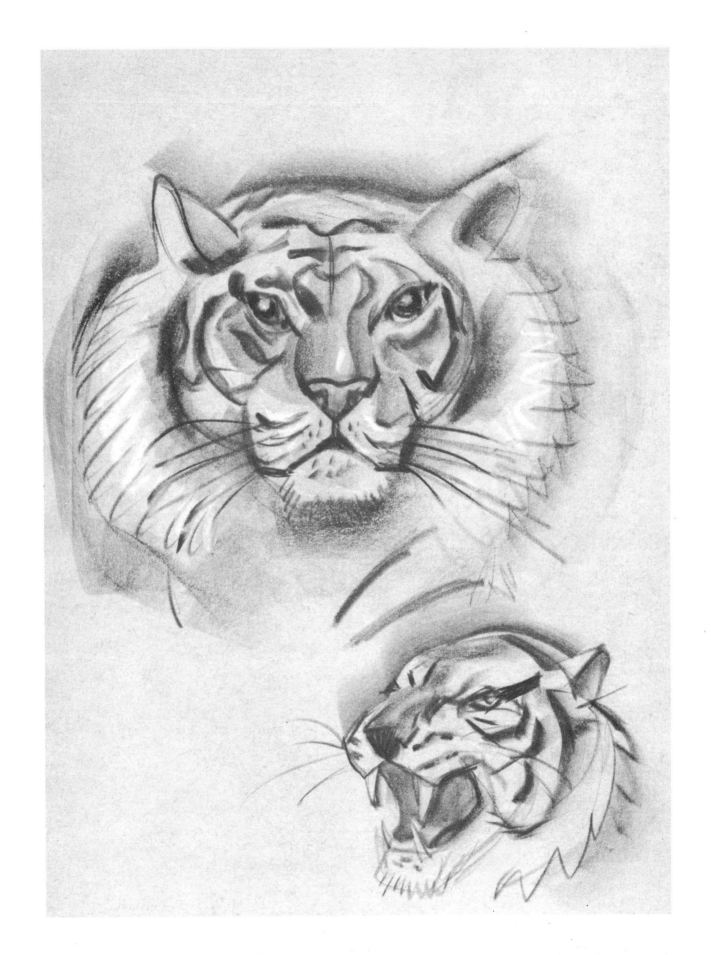

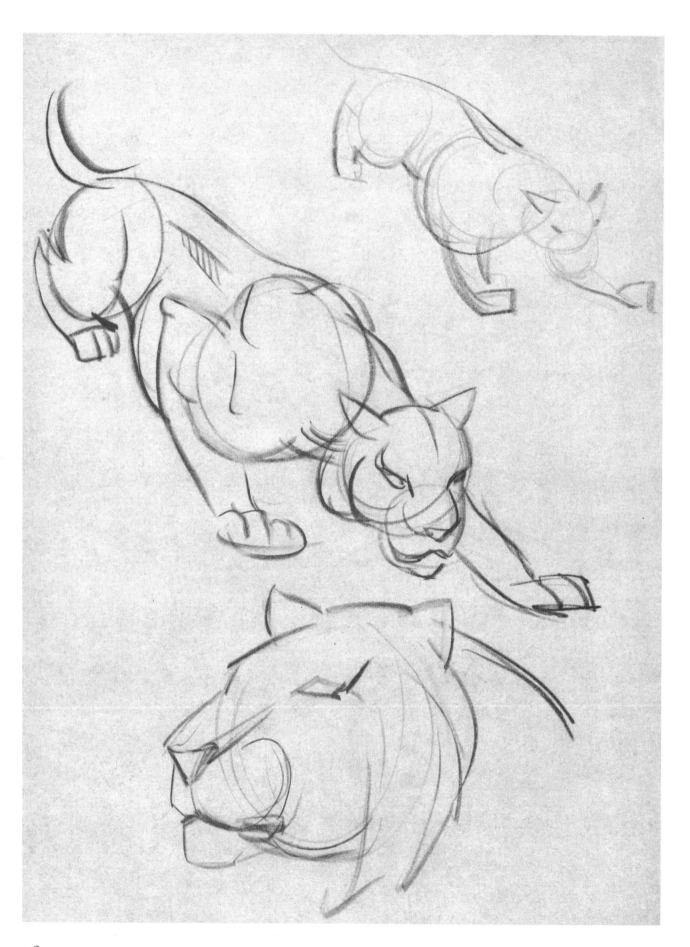

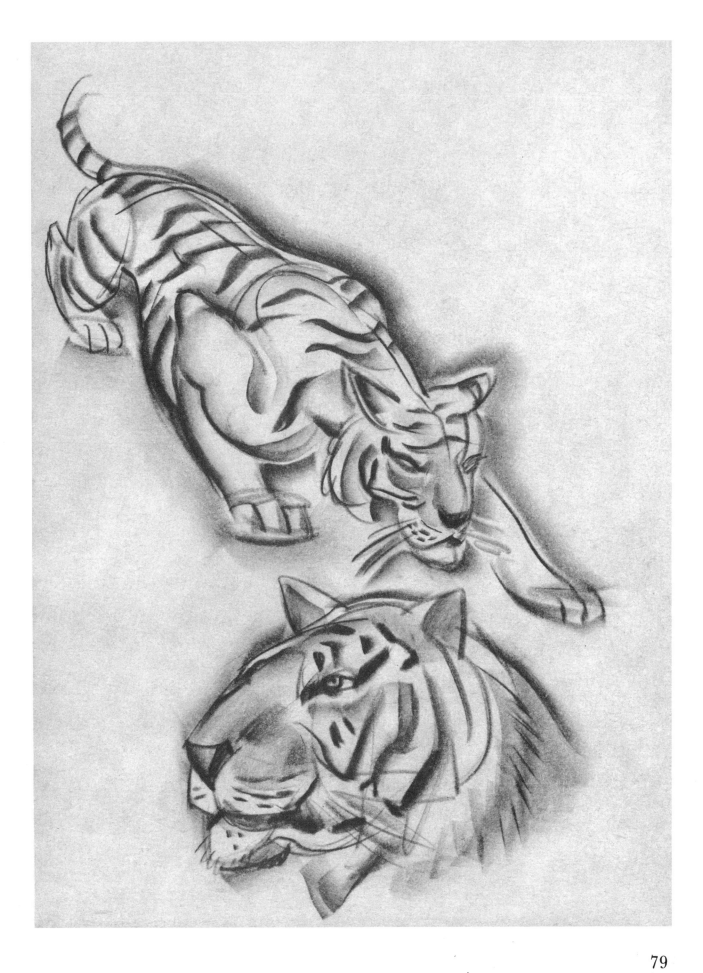

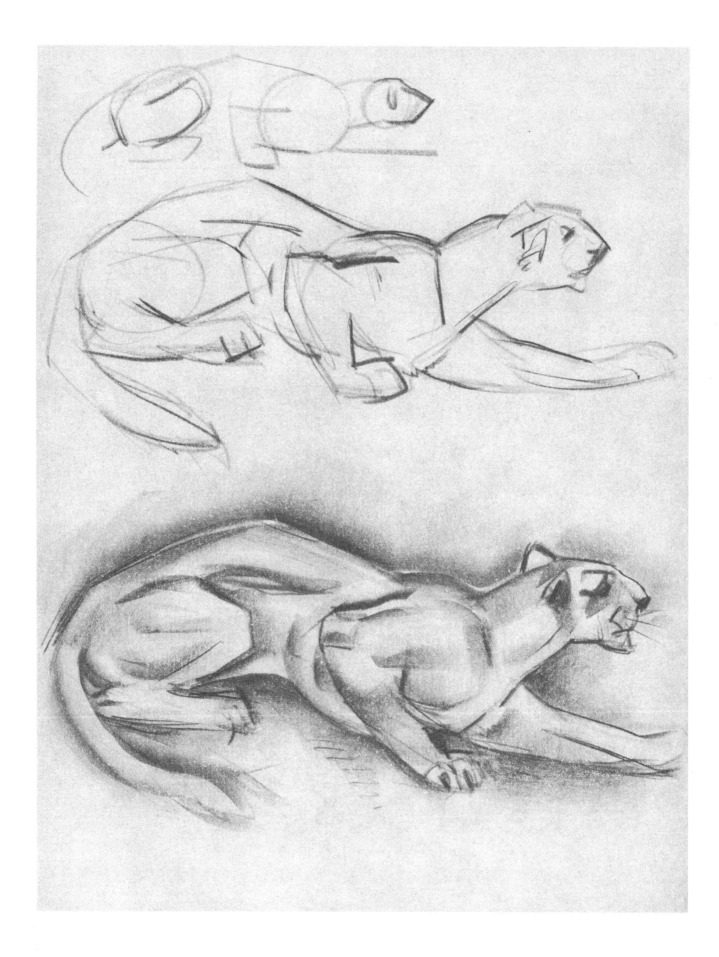

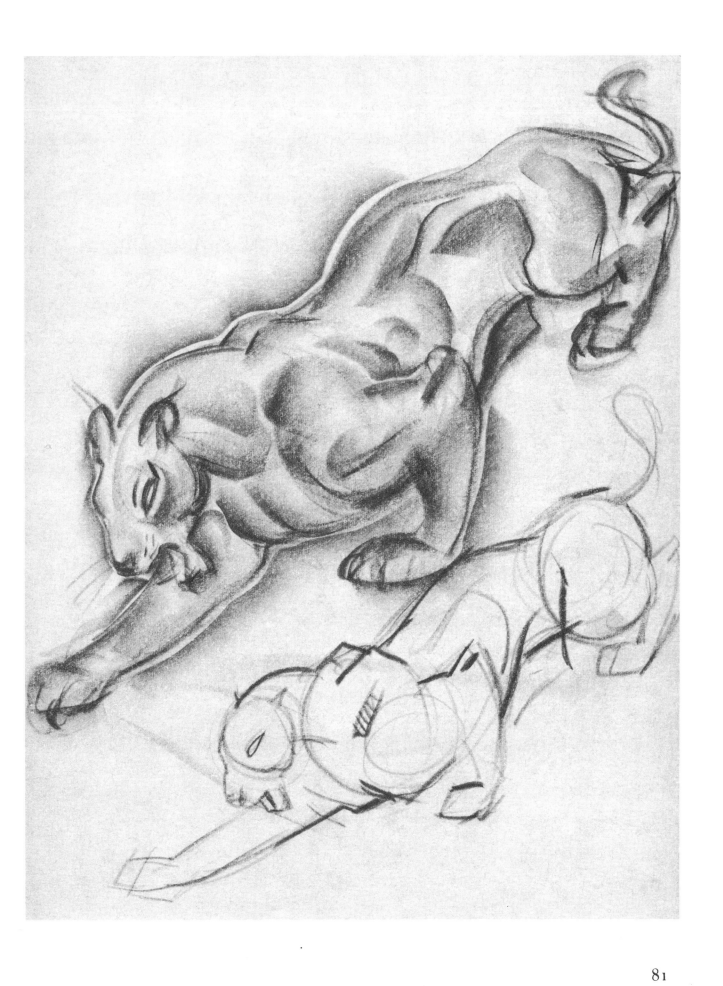

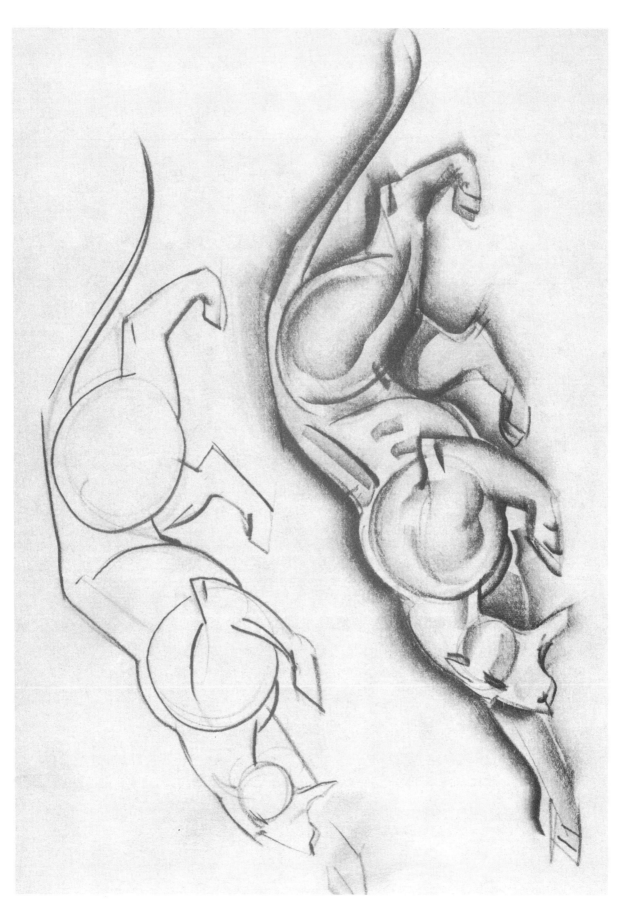

Leopards

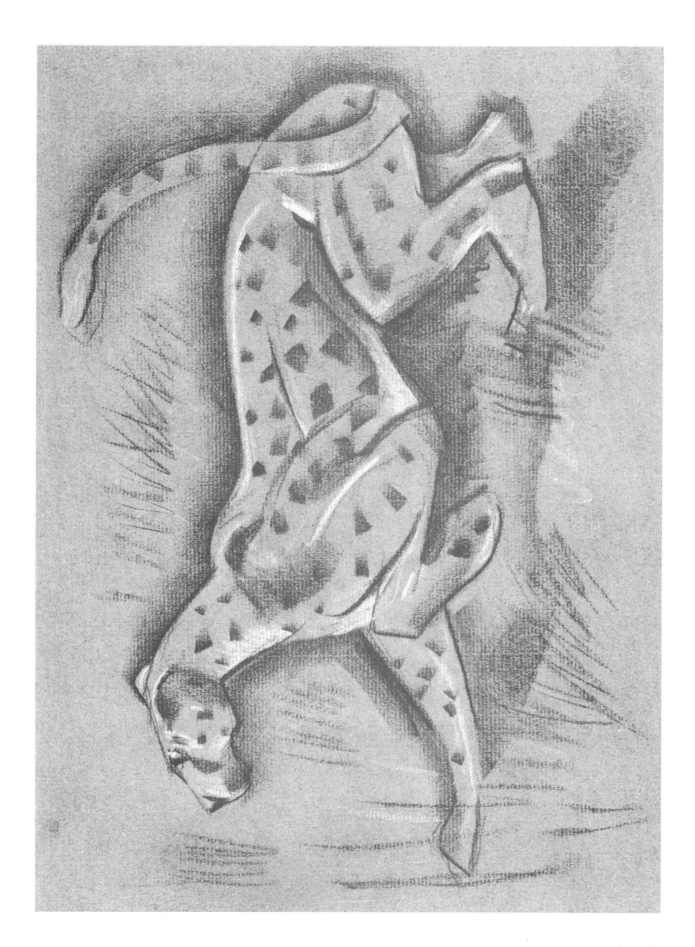

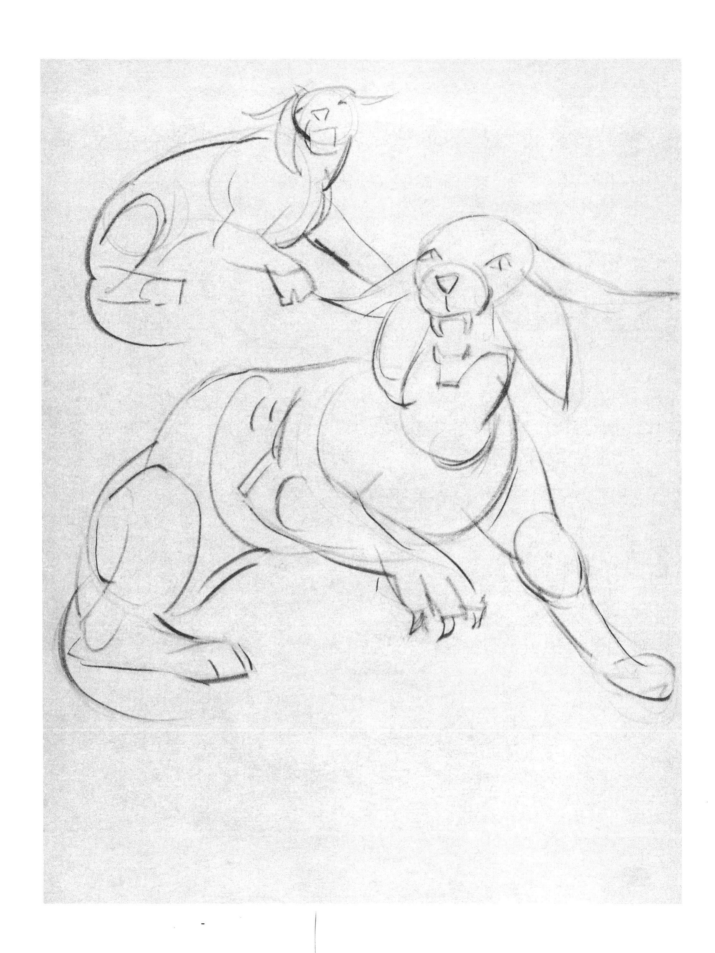

Lynx

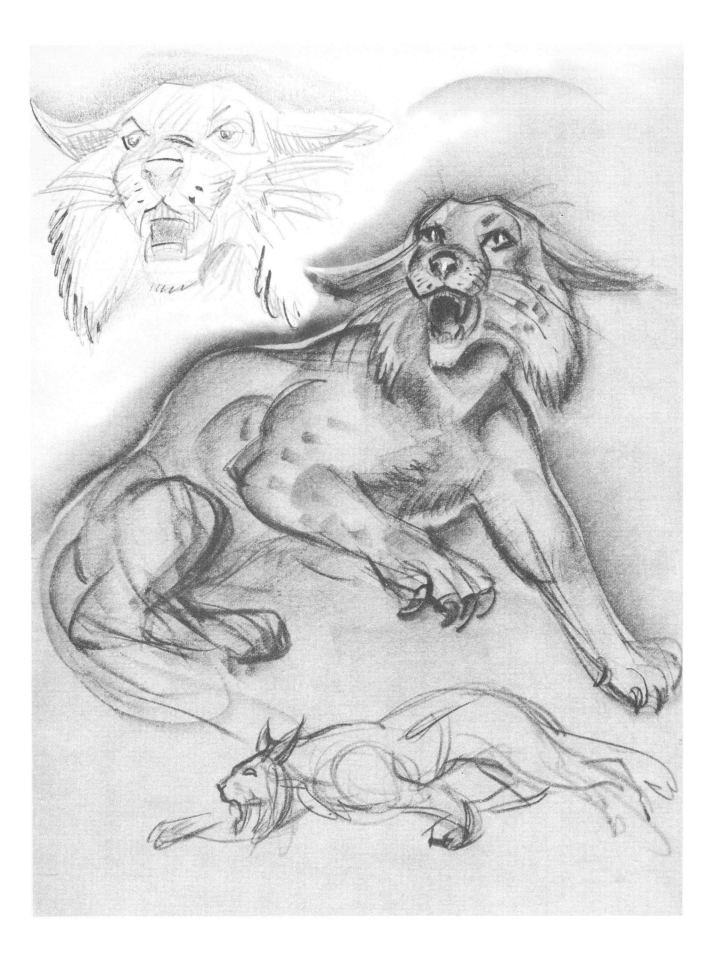

85

# LIONS

⌢⌢⌢ THE LION IS AS MUCH A CAT as the tiger, but he is not so slinky a beast. He must be drawn with a sturdier structure and a more commanding stance. The step studies that follow give an approach to lion structure without stressing the anatomy. In drawing lions, put every emphasis possible on muscle and spring strength.

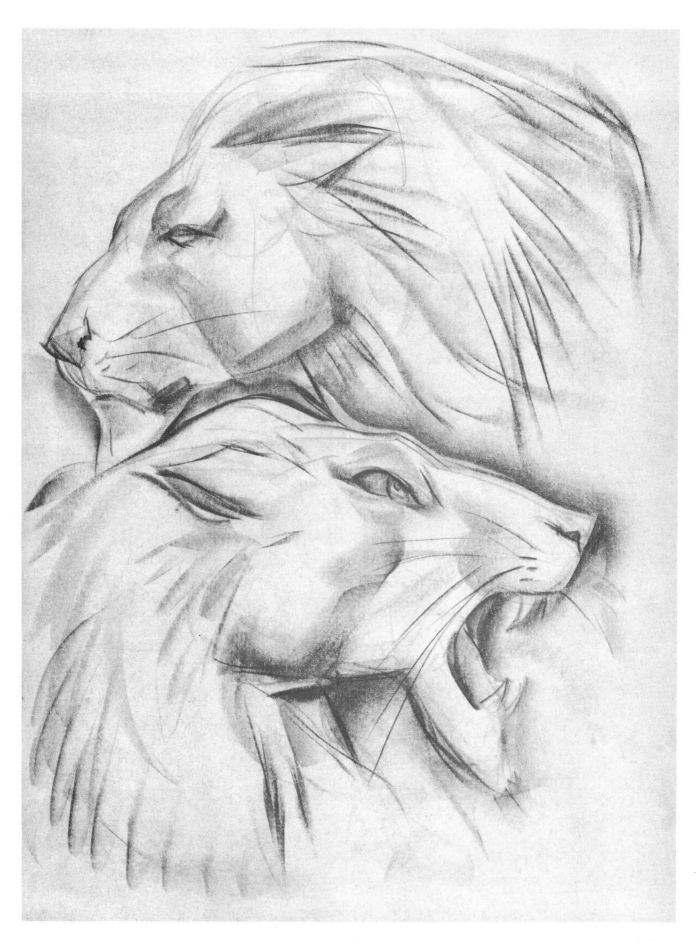

87

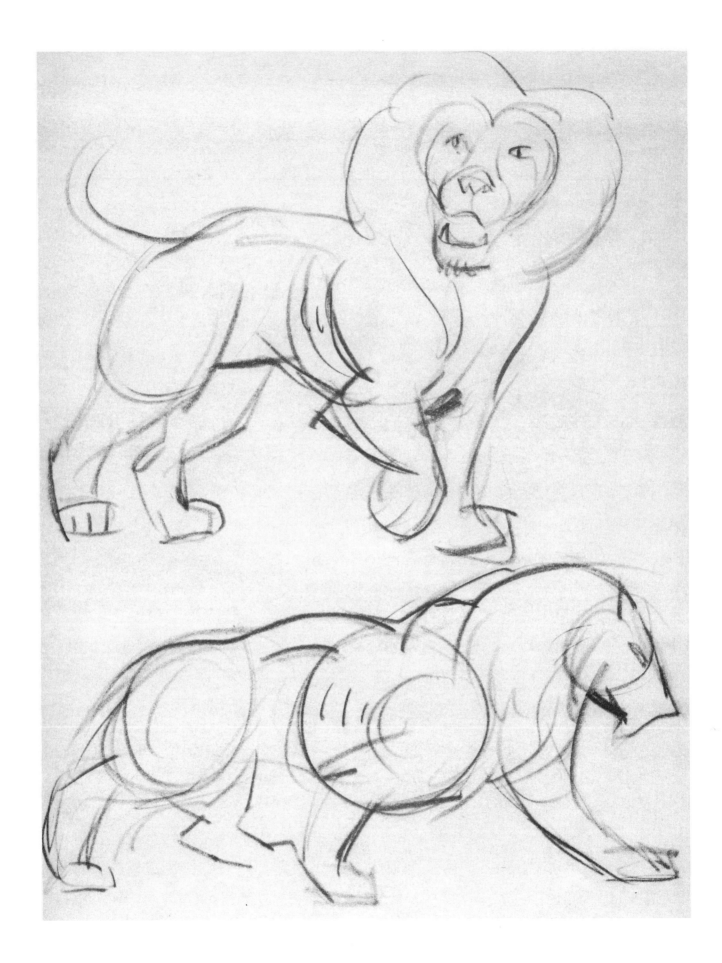

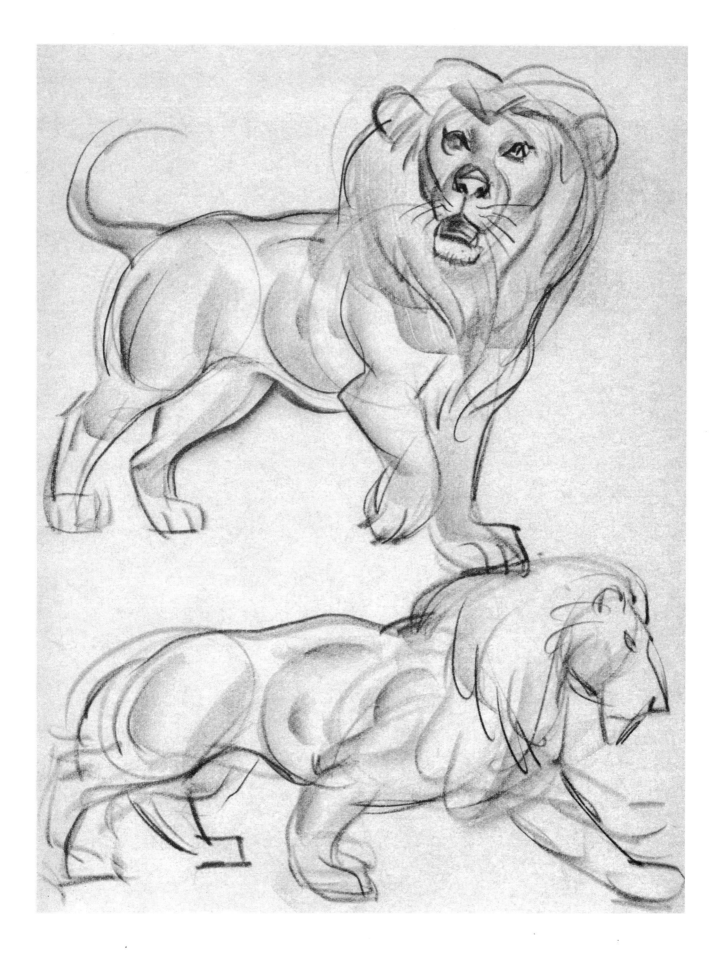

89

# DEER

⌢⌢⌢ THE SAME BASIC PROCESS used for drawing horses holds for the first steps in drawing most species of deer. There are many varieties, differing in shape, color, and spotting. They require direct study in order to learn the peculiarities of each. Sketch them in the zoo whenever possible, or from photographs.

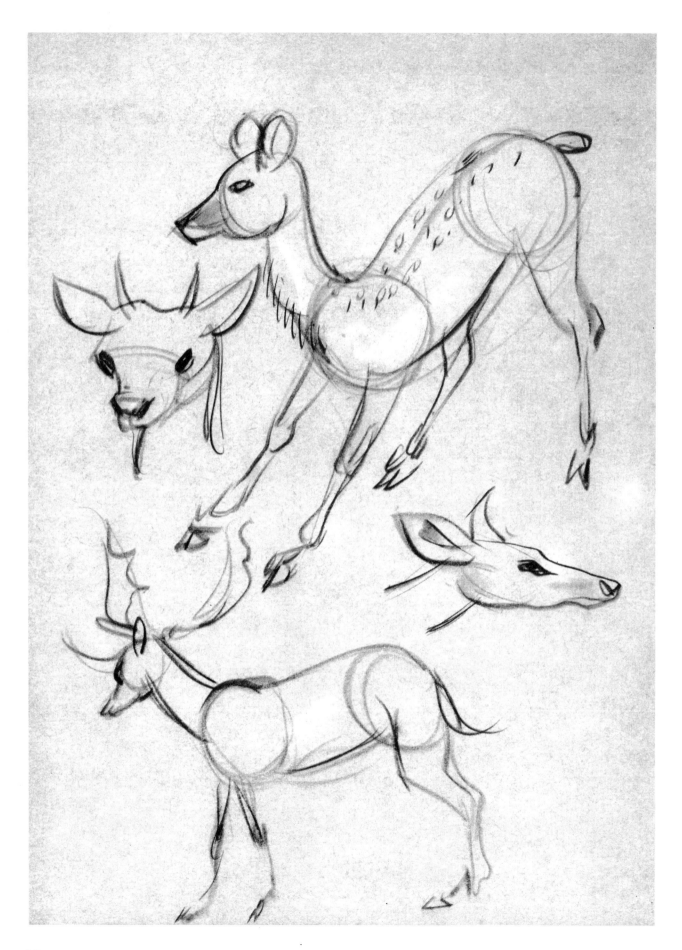

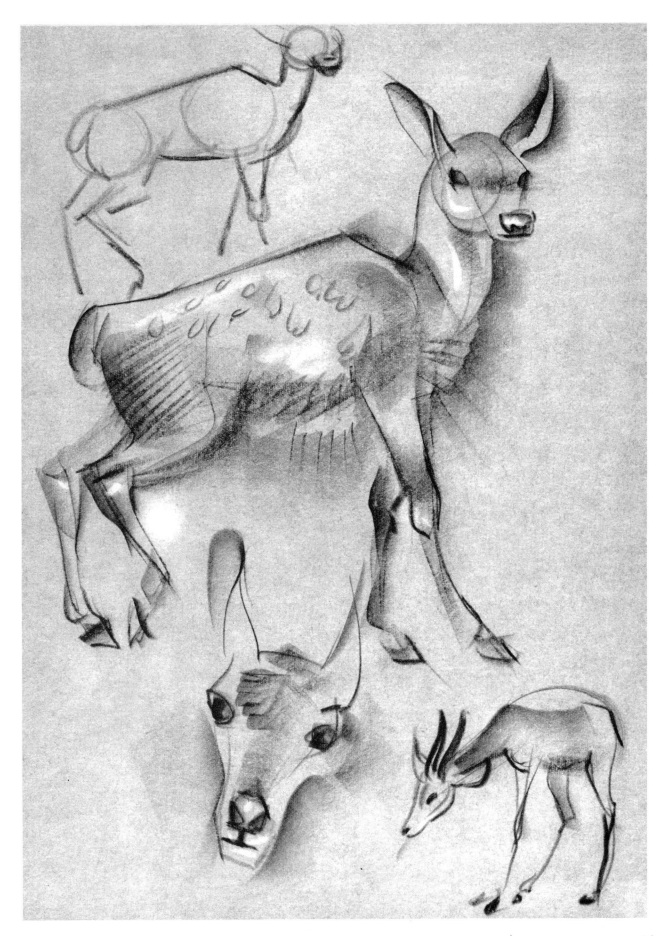

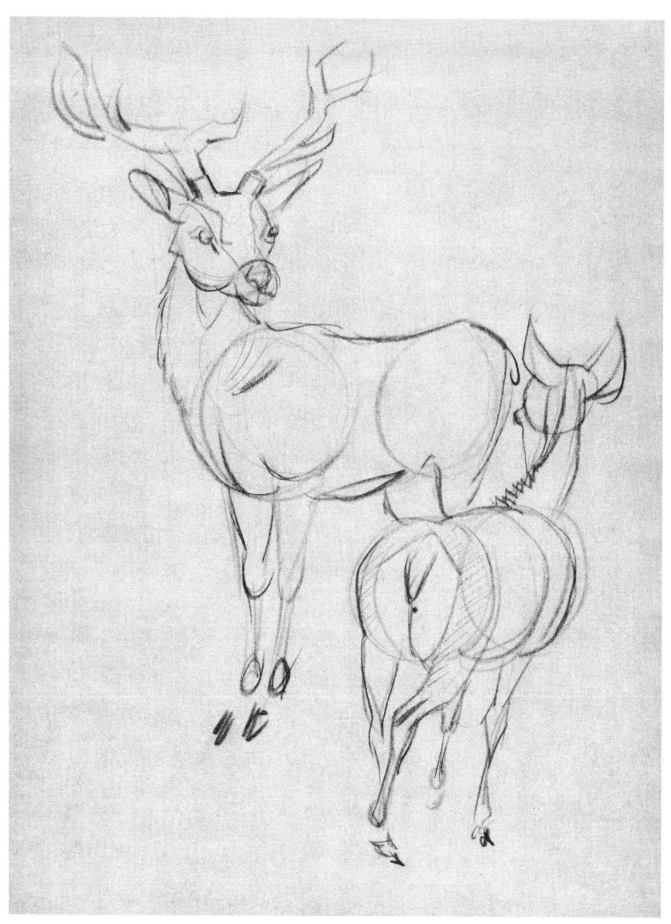

94      Buck and Doe of Horned Deer (above); Moose (opposite)

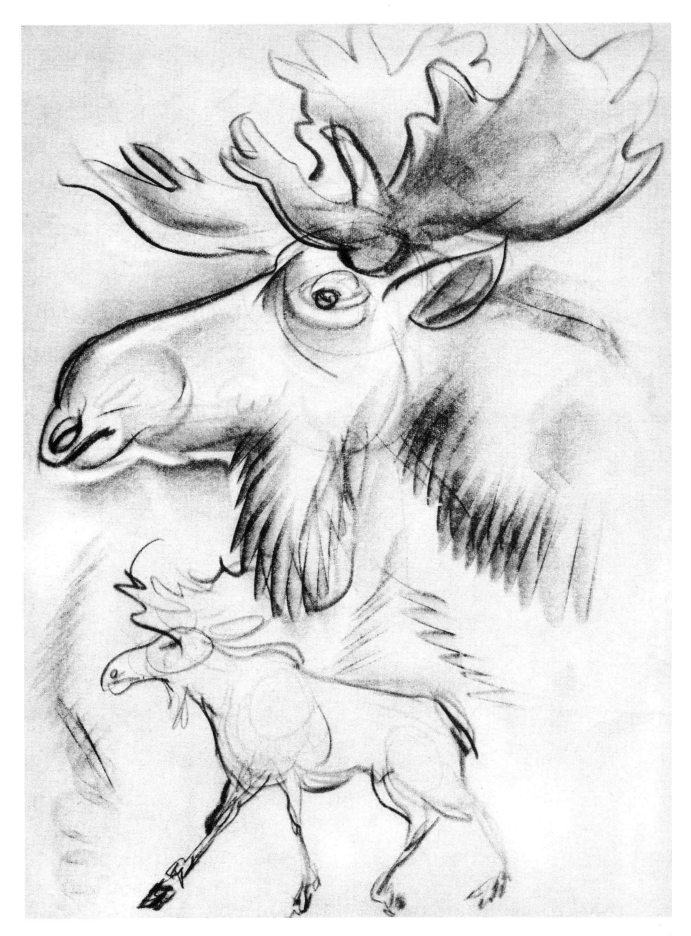

# BUFFALO

∽∽∽ THE GREAT "OUTSIZE" HEAD is the outstanding characteristic of all buffalo species. The torso is surprisingly delicate for so heavy a head, and the hind quarters are nearly as graceful as those of a horse.

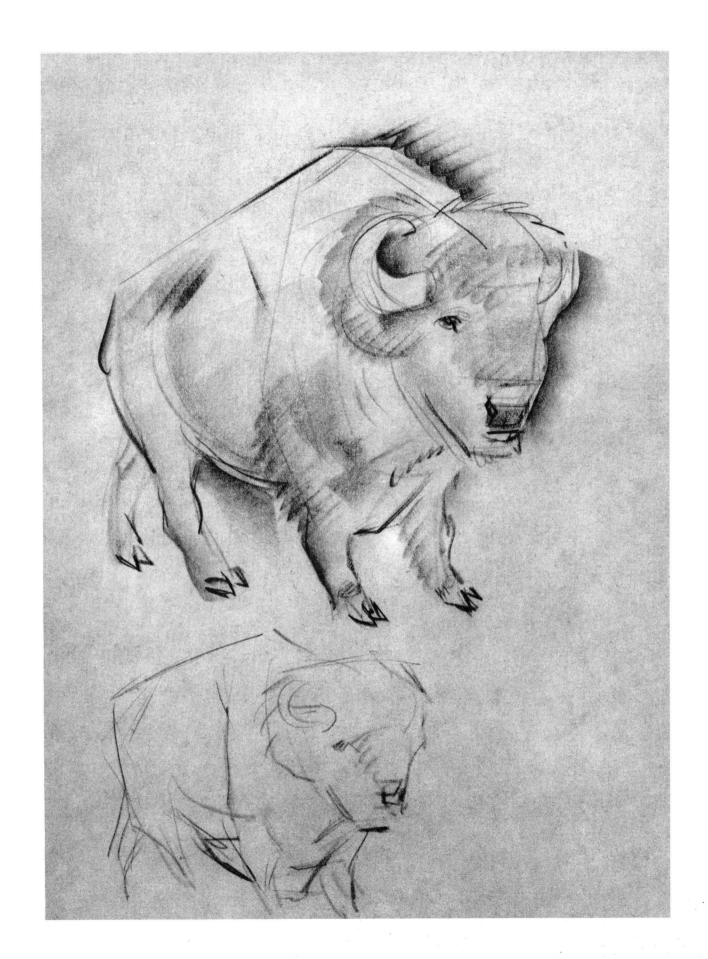

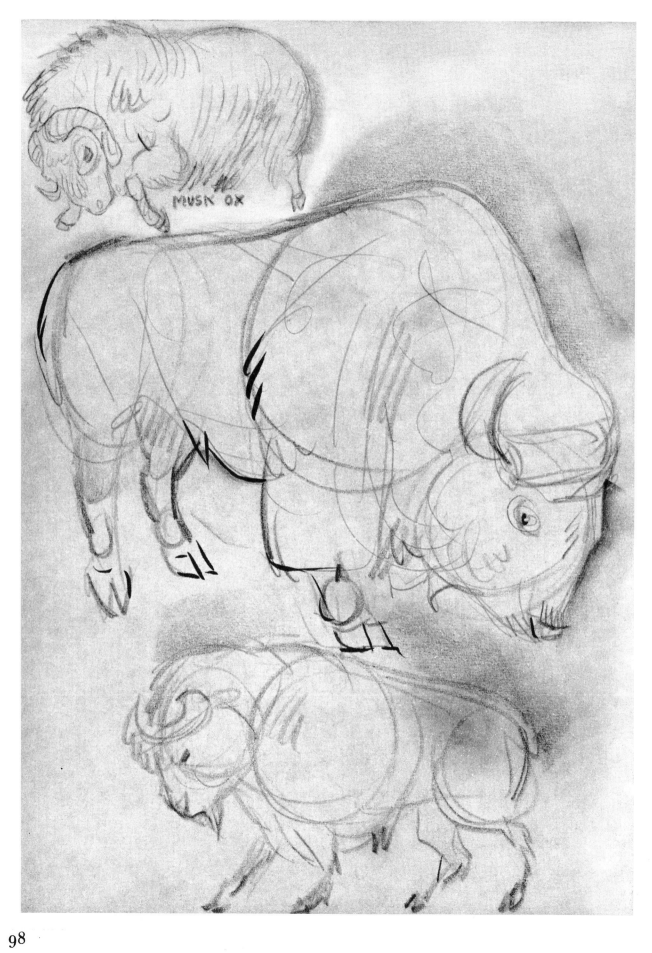

MUSK OX

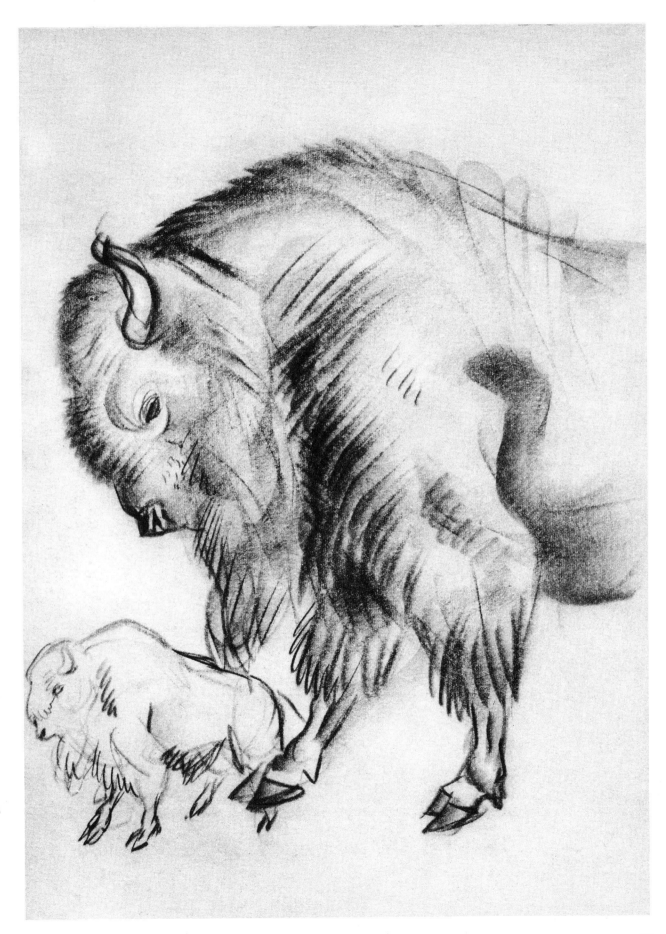

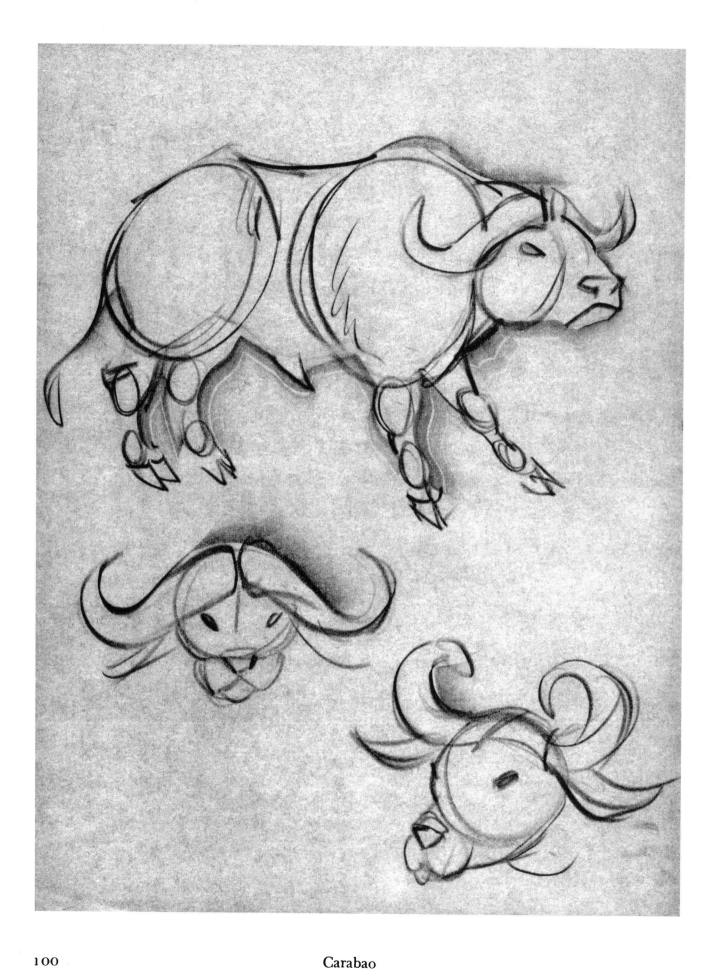

Carabao

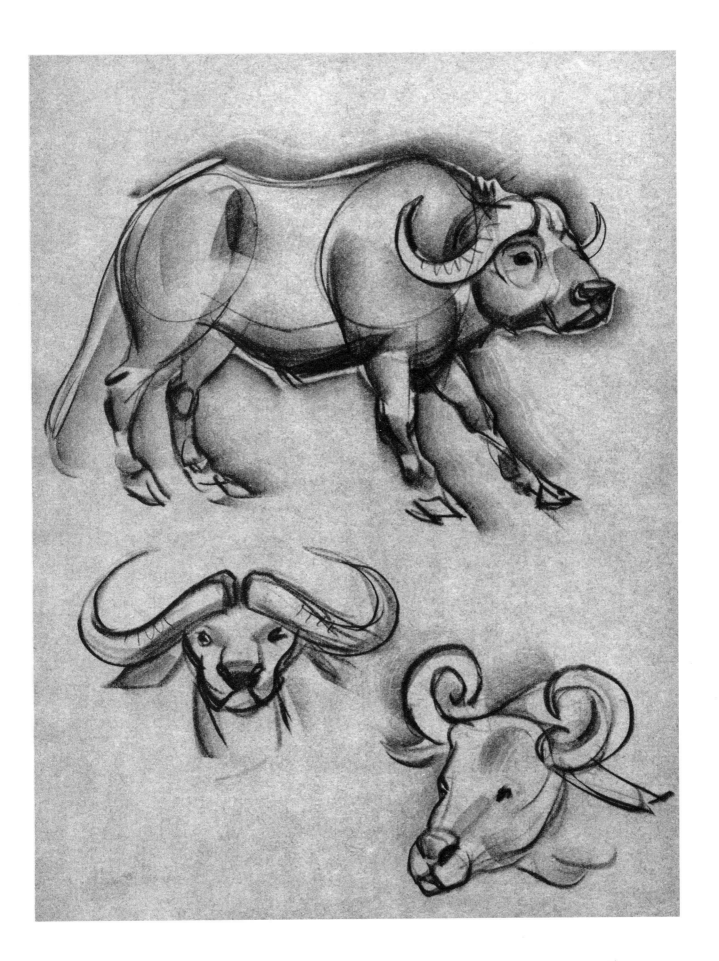

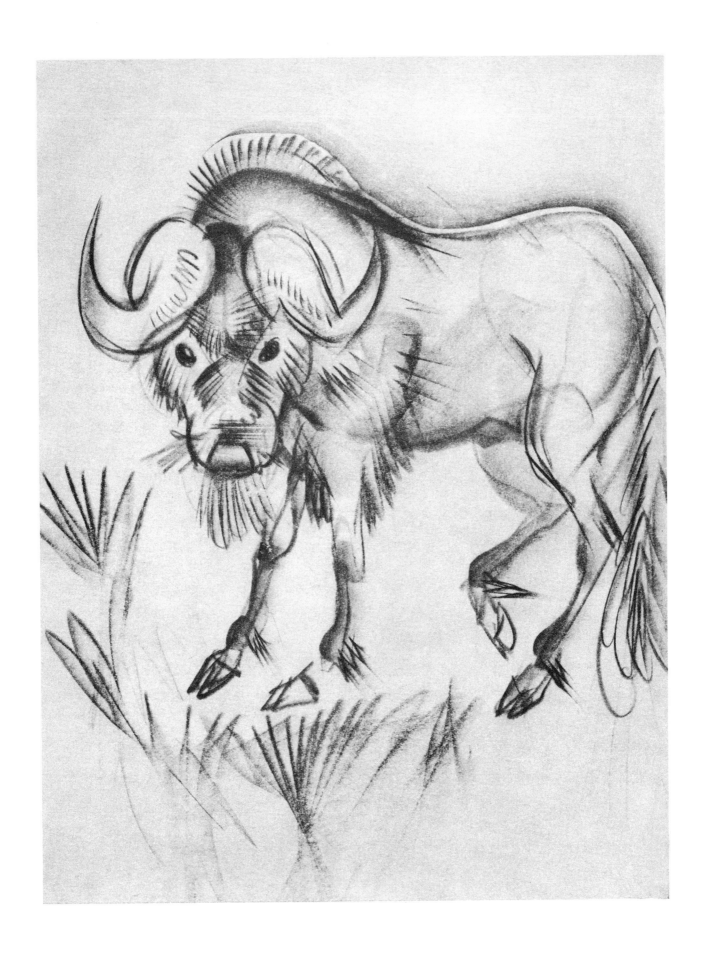

Gnu

# COWS AND BULLS

⌢⌢⌢ The comparatively square torso, high shoulder, and low-slung neck are characteristic of the cows. As for most animals, however, the two-circle principle is applicable. The legs, except that they are shorter and sturdier, are constructed much like those of the horse. Bulls, with their large shoulders and massive heads, are reminiscent of buffalo.

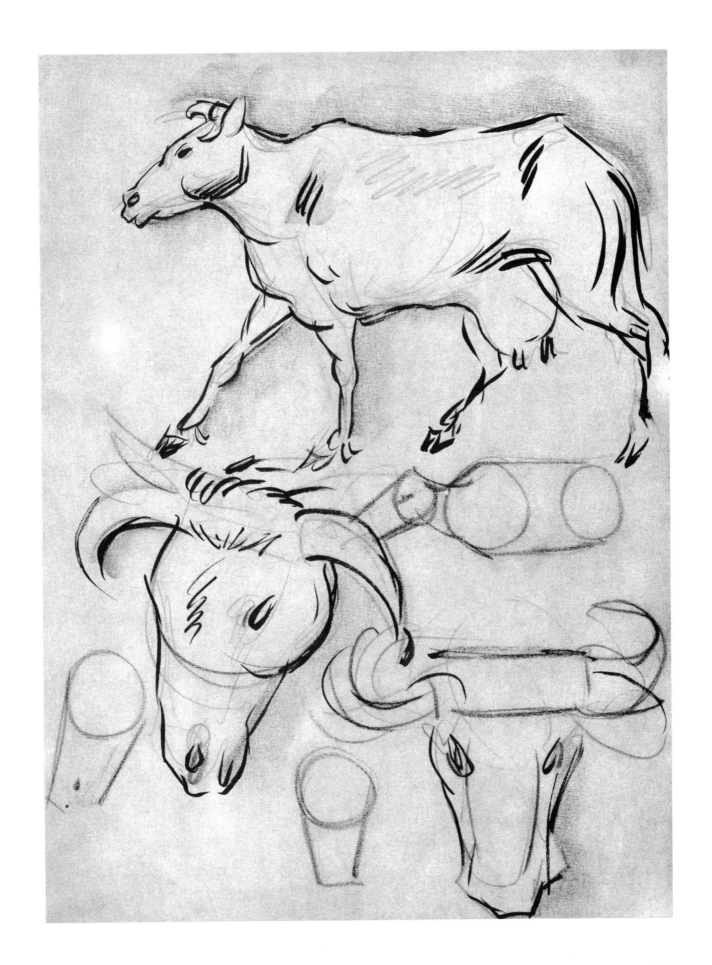

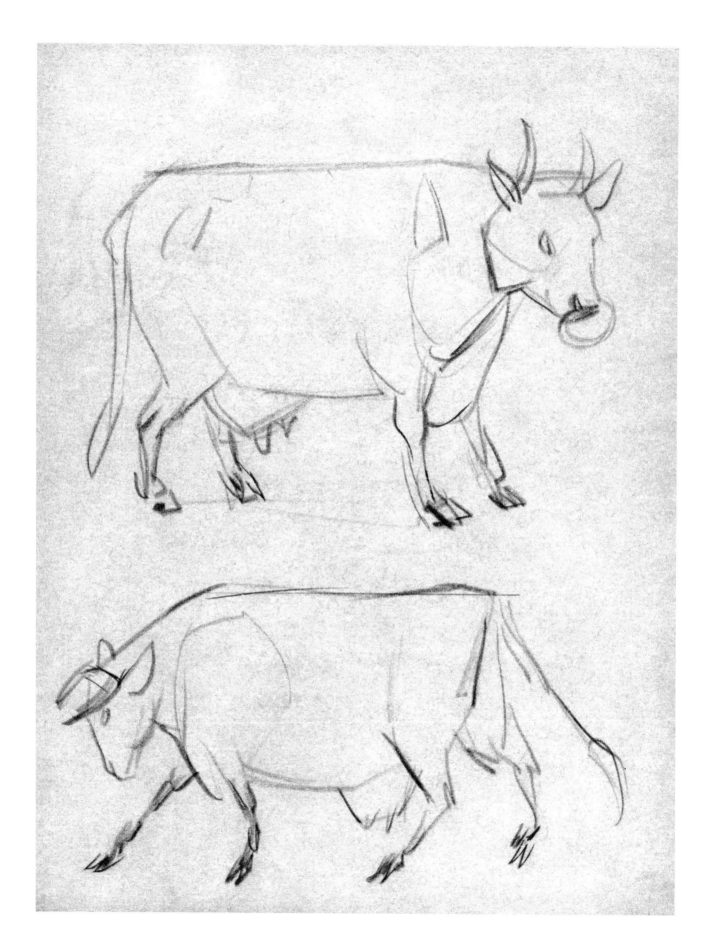

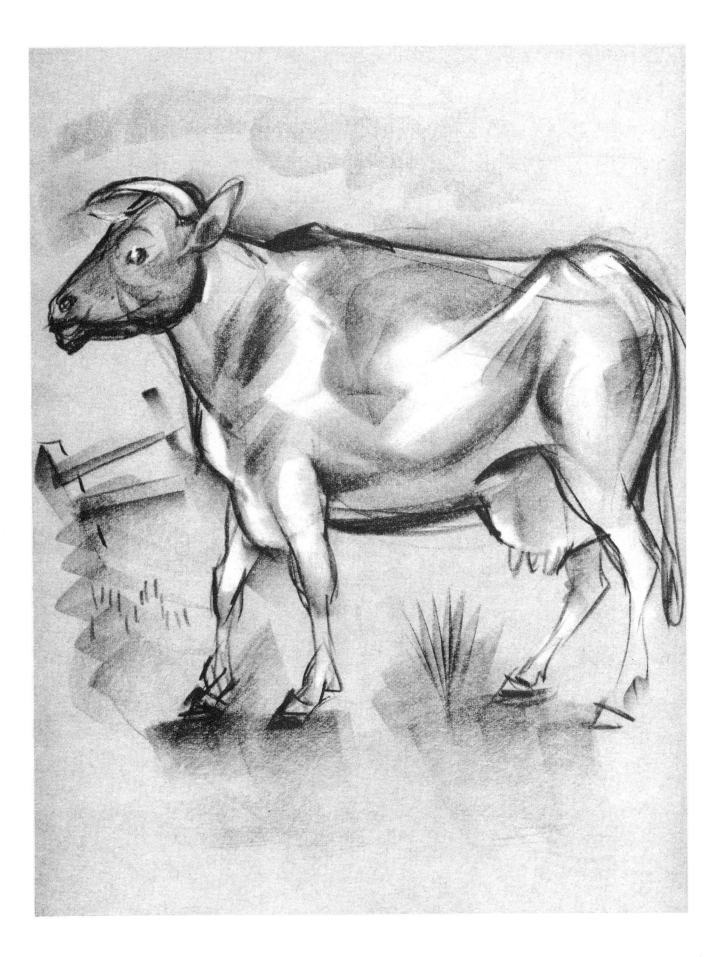

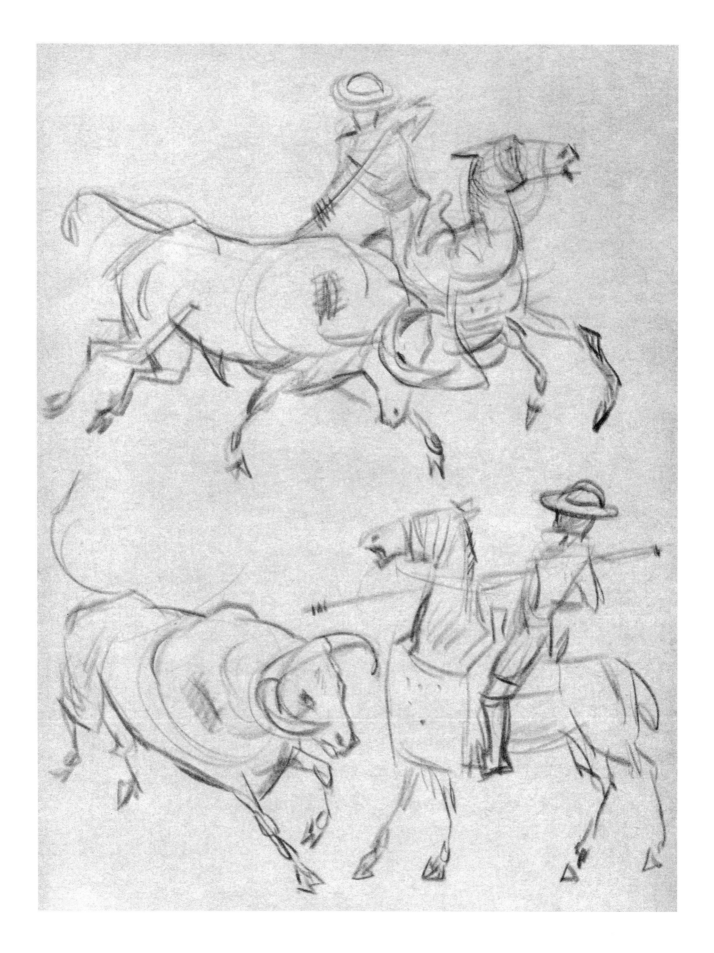

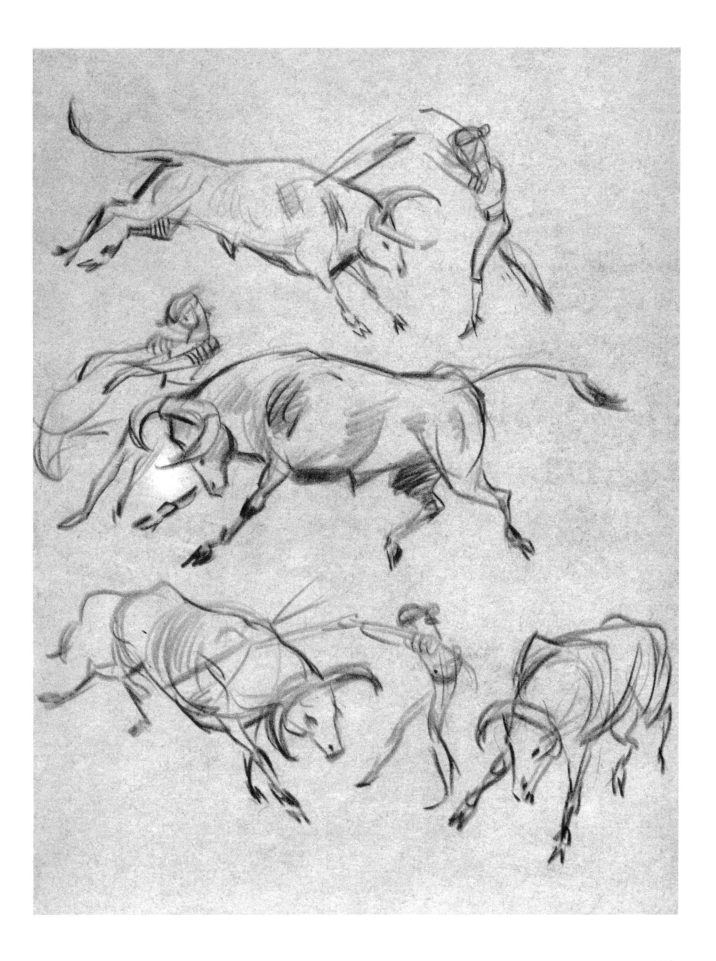

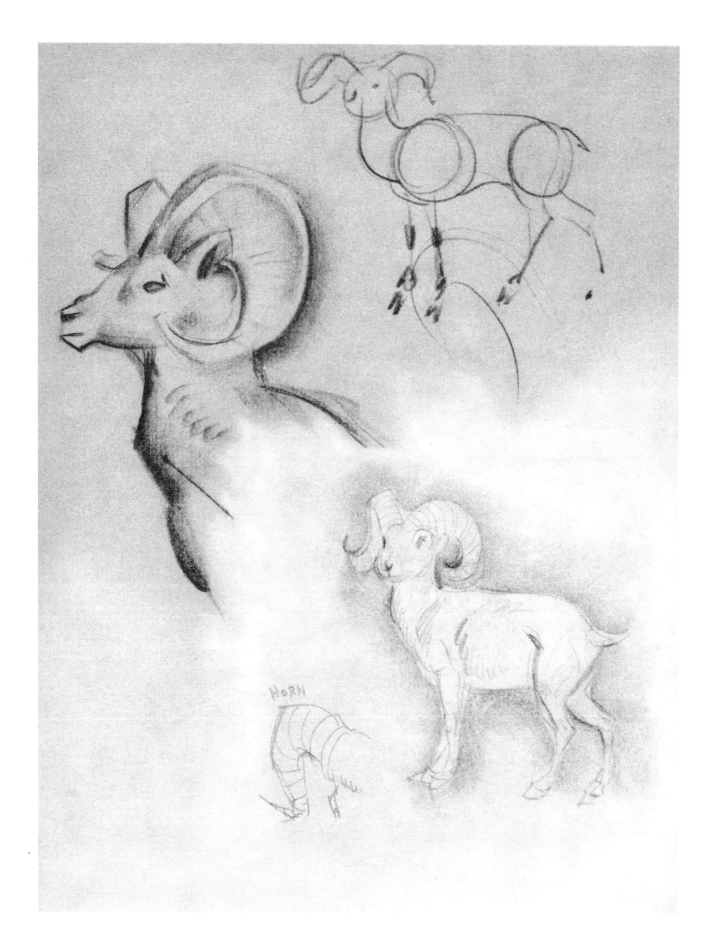

HORN

Sheep and Goats

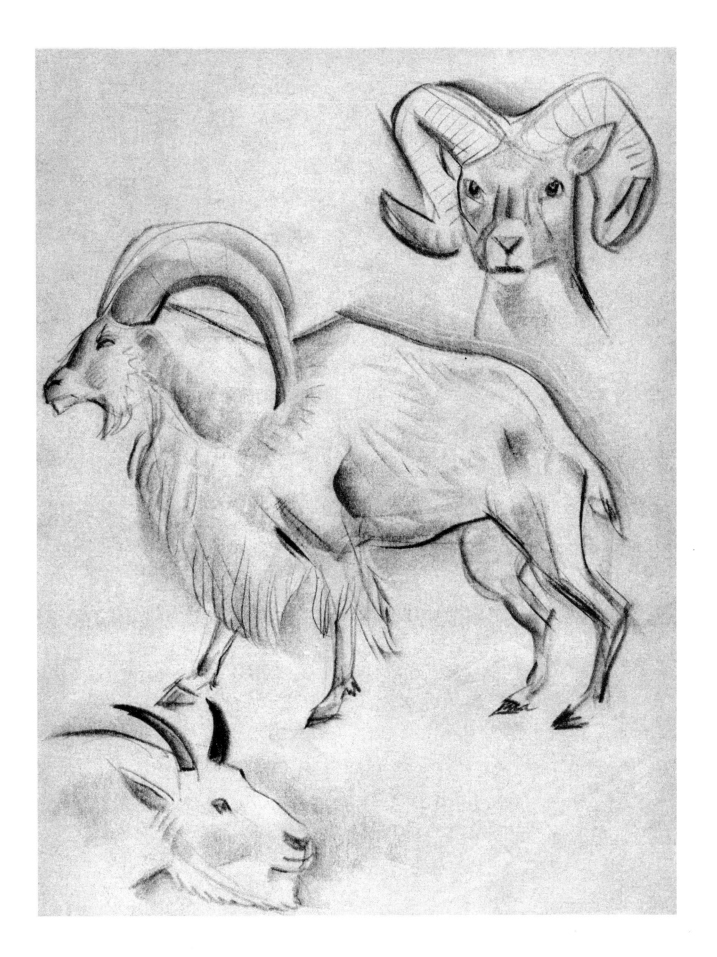

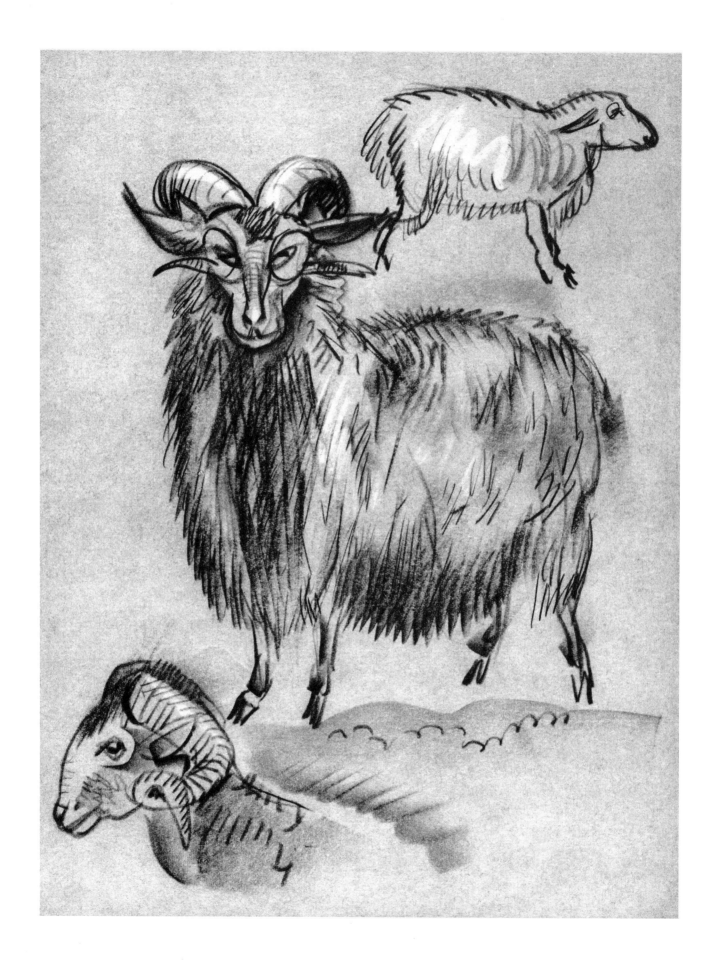

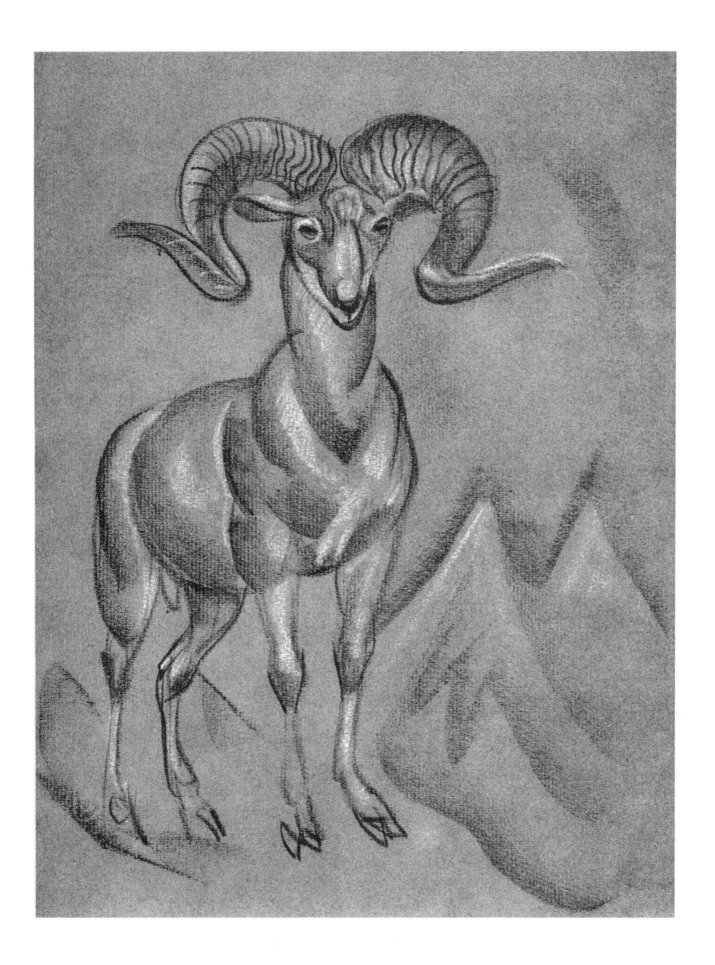

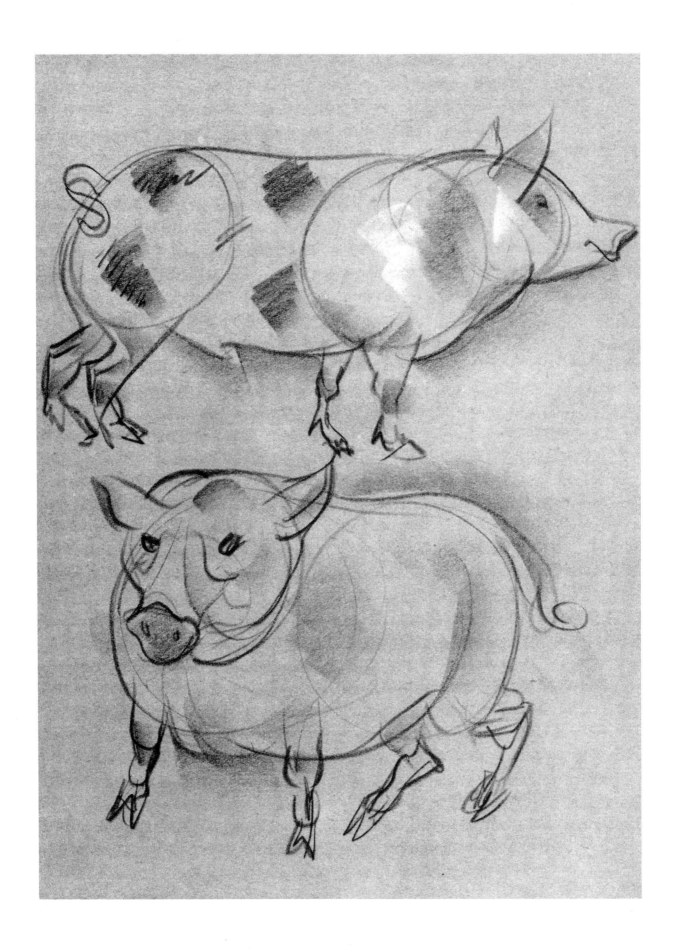

Swine

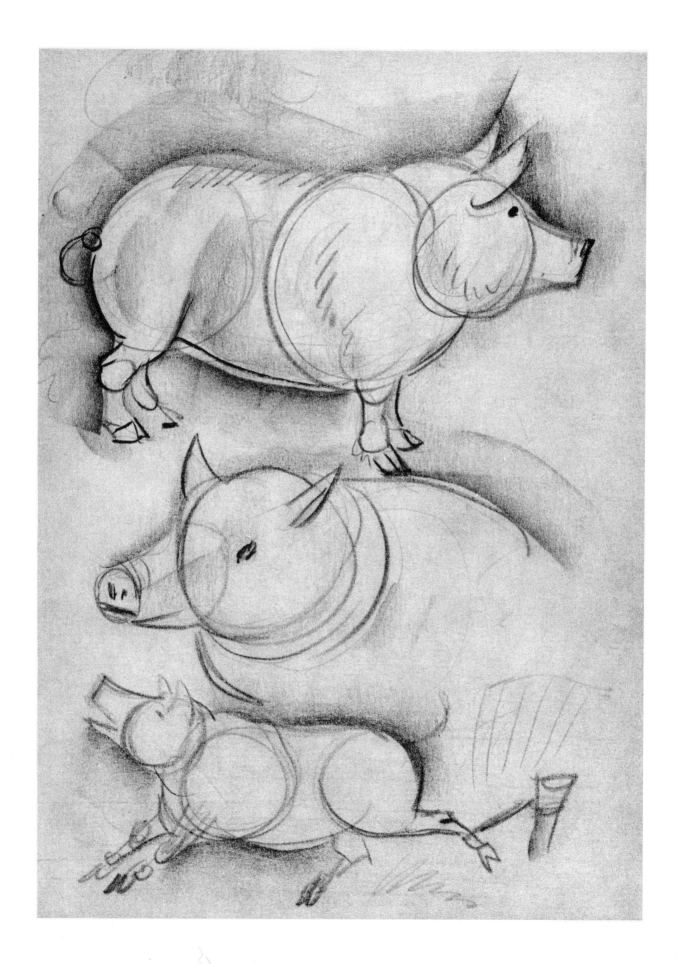

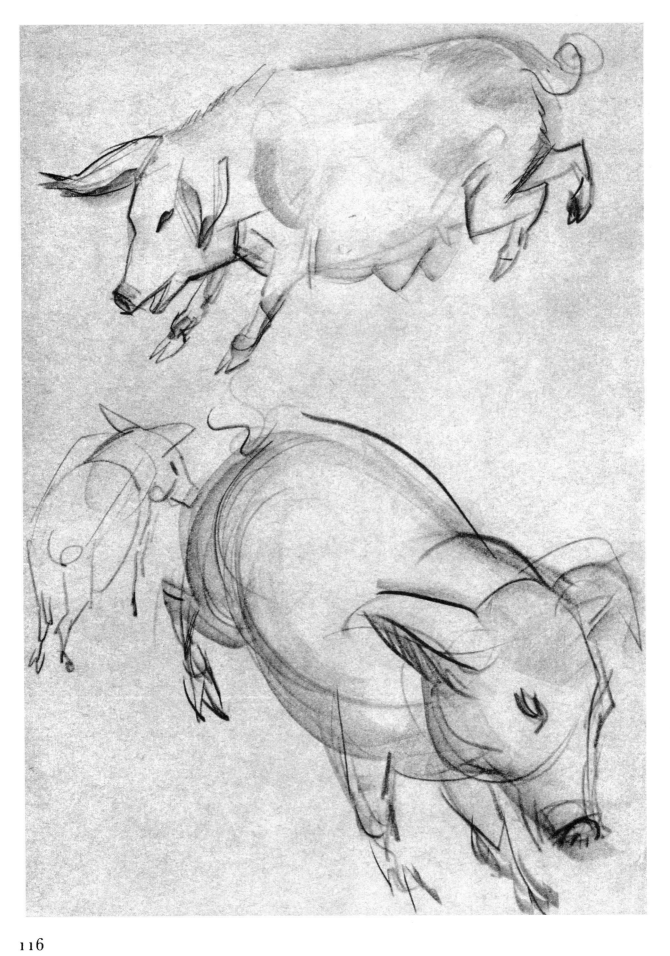

BOAR

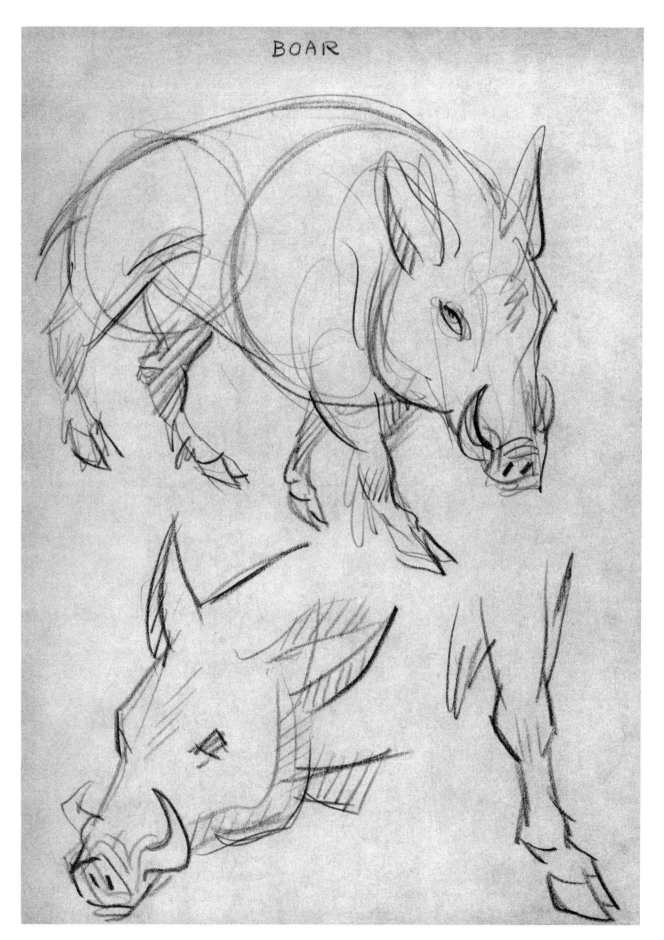

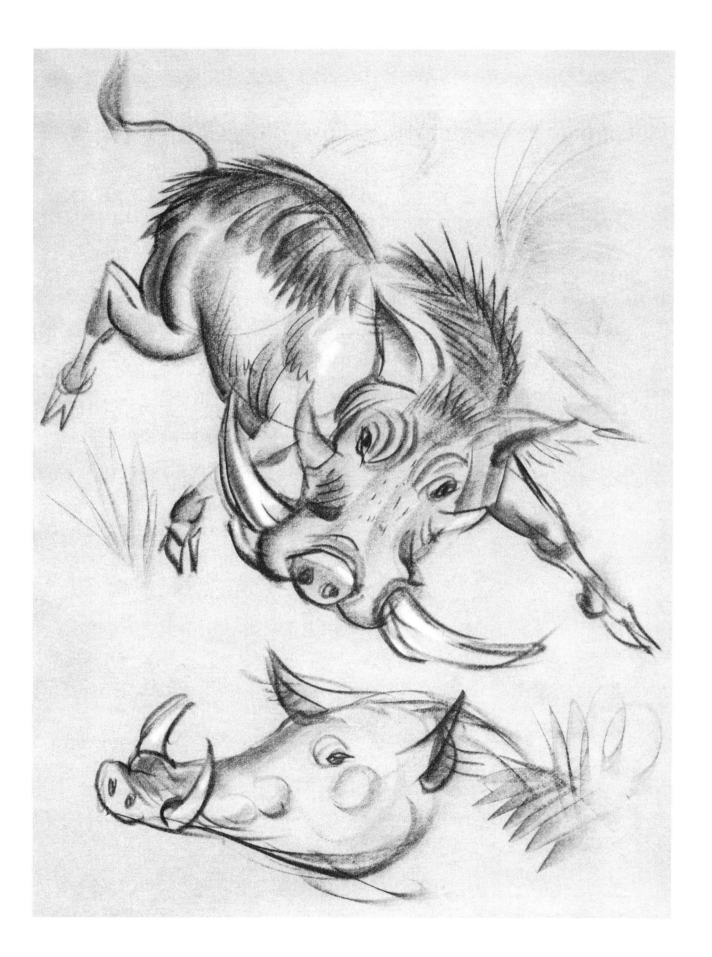

Wart Hog

# ELEPHANTS

ⴰⴰⴰ For all their great bulk elephants are quite bony—their frame structure is readily seen despite the loose skin and massive flesh. The two-circle base adjusted to ovals is an adequate simplification upon which to build the torso of an elephant. The studies show these oval forms and the first steps toward drawing the animal. An oval may also serve as the base for the design of the head.

The following pages present a series of basic studies of the legs of elephants and suggest the manner in which they move.

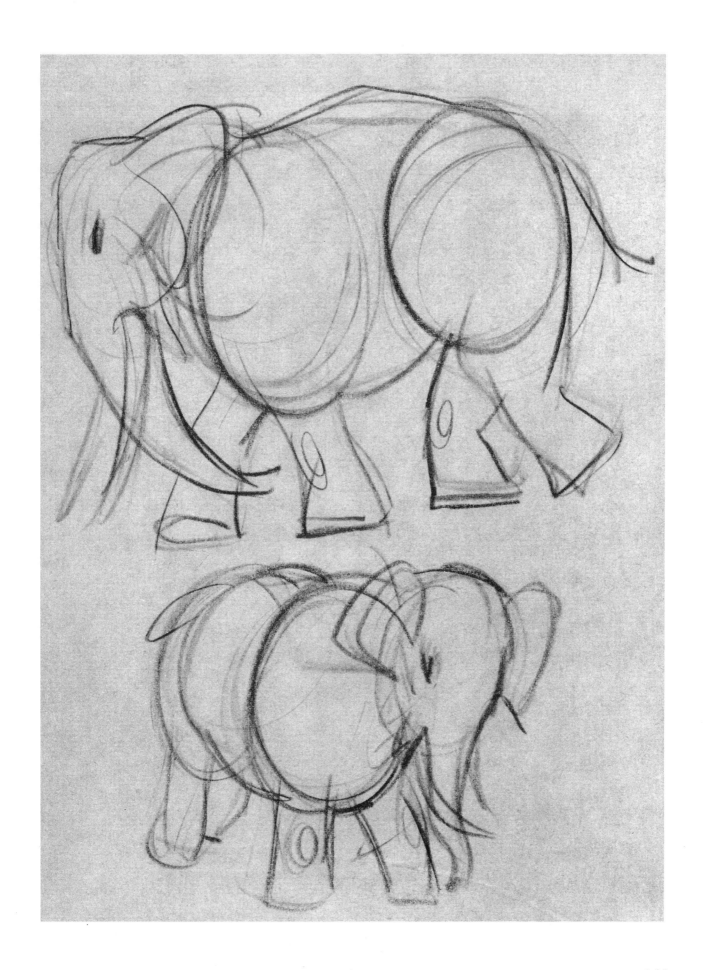

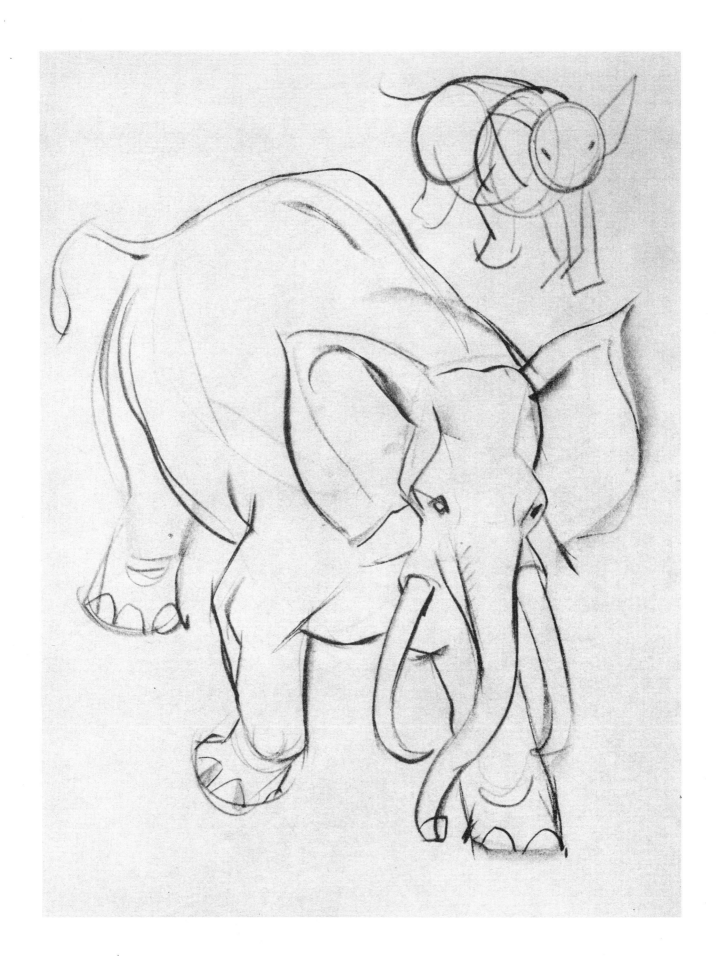

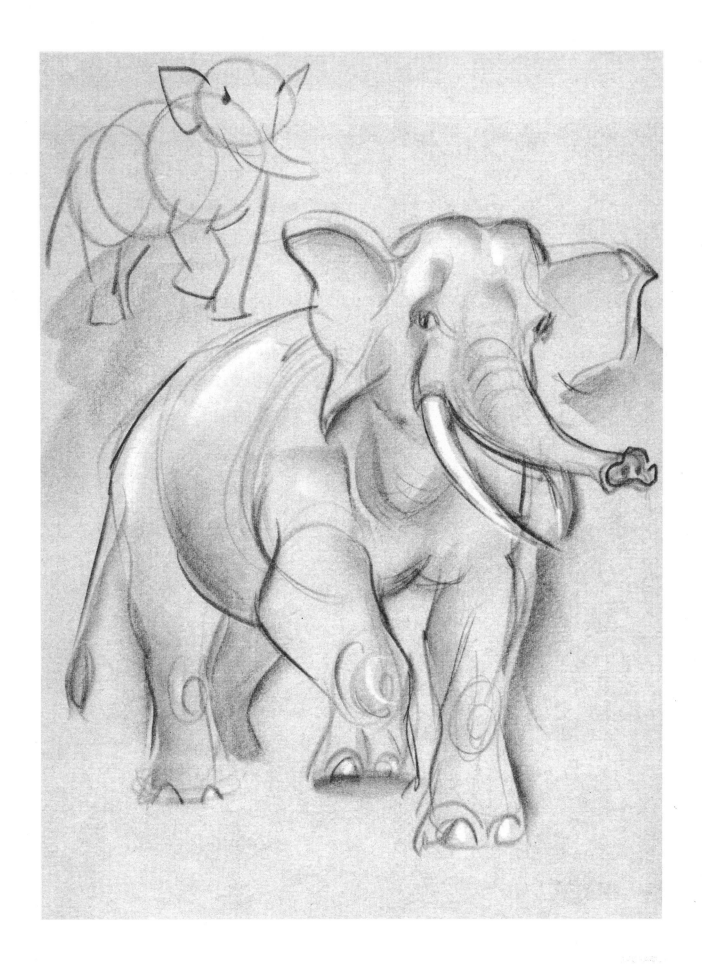

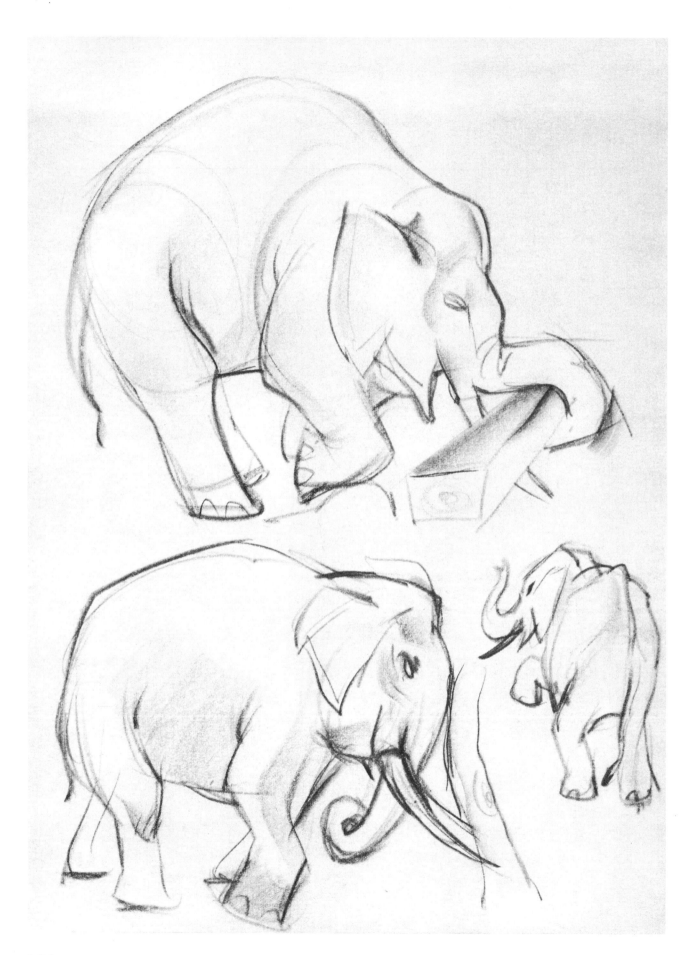

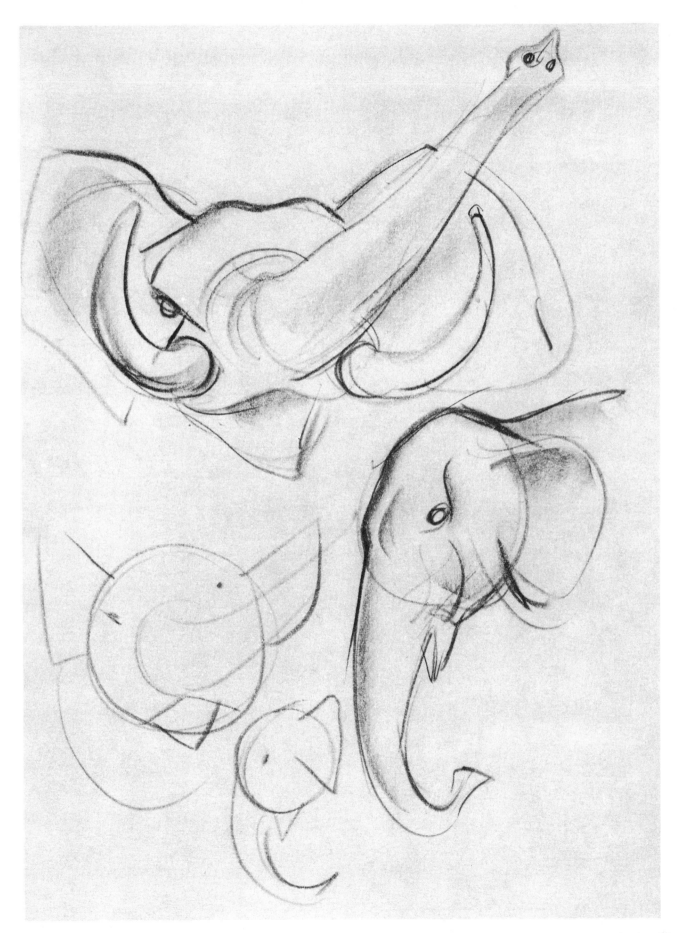

125

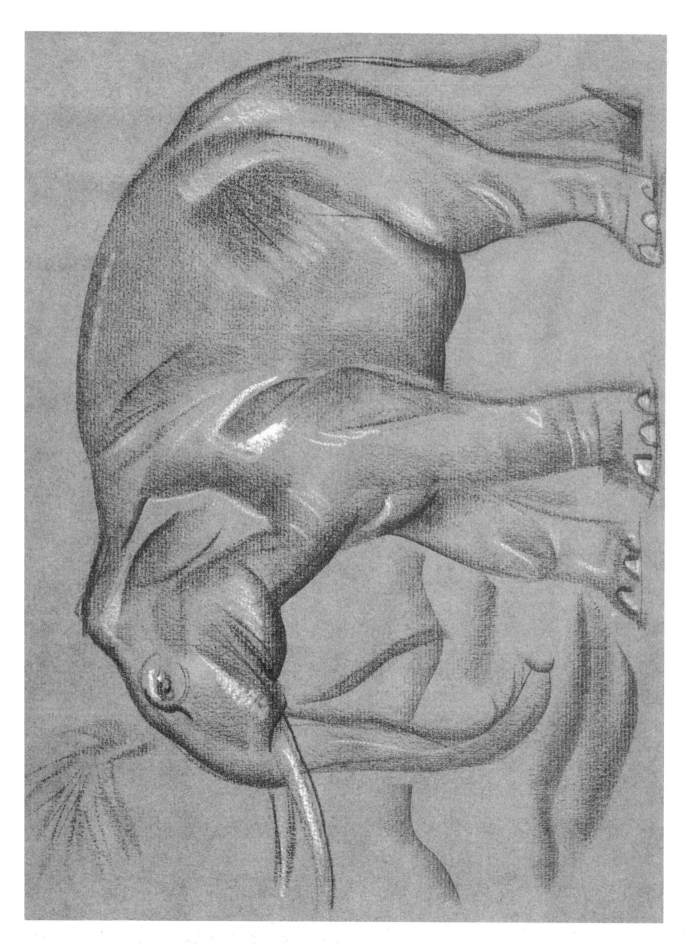

126

# HIPPOPOTAMUS AND RHINOCEROS

⌒⌒⌒ BOTH THE HIPPOPOTAMUS AND THE RHINOCEROS, fortunately for the artist, have skin folds that make convenient divisions of form for study and drawing. Note these skin folds. They occur at joints, where one form ends and another begins. Note also the great bulk of body and the short legs.

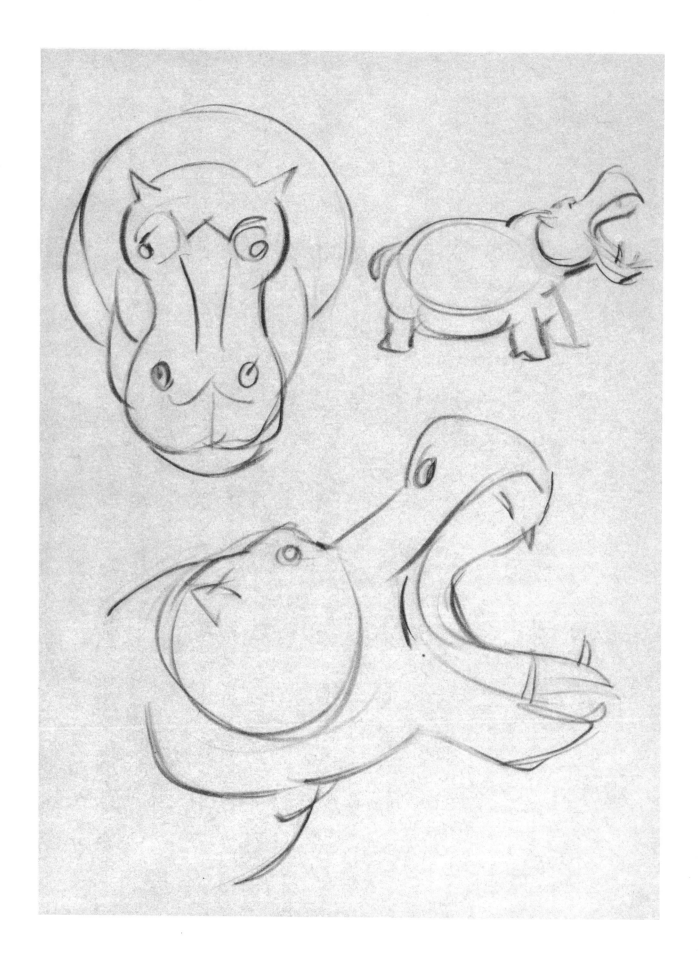

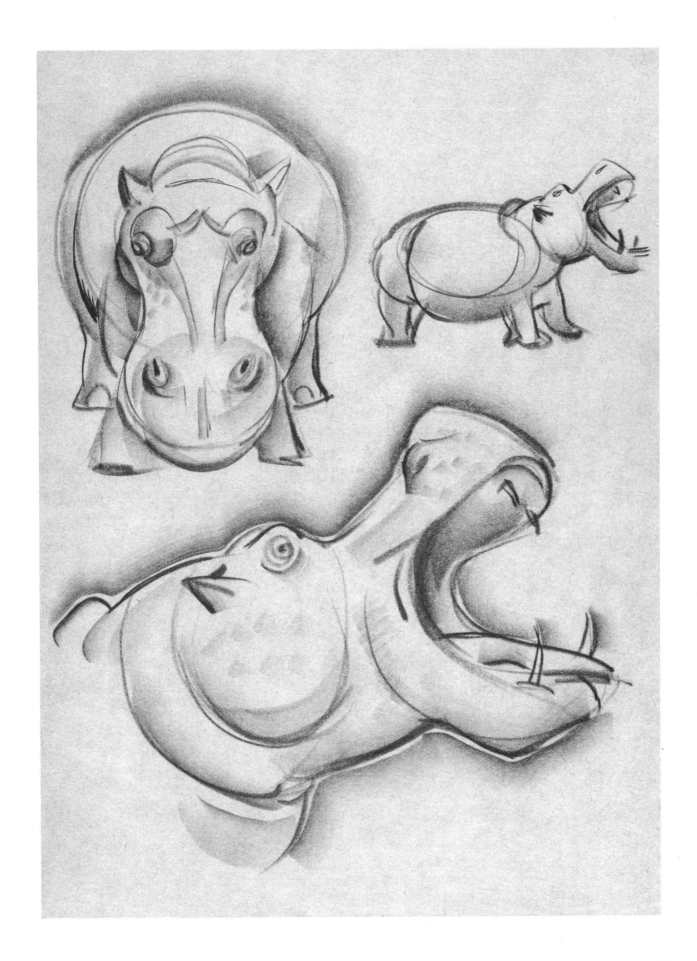

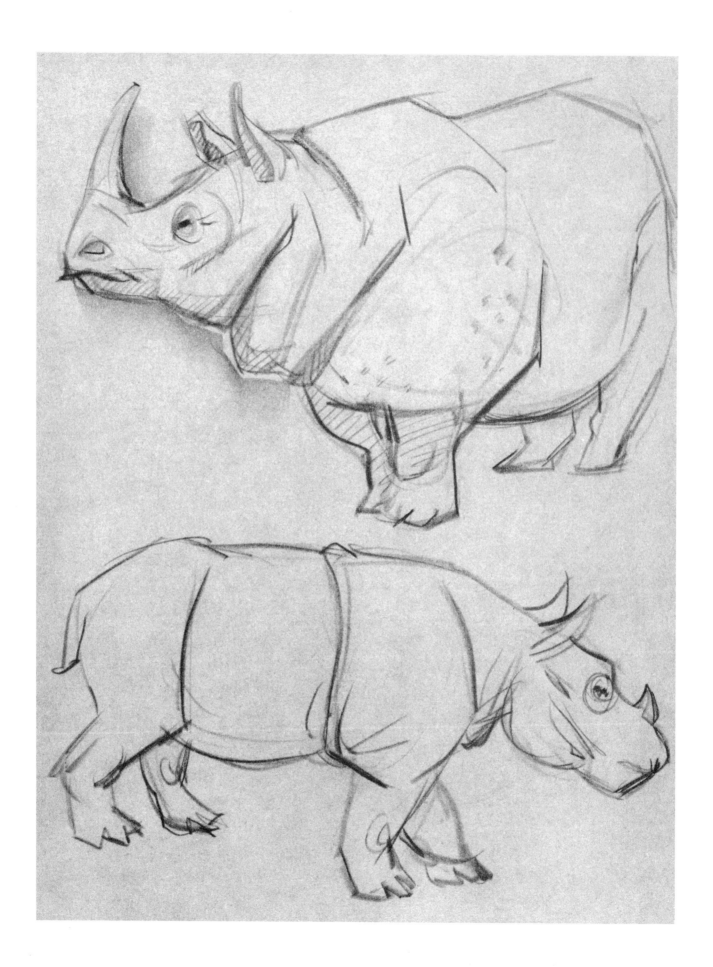

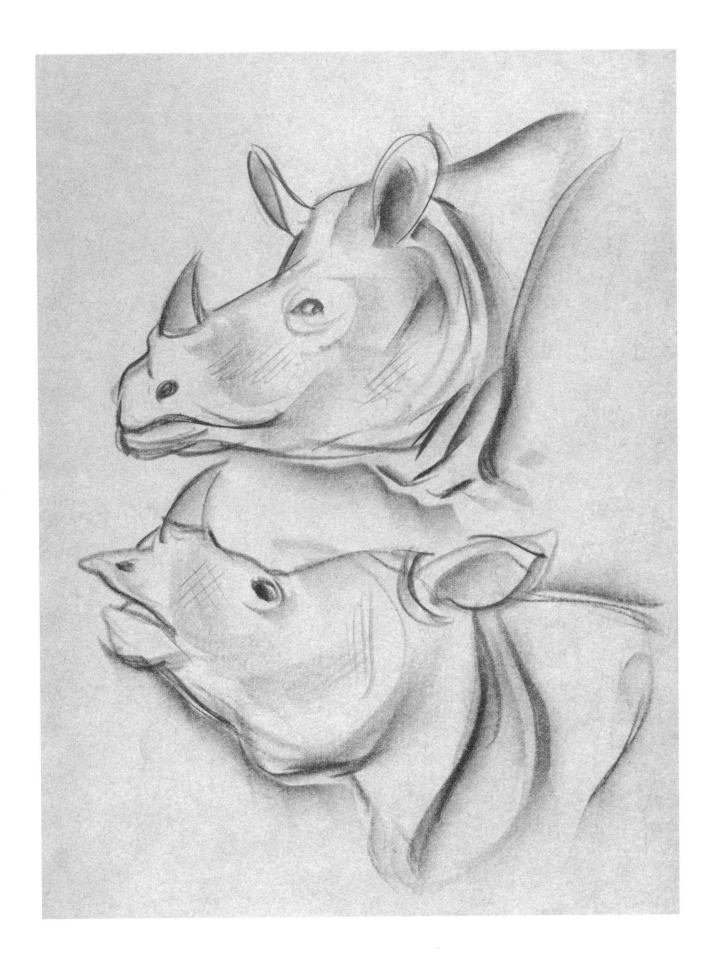

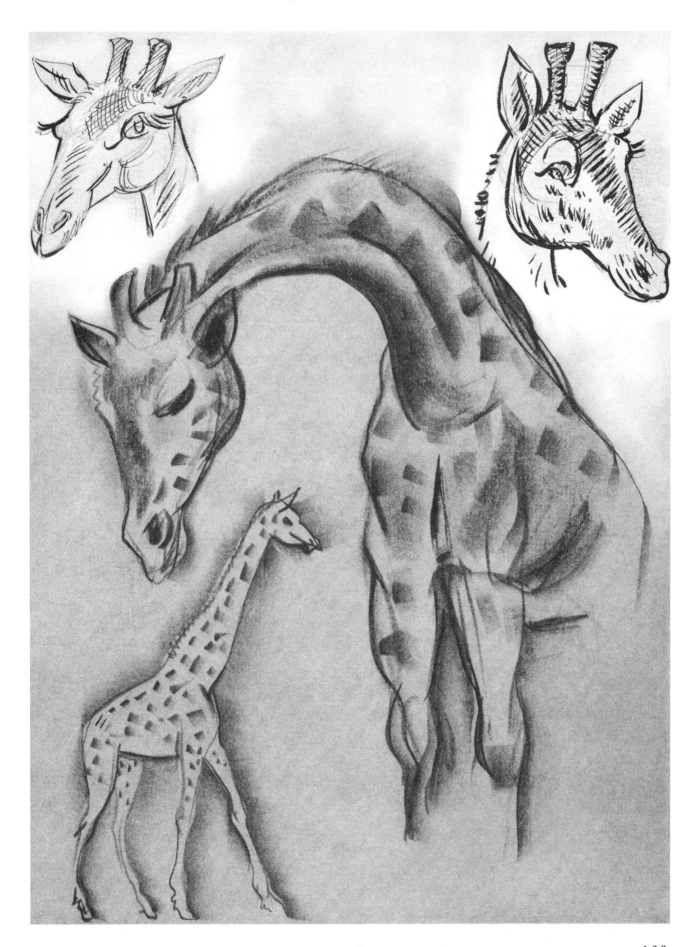

Giraffes

# BEARS

⌒⌒⌒ THE MANY DIFFERENT SPECIES OF BEARS have a similarity of general pattern that obviates the necessity for studying them separately. All, in spite of their ponderous bulk, have firm forms which here and there show through the soft furriness. The lines are generally curved and you may find yourself with a tendency to draw puffy forms; the squaring-off process shown will counteract this.

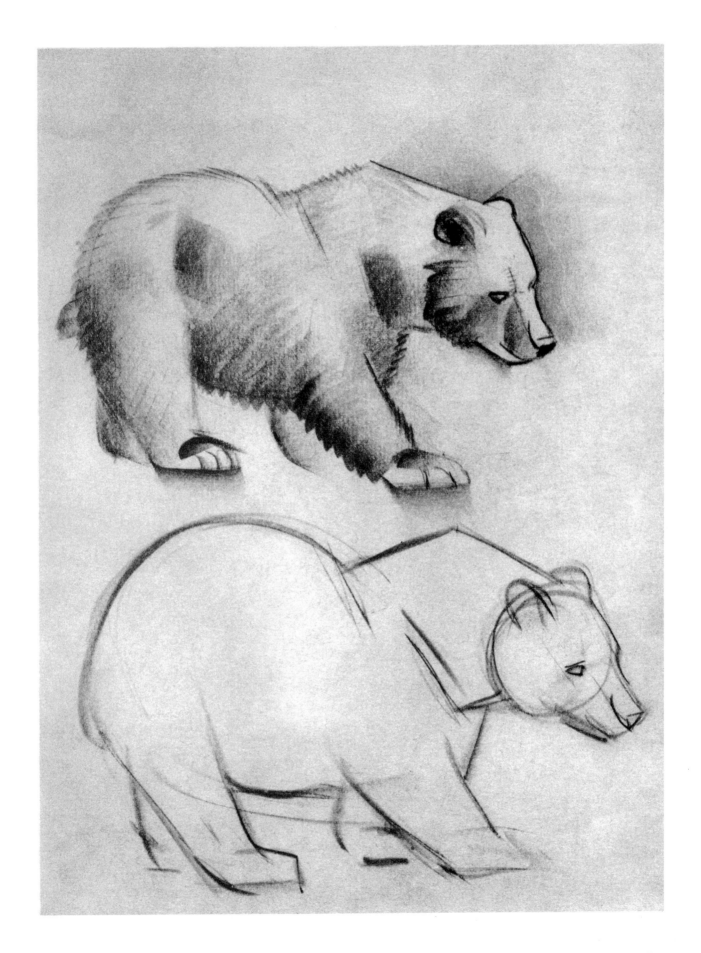

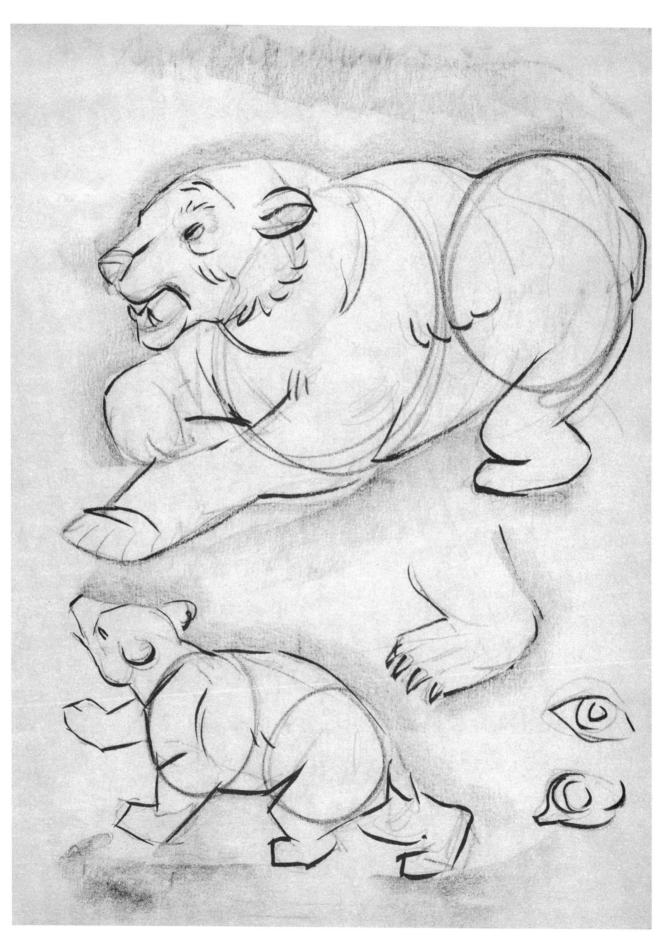

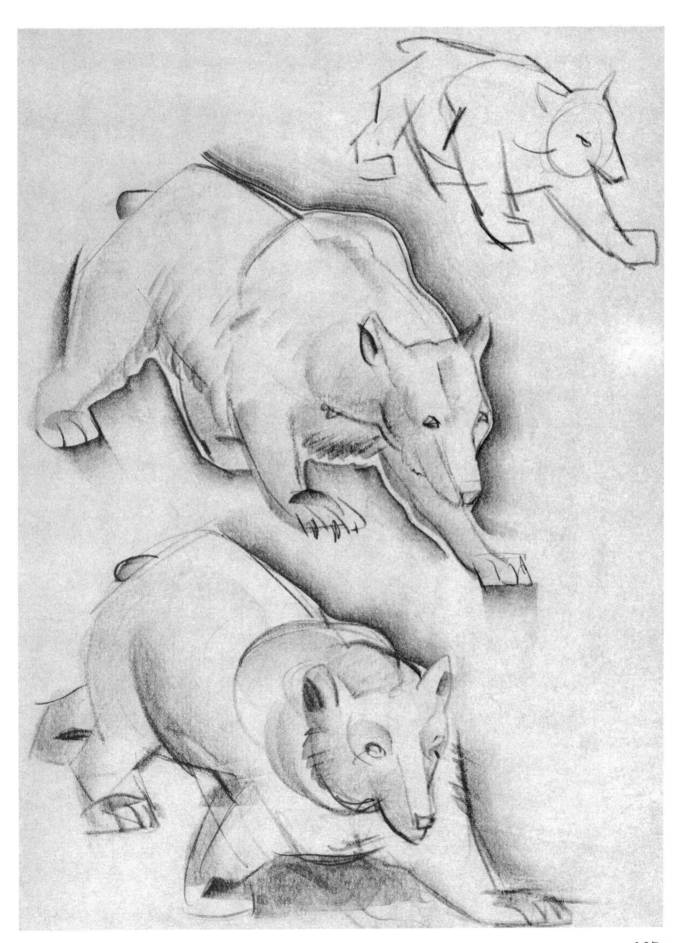

137

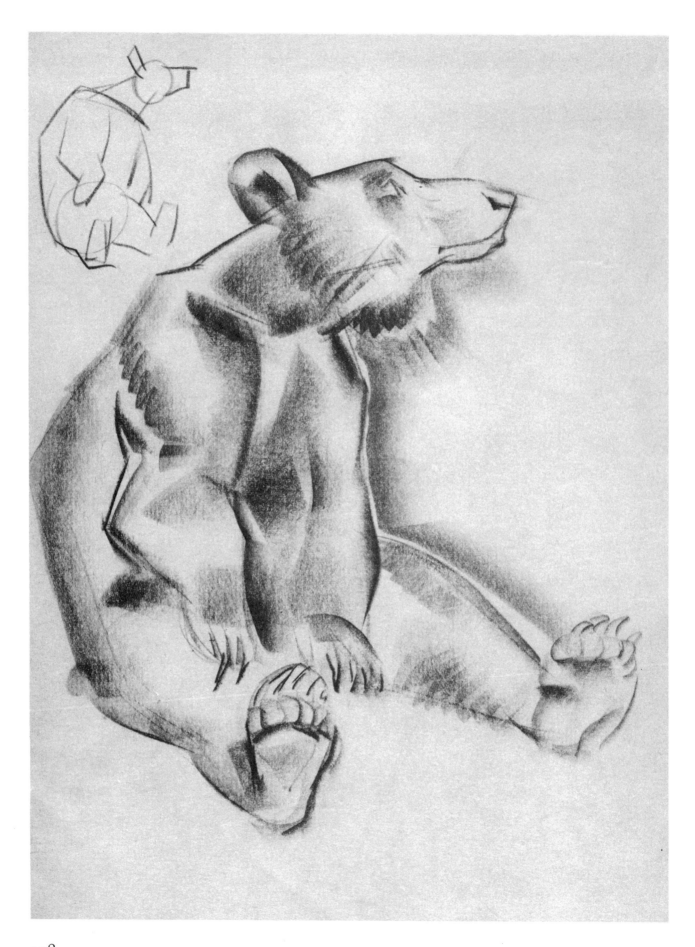

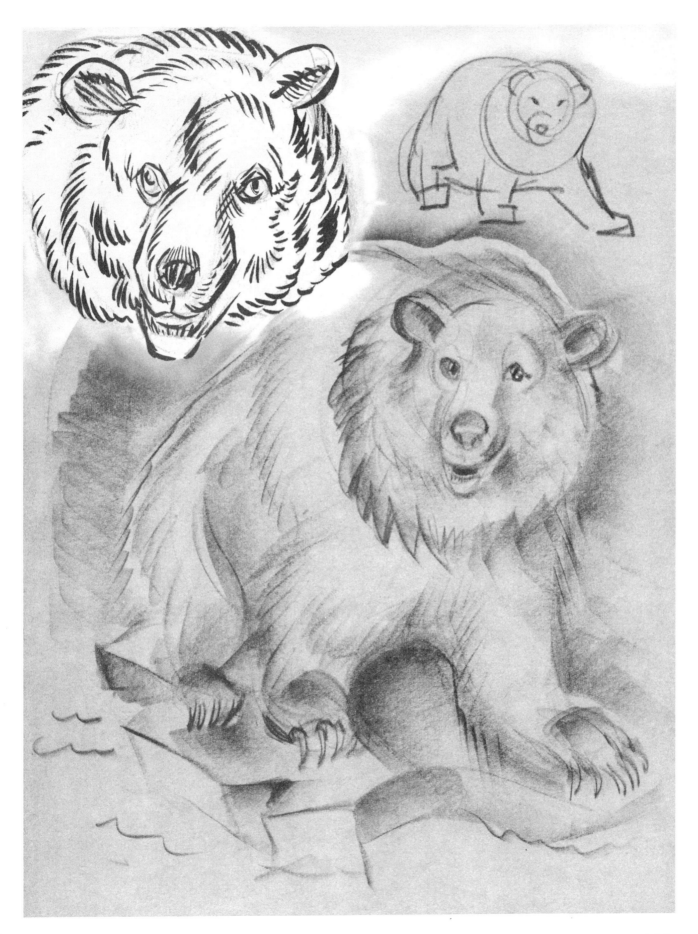

# CAMELS

THE CAMEL HAS SO MANY PECULIAR FEATURES in its structure that it cannot be placed easily into any pattern that serves for drawing other animals. The curious gait, the hump, the great curved neck, the split lip, and the strange foot make him a very "different" animal. Study these odd features from these few position drawings.

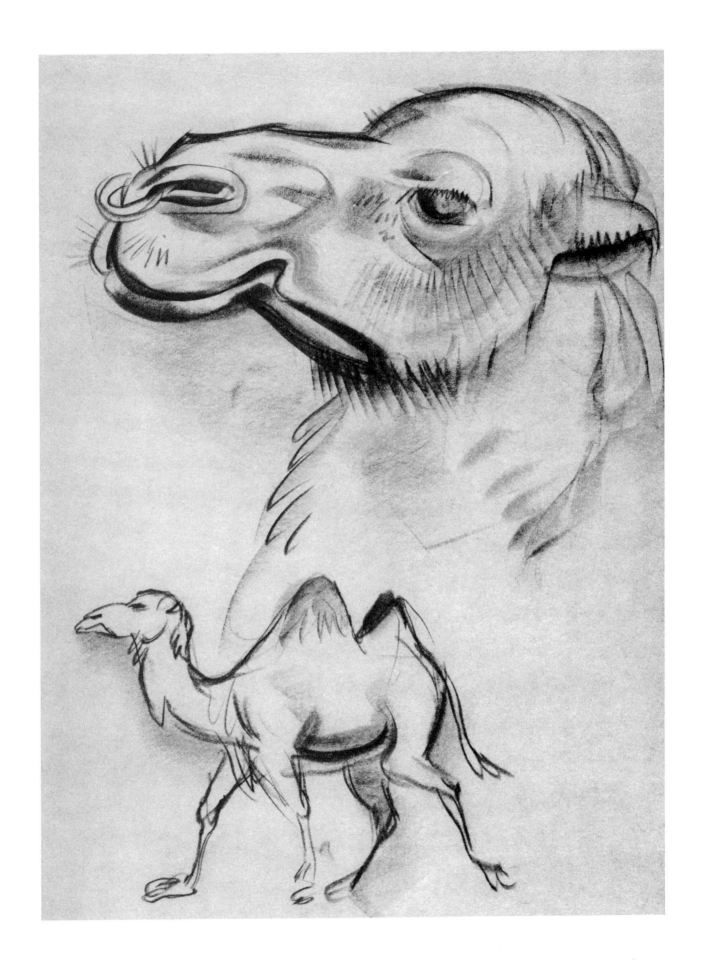

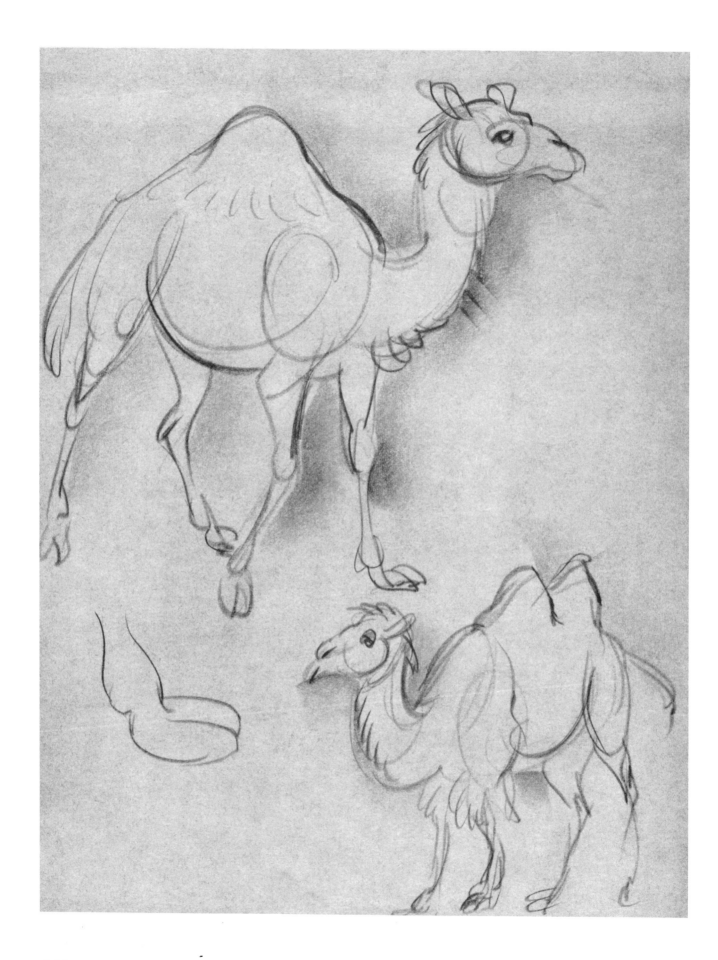

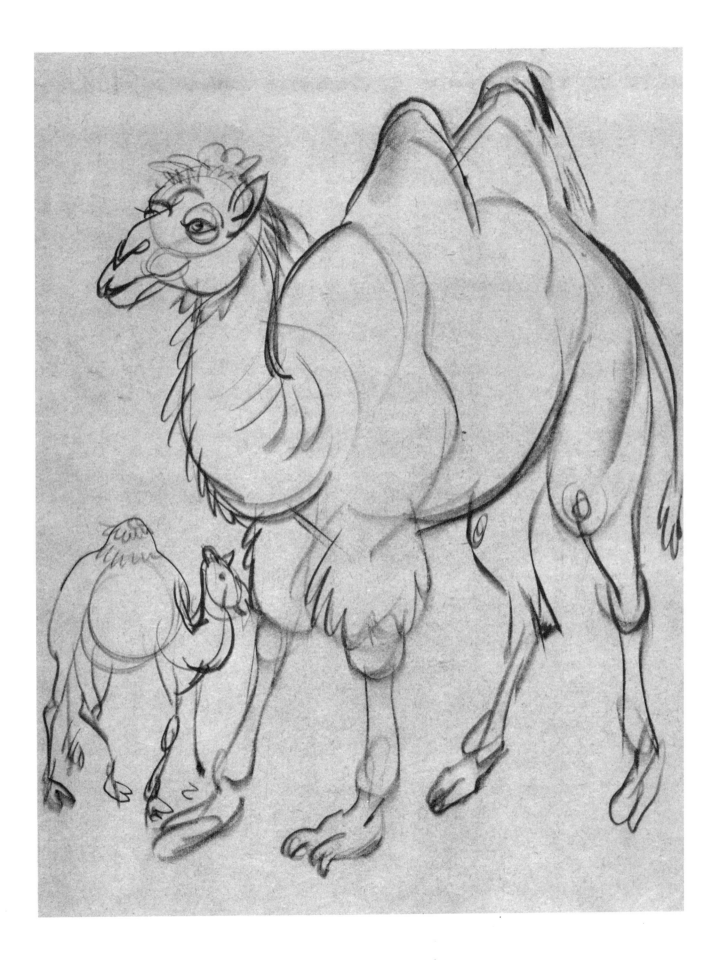

# SQUIRREL, OTTER, BEAVER, MINK, RABBIT, KANGAROO

⌒⌒⌒ THE FORMS OF MANY ANIMALS are adapted to their special ways of moving, of living in general. Such animals include the tree-living squirrel, the dam-building beaver, the low- and long-bodied weasel, the rabbit with his strong hind legs. Yet observation of these animals will enable you to see a kinship in form with other animals. The two-circle principle holds.

But the kangaroos belong among the "ain't no such animal" group, those that conform to no general type. They are not doglike, horselike, or catlike. They must be sketched from life and studied from photographs for their peculiar features. No generalized plan for drawing them can be devised, since the kangaroo form is so completely special. A simplified study is shown on page 149.

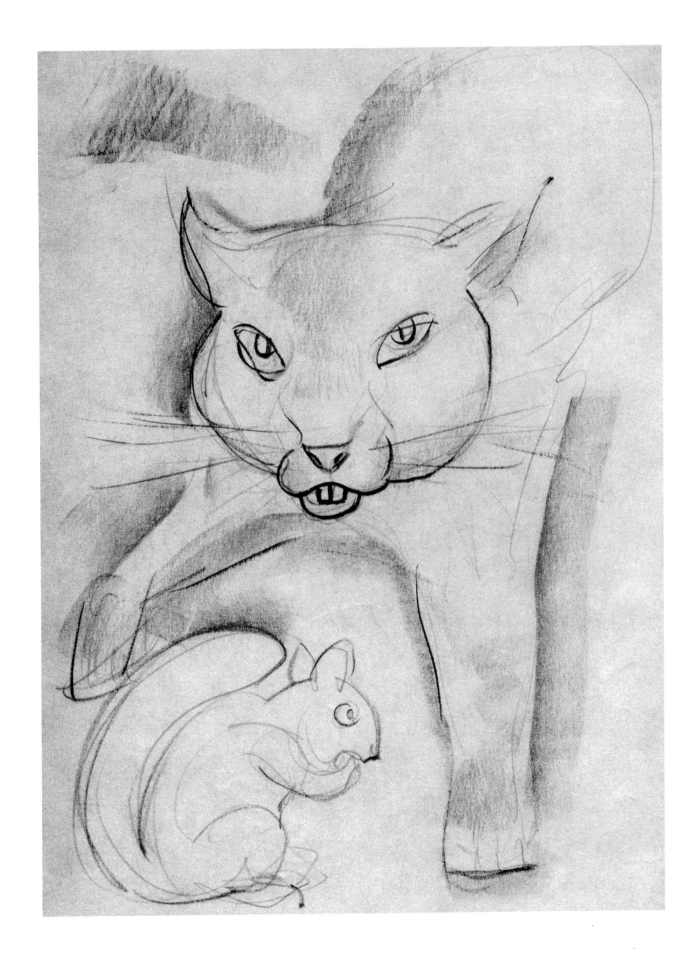

145

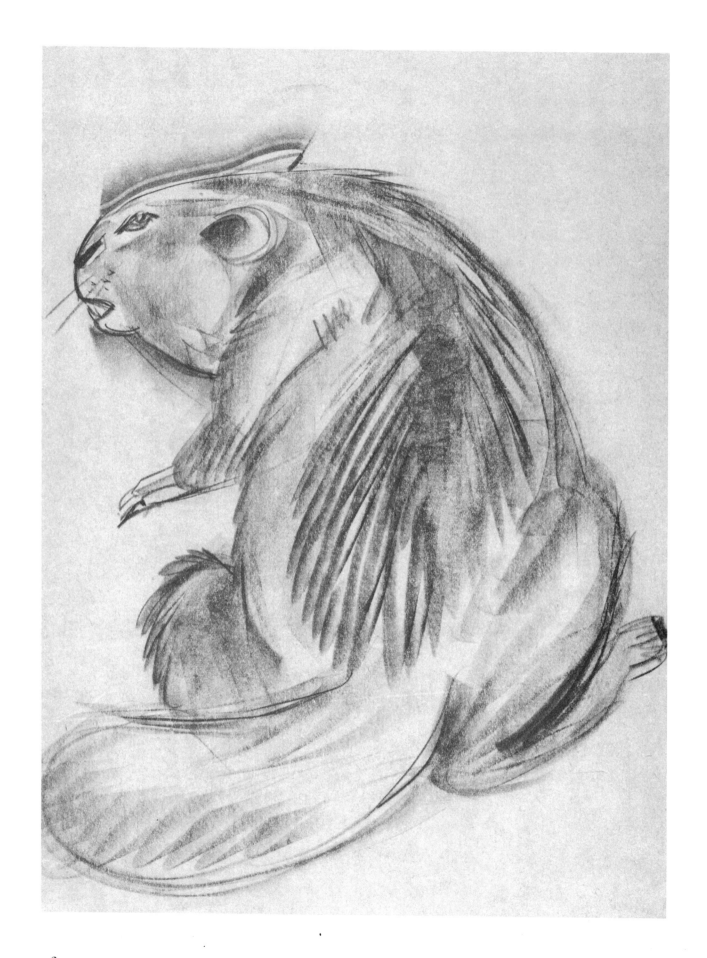

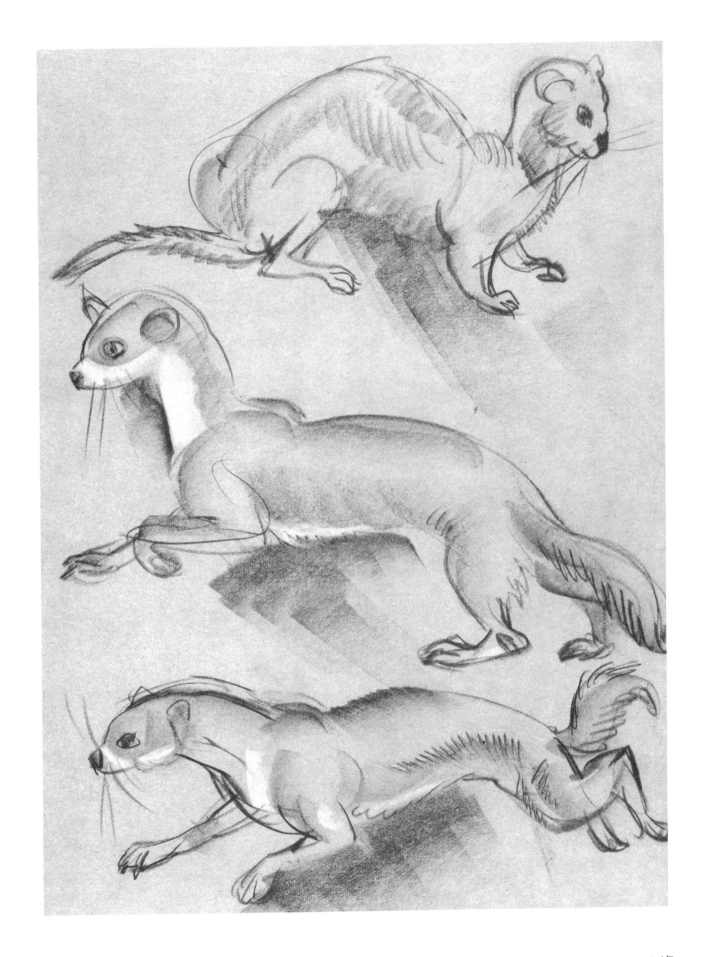

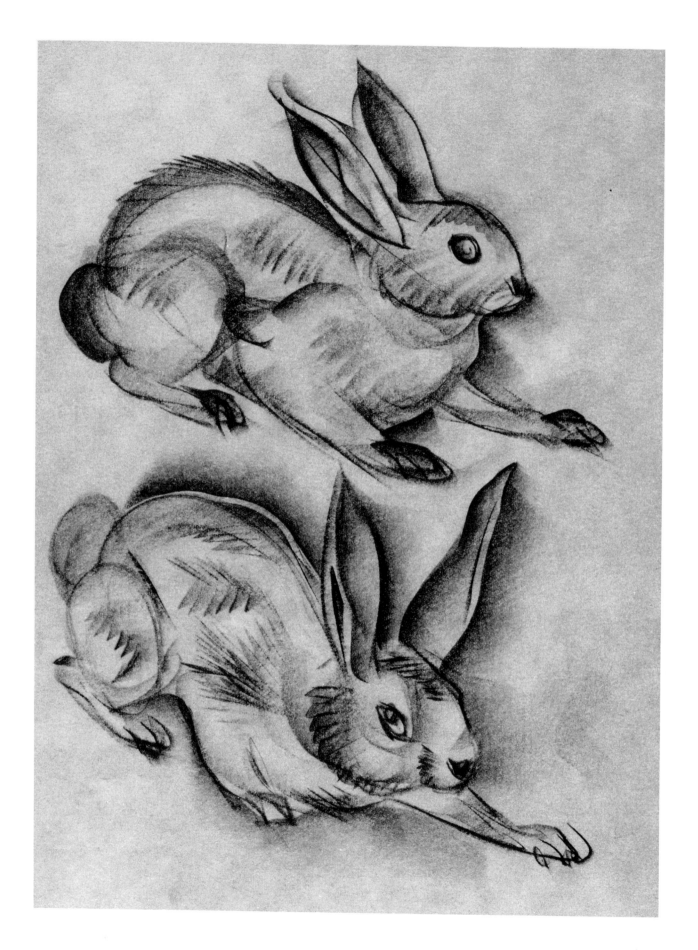

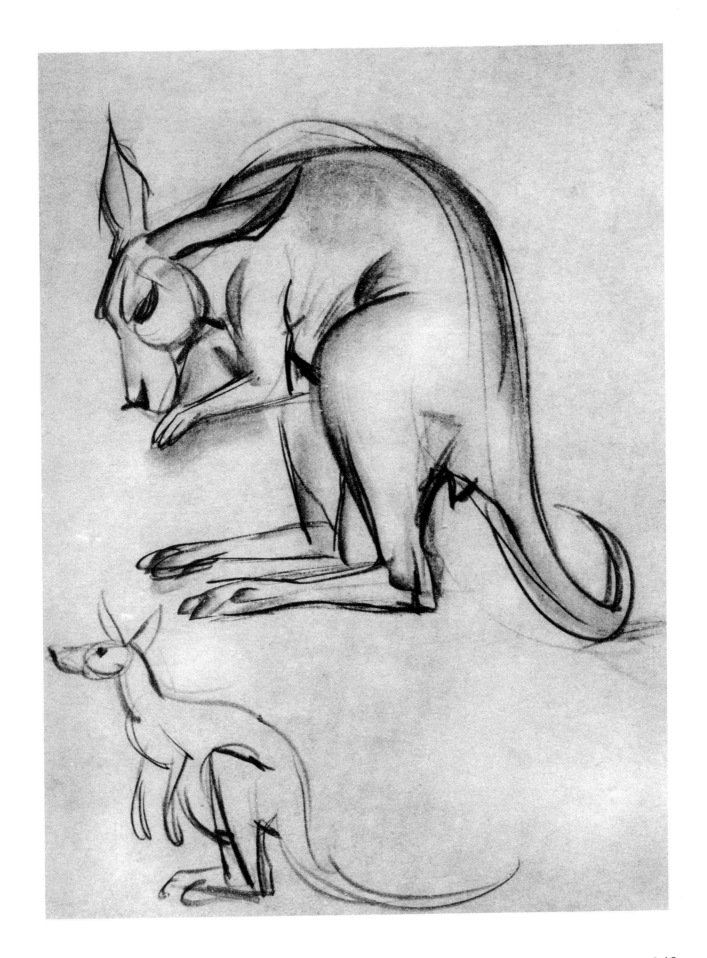

# BIRDS

⌒⌒⌒ THE INNUMERABLE VARIETIES OF BIRDS are subjects for endless study and the differences in their markings, shapes, sizes, and habits have been the life study of many naturalists. Here, however, for purposes of drawing, we are concerned only with those special qualities that characterize a bird. These are lightness, flight, grace, and speed, and general form of wing and body. We are concerned with bird action rather than with details of bird structure, for in action lies what is most birdlike. Yet principles of structure—for flight rather than superficial anatomy—are the basic studies for drawing birds. Wing shape and wing position—in flight, soaring, rise, and descent—are a major part of bird study and we show a number of analyzed wing shapes and flight positions.

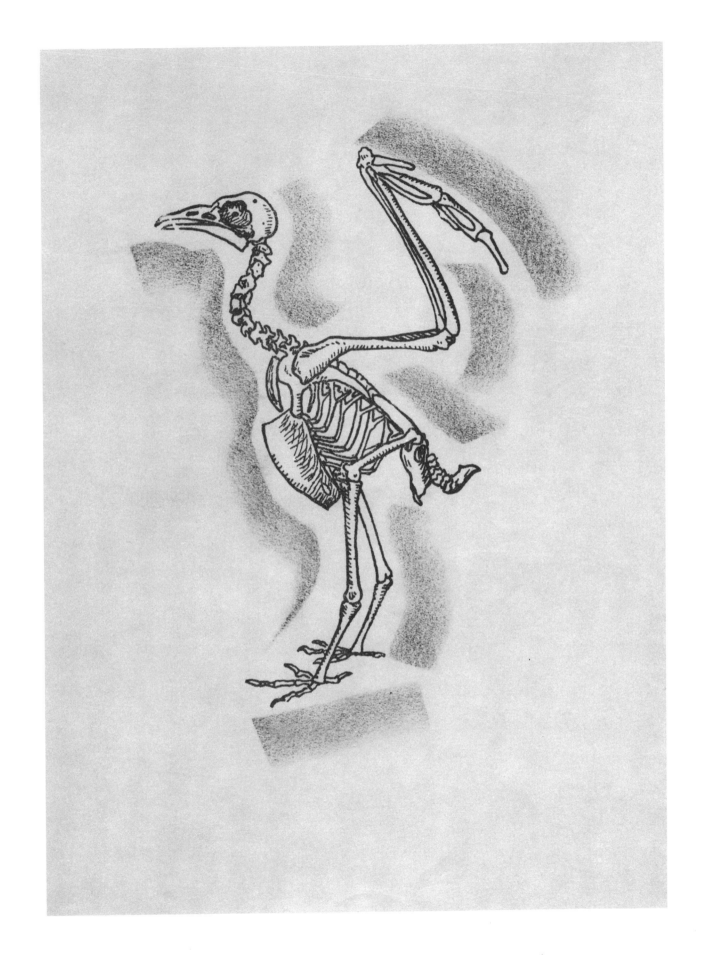

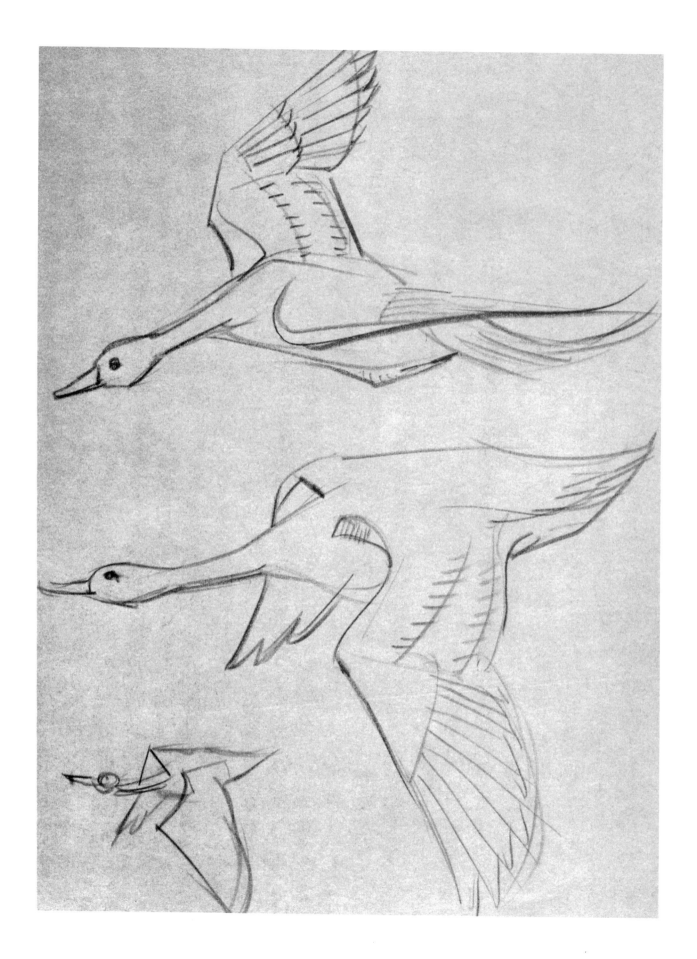

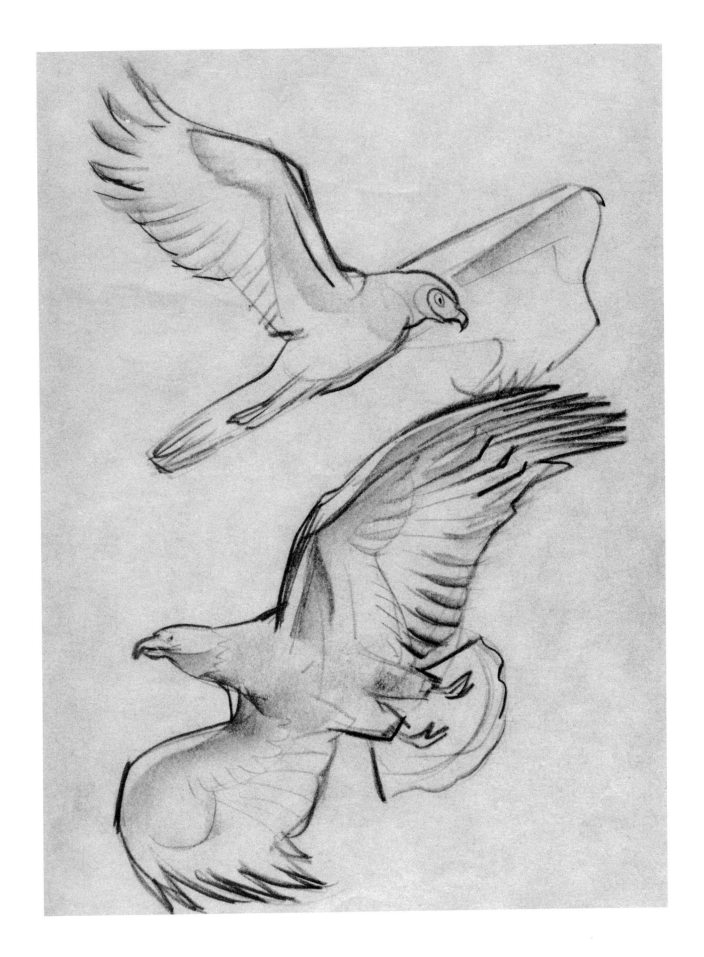

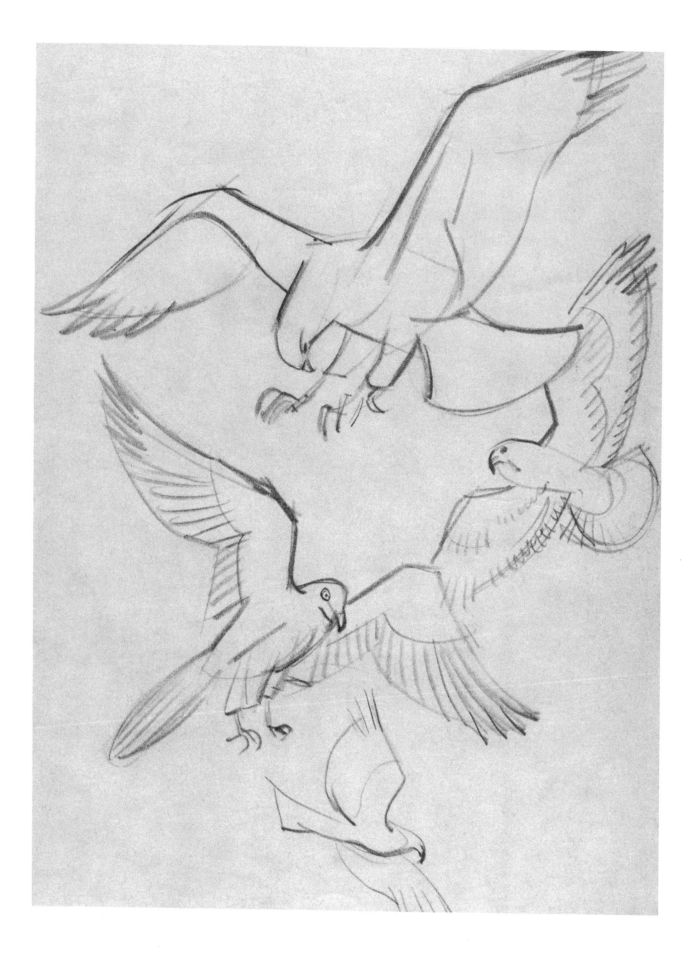

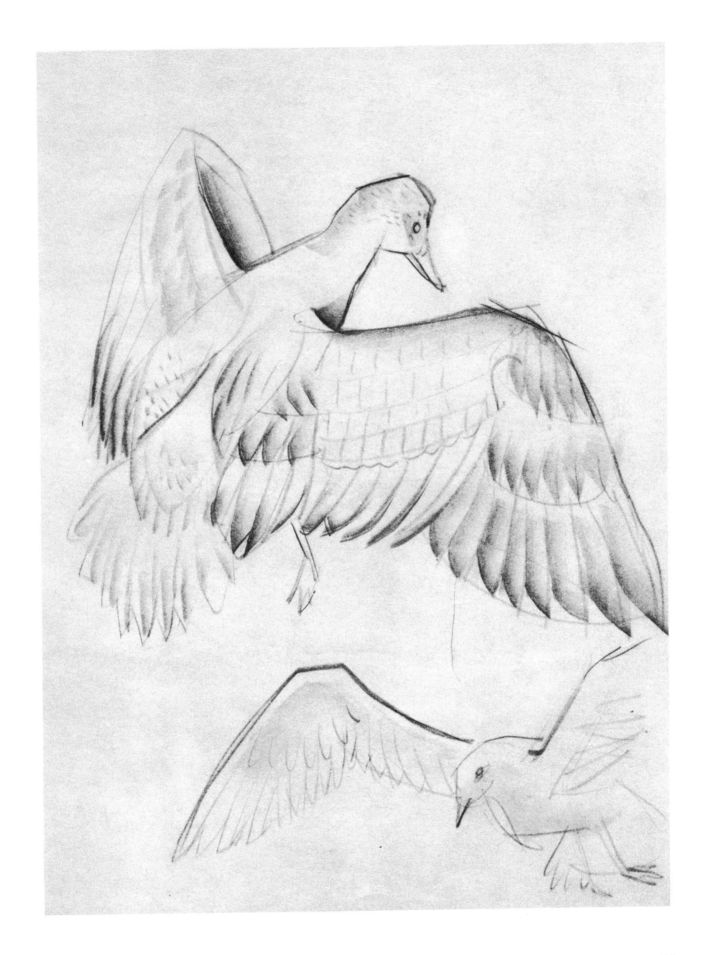

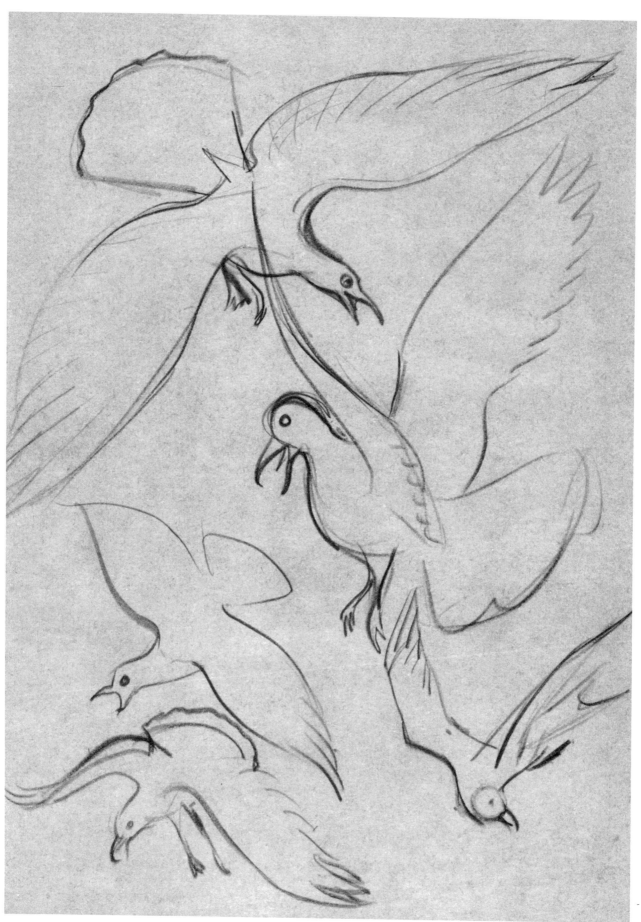

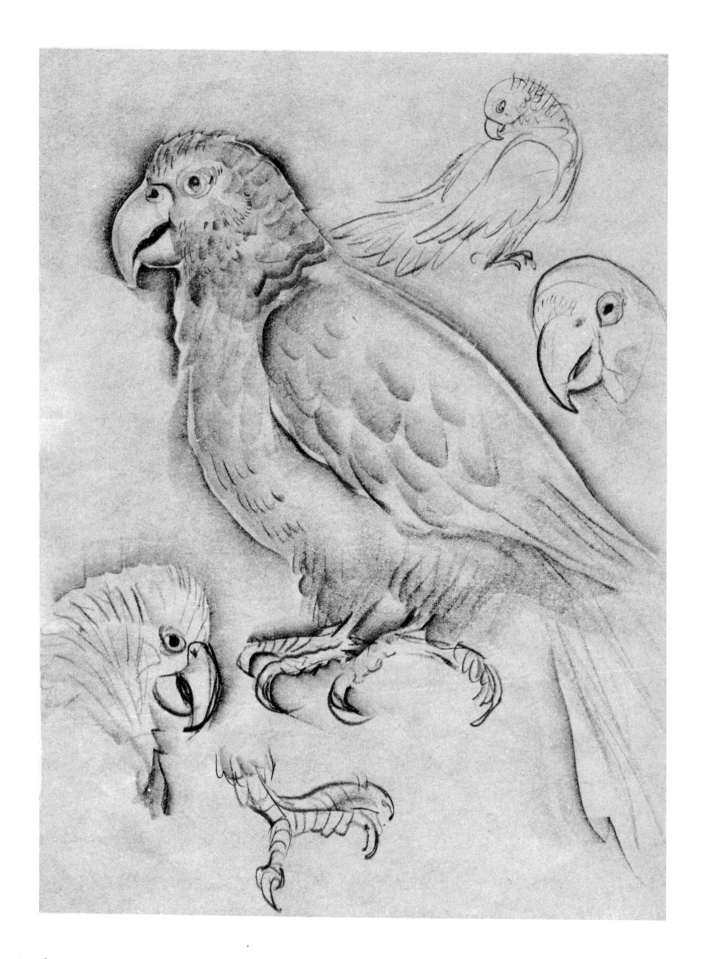

# MONKEYS AND APES

ᴀᴀᴀ THE SKELETONS OF ALL THE SIMIANS are very similar, and all are closely related to that of man in most important details. Except for variations in bone lengths, skull shapes, and occasional minor details like prehensile tails or vestigial ones, simians are —for drawing purposes—men with a peculiar stance, with more hair, and—in some species—with a doglike face. Study particularly the apelike stance and peculiar methods of locomotion. The following pages show several species of ape in studies that emphasize main surface characteristics.

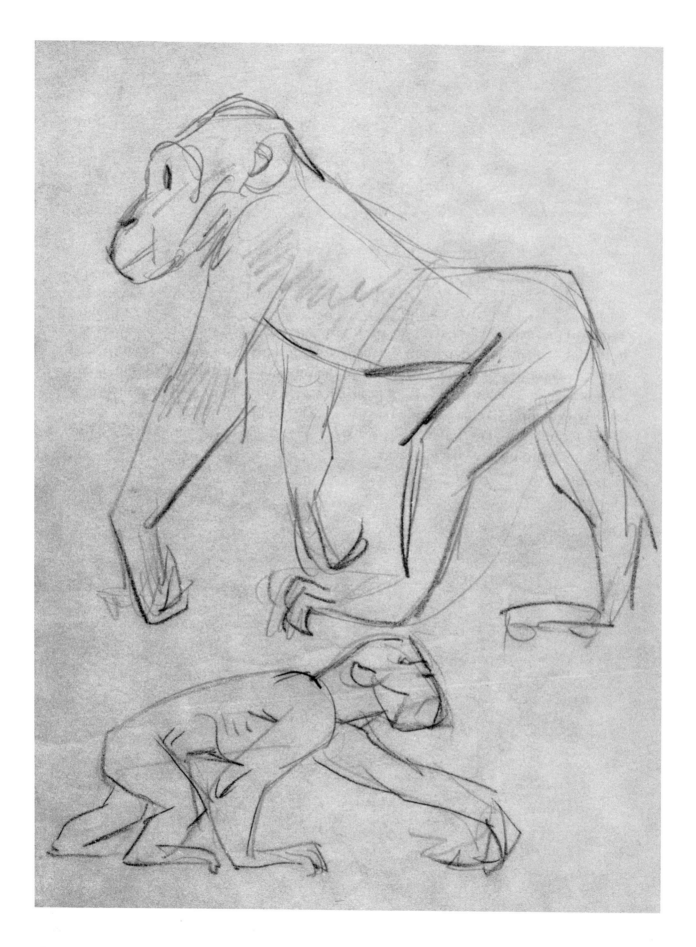

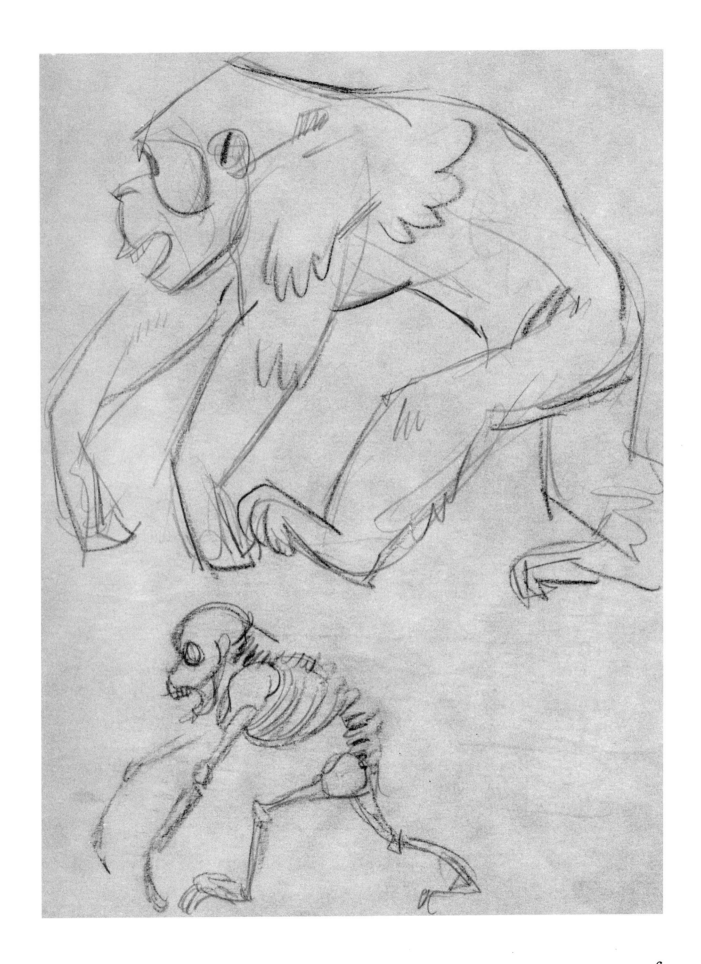

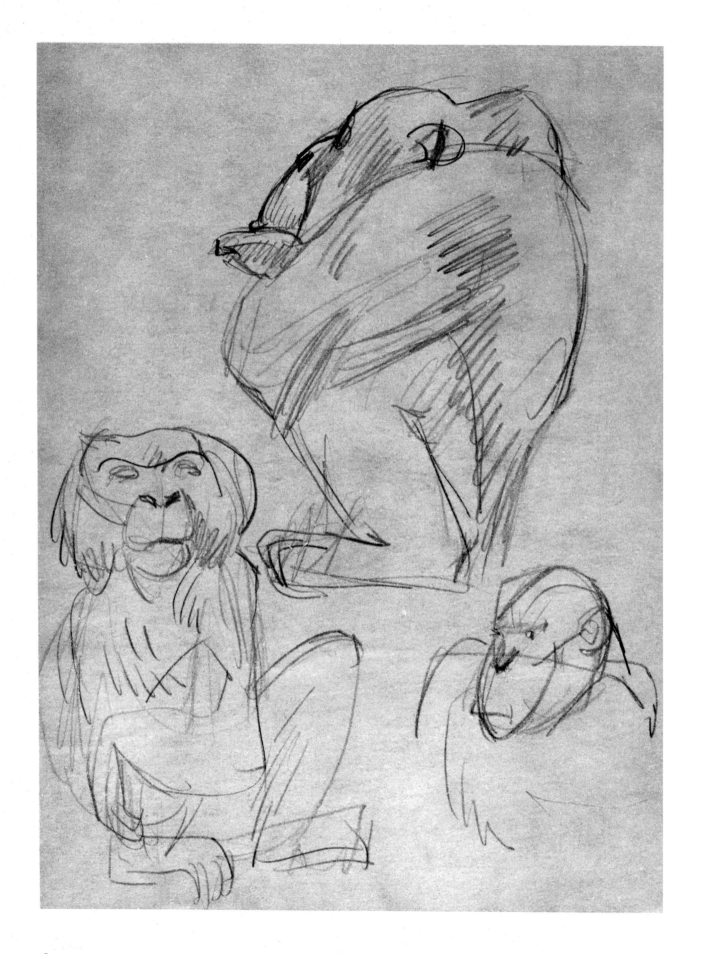

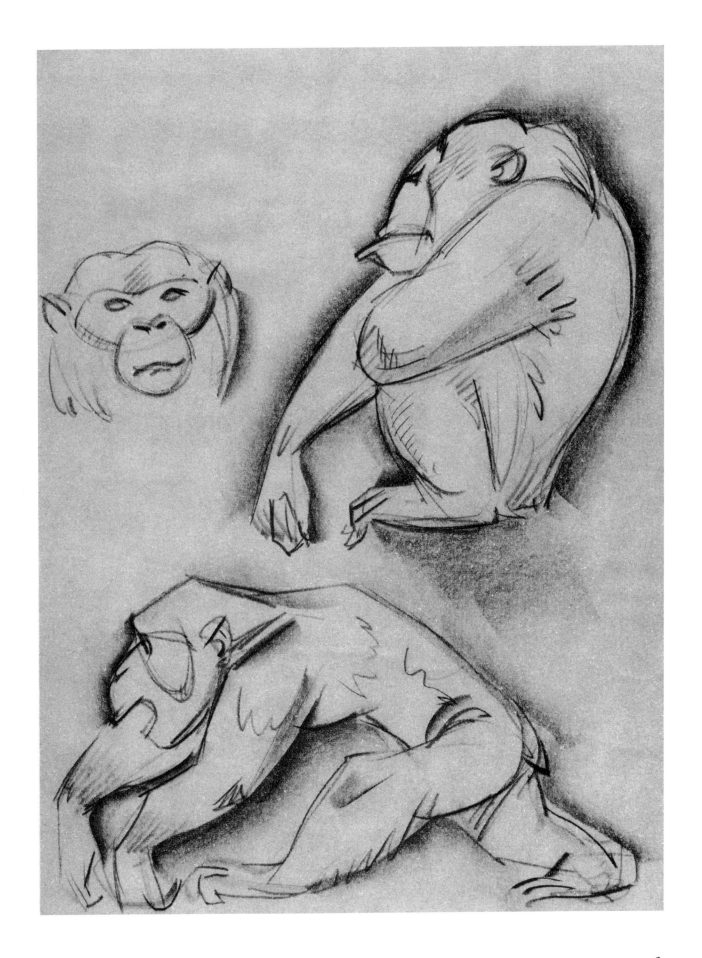

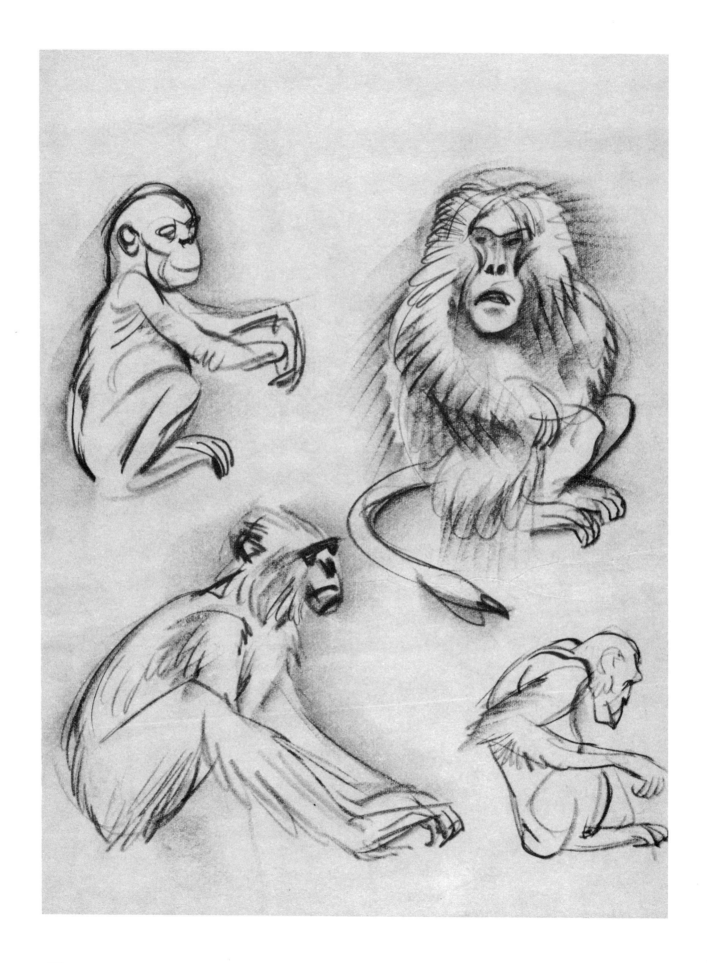

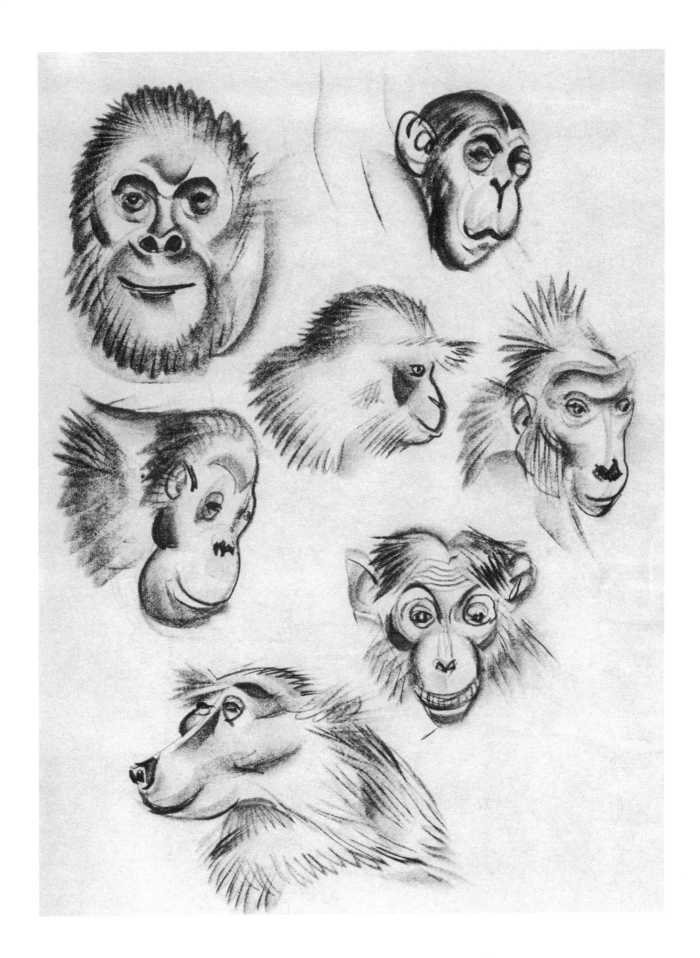

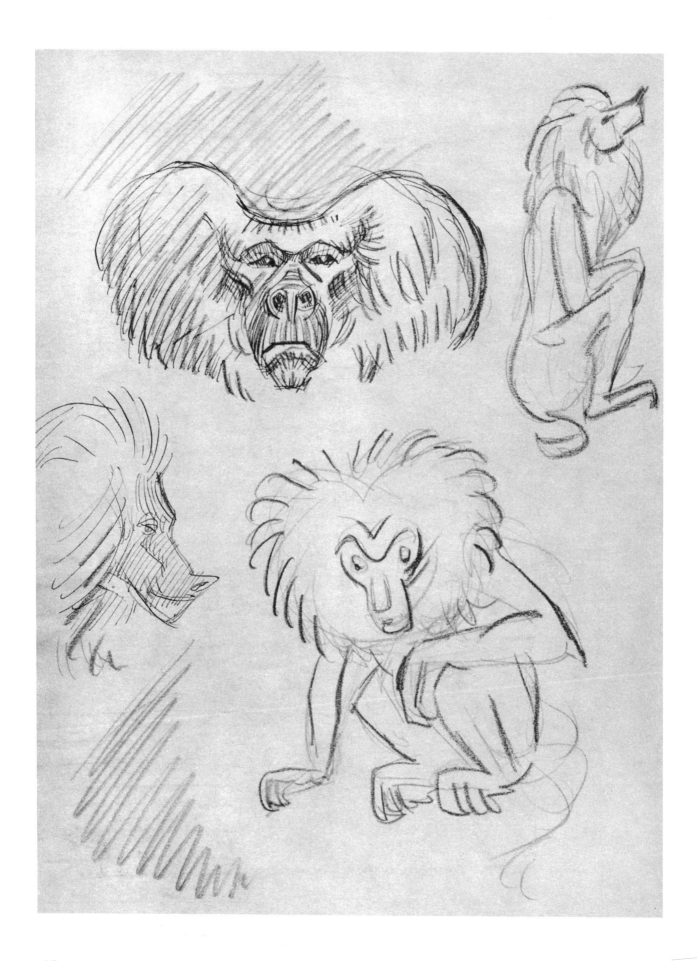

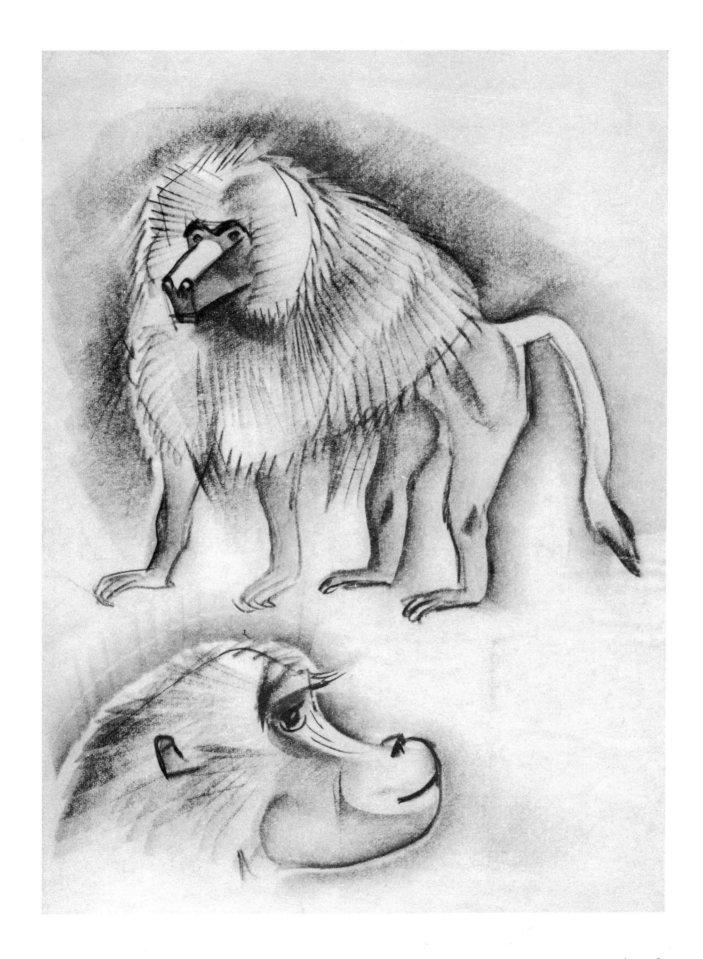

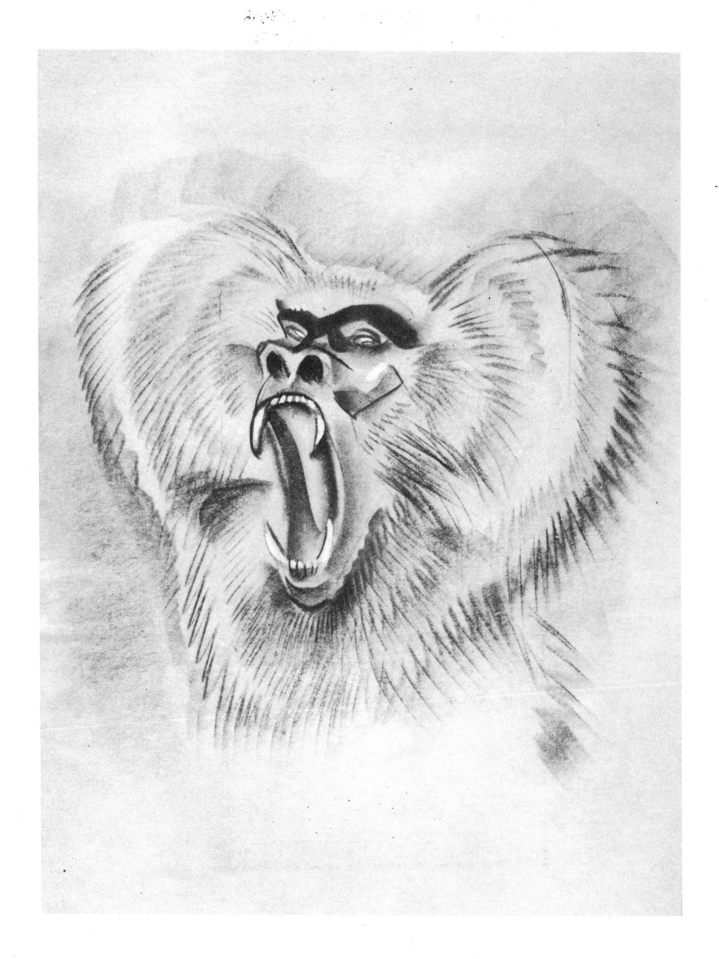